MOTHER

"Step right up for the greatest show on earth. The biologic show. Any being you ever imagined in your wildest and dirtiest dreams is here and yours for a price. The biologic price you understand..."

- William S. Burrough
Sidetripping

Printed in Germany
ISBN 3-9805876-4-9

Badlands
Charles Gatewood Photographs

Goliath

Contents
Inhalt
Sommaire
Contenido
Indice

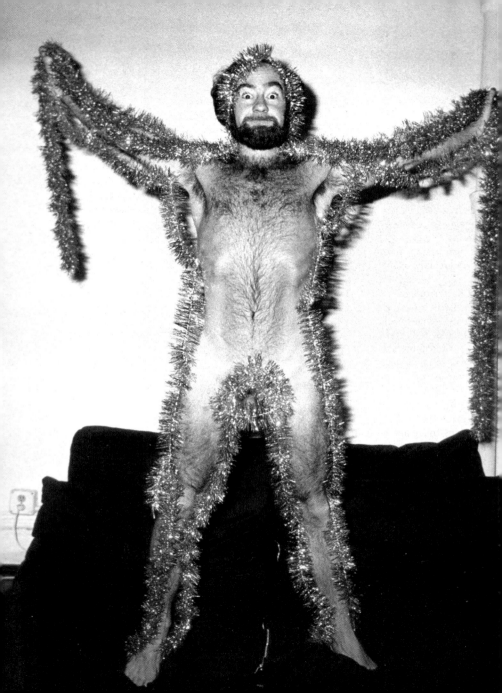

"The way a person looks on the outside is the window to their innermost soul",

according to a Persian proverb, a few hundred years older than the modern print media culture we attribute this wise old saying to now. Photographers knew this to be true, as their first and most common subjects were people. And what was captured on camera (faces, poses, costumes), also revealed sides of people they didn't necessarily want to show. Certainly the only truly objective things were always the cameras themselves, but rarely the photographers behind them and that is why pictures like those by Charles Gatewood are so very rare and a selection like this represents a collection of rarities on three levels: as realities, as documents, as works of art.

In his early snapshots he documented, with a touch of humour but not without some melancholy, the life of beatniks, masters in the art of living, anti-social elements of society, travellers going off the rails for a night or dropping out of society for life. With the intensity of someone right in the midst of them Gatewood experienced the changes in America, the change in our western society. After all the upheaval, dictatorships and revolutions man has apparently gone back to his roots: At the root of all things stands the individual, who remains when there's nothing else left.

The drama of social isolation and the coming together in groups again, apparently it is better to live communally, is brought to life by Charles Gatewood with great visual intensity in a genre of photography perceived as "monstrous" by some outsiders. The word "monster" comes from monstrare (Latin = to show) and originates from Roman oracular utterances. Monstrous was understood to mean all scientifically unexplained natural phenomena on a terrifying scale: storms, floods, earthquakes, but also deformed and disfigured people, deemed to be communications from superhuman powers. We call these monsters. They want to show us something.

If you compare Gatewood's early photos with his later work, today's work is blatantly trashy, on the face of it, just as trashy as the way the bourgeois world thirty five years ago perceived the whole Beat culture. The bourgeois scarecrows back then are respectable historical icons today and so it is hard to see the new contemporary phenomena in the same light and to accept them, particularly when they do not correspond to our aesthetic and moral standards. Beauty and morality have no universal validity, only situational correctness at all times instead.

For over three decades Gatewood has been photographing alternative and/or peripheral lifestyles. "His models" moved around freely and performed for the camera, they didn't do it for the money, but for the desire to be documented. So these were authentic pictures not easily endured by a middle class chamber of horrors, as anyone who enjoys getting the creeps, is afraid of real life. Gatewood's libertine environment has a different smell to it than the deodorised world of air conditioned studios.
Charles Gatewood's photos are snippets of the human condition; and as such they are not dark, but on the trail of life.

The editor

Charles Gatewood photographed by Toby Old

"Die Außenseite eines Menschen ist das Titelblatt des Inneren",

sagt ein ein persisches Sprichwort, ein paar hundert Jahre älter als die moderne Printmedienkultur, der wir diese Weisheit ins Stammbuch schreiben. Die Fotografen wußten es per se, denn ihre ersten und häufigsten Objekte waren Menschen. Und was die den Kameras darboten (Mienen, Posen, Kostüme), offenbarte auch jene menschlichen Seiten, die man nicht unbedingt zeigen wollte. Wirklich objektiv waren freilich immer nur die Aufnahmegeräte, seltener die Fotografen selbst, und deshalb sind Bilder wie die von Charles Gatewood so selten und eine Auswahl wie die vorliegende eine Sammlung von Seltenheiten in dreifachen Sinne: als Realien, als Dokumente, als Kunstwerke.

In seinen frühen „Schnappschüssen" dokumentiert er humorvoll, aber nicht ohne Melancholie, das Leben von Beatniks, Lebenskünstlern, Asozialen, Gradwanderern, für eine Nacht entgleist oder lebenslang ausgestiegen. Mit der Intensität eines mitten unter ihnen befindlichen erlebte Gatewood den Wandel Amerikas, den Wandel unserer westlichen Gesellschaft. Nach all den Aufbrüchen, Bevormundungen, Revolutionen ist der Mensch scheinbar an seinen Ausgangspunkt zurückgekehrt. Am Ursprung aller Dinge steht das Individuum, das übrig bleibt, wenn sonst nichts mehr übrig ist.

Die Dramatik der sozialen Isoliertheit und das Sichwiedersammeln in Gruppen - gemeinsam läßt es sich scheinbar besser leben? - vergegenwärtigt Charles Gatewood visuell verdichtet in einer für manchen Außenstehenden empfundenen „Monstrum" Fotografie. Das Wort monstrum kommt von monstrare (lat.=zeigen) und entstammt der römischen Orakelsprache. Als monströs galten alle wissenschaftlich unerklärten Naturerscheinungen der furchterregenden Kategorien: Gewitter, Fluten, Erdbeben, aber auch Missgeburten und Deformierungen, die als Mitteilungen übermenschlicher Mächte galten.
Monster wollen uns etwas zeigen.

Vergleicht man Gatewoods frühe Aufnahmen mit späteren Arbeiten, wirken die heutigen auffällig trashig, doch oberflächlich betrachtet, genauso trashig, wie die bürgerliche Welt vor fünfunddreißig Jahren die gesamte Beatkultur empfanden. Heute sind die Bürgerscheuchen von damals ehrenwerte historische Ikonen und doch fällt es schwer, mit den selben Augen neue zeitgenössische Phänomene zu betrachten und zu akzeptieren, besonders, wenn sie nicht unseren ästhetischen und moralischen Wertmustern entsprechen. Doch Schönheit und Moral haben keine universelle Geltung, sondern stets nur situative Richtigkeit.

Seit über drei Jahrzehnten fotografiert Charles Gatewood alternative und/oder periphere Lebensstile. "Seine Modelle" bewegten sich frei und stellten sich selbst dar, sie taten es nicht ums Geld, sondern aus dem Wunsch, dokumentiert zu werden. So wurden es authentische Schaubilder, die ein bürgerliches Horrorkabinett nicht ohne weiteres erträgt, denn wer sich gerne gruselt, fürchtet das wahre Leben. Gatewoods libertines Milieu hat eine andere Ausdünstung als die deodorierte Welt klimatisierter Studios.

Charles Gatewoods Fotos sind Abzüge menschlichen Befindens; als solche sind sie nicht dunkel, sondern dem Leben auf der Spur.

Der Herausgeber

"L'aspect extérieur d'un homme est la page de titre de son intérieur",

dit un proverbe persan de plusieurs siècles plus vieux que la culture des médias imprimés à laquelle nous attribuons aujourd'hui cette maxime pleine de sagesse. Les photographes le savaient intuitivement puisque leurs premiers et leurs plus fréquents motifs ont été les êtres humains. Et ce que ces derniers ont présenté à leurs caméras (expressions des visages, poses et costumes) a révélé aussi les aspects de la nature humaine que l'on n'avait pas forcément l'intention de montrer. Il est évident que seuls les appareils étaient vraiment objectifs, les photographes eux-mêmes ne l'étant que très rarement. C'est pourquoi des clichés comme ceux de Charles Gatewood sont exceptionnels et la présente collection de photos rare à trois points de vue: en tant qu'objets concrets, en tant que documents et en tant qu'oeuvres d'art.

Dans les "instantanés" réalisés au début de sa carrière, il documente avec humour mais non sans mélancolie la vie des beatniks, des adeptes de la vie de bohème, des asociaux et de ceux qui se trouvent à la limite de la marginalité, déviant pour une nuit seulement ou pour le reste de leur vie. Après tous les éclatements, les contraintes et toutes les révolutions, l'homme semble être revenu à son point de départ: A l'origine de toutes choses est l'individu qui, lui, demeure lorsque plus rien d'autre ne reste.

Le caractère dramatique de l'isolement social et la propension à se rassembler en groupes – il paraît plus facile de vivre à plusieurs – Charles Gatewood les retrace visuellement de manière comprimée au travers d,une photographie qui est perçue comme "monstrueuse" par les non-initiés. Le mot monstre vient de monstrare, en latin montrer, et tire ses origines du langage des oracles romains. On considérait comme monstrueux tous les phénomènes naturels effrayants que la science ne pouvait expliquer: les orages, inondations, tremblements de terre au même titre que les êtres difformes et les malformations qui étaient tenues pour des messages des forces surnaturelles. C'est ce que nous appelons des monstres. Ils veulent nous montrer quelque chose. Si l'on compare les premiers clichés de Gatewood avec ses travaux ultérieurs, ceux qu'il réalise actuellement donnent l'impression très nette d'être plus "orduriers" mais, considérés de manière superficielle, ils ne sont ni plus ni moins ignobles que le monde des bourgeois jugeait l'ensemble de la culture beat il y a 35 ans. Aujourd'hui, les épouvantails à bourgeois de l'époque sont devenus de vénérables icônes historiques et, pourtant, on a du mal à regarder ces nouveaux phénomènes de notre temps avec les mêmes yeux et à les accepter, surtout s'ils ne sont pas en accord avec nos modèles de valeurs esthétiques et morales. Cependant, la beauté et la morale ne sont pas des critères universellement valables mais limités à certaines situations.

Depuis plus de trente ans, Gatewood photographie des styles de vie parallèles et/ou en périphérie de la société. Ses "modèles" étaient libres de leurs mouvements et se sont représentés eux-mêmes à leur façon; ils ne l'ont pas fait pour de l'argent mais parce qu'ils désiraient documenter leur manière de vivre. Ainsi ont été créées des images authentiques, difficiles à supporter dans une espèce de galerie des horreurs bourgeoise, car ceux qui aiment se faire peur ont peur des horreurs que la réalité leur réserve. Le milieu libertin de Gatewood a une odeur différente de celle de l'univers désodorisé des studios climatisés.

Les photos de Charles Gatewood sont des tirages de la condition humaine; en tant que tels, ils ne sont pas obscurs mais, au contraire, à la recherche de la vie.

L'éditeur

"La apariencia de una persona es el reflejo de su interior"

Es lo que dice un proverbio persa de hace siglos, es decir, mucho antes que la cultura moderna de los medios de impresión a la que atribuimos esta máxima. Los fotógrafos lo sabían perfectamente , puesto que las personas eran sus primeros y más numerosos objetos. Lo que éstas representaban ante las cámaras (gestos, poses, vestuario) revelaba también aspectos humanos que no necesariamente querían mostrar. Naturalmente, sólo las cámaras fotográficas son totalmente objetivas, raras veces lo son los fotógrafos, por eso son tan inusitadas las fotografías como las de Charles Gatewood. La presente selección es una recopilación de peculiaridades en tres vertientes: como realidad, como documento y como obra artística.

En sus primeras instantáneas, presenta con humor, aunque también con melancolía, la vida de beatniks, vividores, asociales, errantes, descarriados durante una noche o marginados de por vida. Con la intensidad de haberse encontrado entre ellos, Gatewood vivió la transformación que se produjo en América, la transformación de nuestra sociedad occidental. Después de todas las rupturas, proteccionismos, revoluciones, el hombre parece haber vuelto al punto de partida: En el origen de todas las cosas está el individuo que permanece cuando ya no queda nada más.

Charles Gatewood condensa visualmente en una fotografía lo que algunos profanos perciben como fotografía de "monstruos": el dramatismo del aislamiento social y la nueva unión en grupos motivada por la idea de que juntos se vive mejor. La palabra "monstruo" proviene de monstrare (en latín, mostrar) y procede del lenguaje del oráculo romano. Se consideraban monstruosos todos los fenómenos de la Naturaleza inexplicables desde el punto de vista científico y que infundían temor: las tormentas, las inundaciones, los terremotos, pero también los engendros y criaturas deformes que se consideraban como evidencia de la existencia de poderes sobrenaturales. A éstos los denominamos monstruos. Nos quieren mostrar algo.

Si se comparan las primeras fotografías de Gatewood con trabajos posteriores, las actuales parecen ser de pobre calidad, pero si se observan superficialmente, poseen la misma baja calidad que el conjunto de la cultura beat tenía para la vida burguesa de hace treinta y cinco años. Los esperpentos burgueses de antaño son hoy dignos iconos históricos, sin embargo, resulta difícil ver con los mismos ojos nuevos fenómenos contemporáneos y aceptarlos, especialmente cuando no se corresponden con nuestros modelos estéticos y morales. Pero la belleza y la moral no poseen una validez universal, sino que siempre son aceptadas en función de la situación.

Desde hace más de tres décadas Gatewood fotografía estilos de vida alternativos o marginales. "Sus modelos" se mueven libremente y se presentan a sí mismos, no lo hacen por dinero, sino por el deseo de verse fotografiados. De esta forma, ha obtenido auténticos esbozos que un grupo burgués asustadizo no soporta fácilmente, y es que quien se estremece con facilidad, teme la vida verdadera. El ambiente libertino de Gatewood posee una emanación diferente al perfumado mundo de los estudios climatizados.

Las fotos de Charles Gatewood son un reflejo de las situaciones de las personas; y por eso no son oscuras, sino que siguen la pista de la vida.

El editor

"Il lato esteriore di una persona è lo specchio del suo lato interiore",

recita un proverbio persiano, risalente ad un paio di secoli prima della moderna cultura dei mezzi stampati, a cui rinfacciamo questa massima. I fotografi ne erano già consapevoli, in quanto i primi soggetti da loro più frequentemente ripresi erano le persone. E ciò che offrivano alle macchine fotografiche (espressioni, pose, costumi) evidenziava anche quegli aspetti umani che non necessariamente si volevano mostrare. Tuttavia veramente obiettive sono sempre solo state le macchine fotografiche, raramente sono stati obiettivi i fotografi, e per questo motivo le foto come quelle di Charles Gatewood sono così rare; una selezione come la presente è una collezione di rarità in un triplice senso: in quanto cose reali, documenti, opere d'arte.

Nelle sue precedenti "istantanee", egli documenta, pieno di umore, ma non senza malinconia, la vite dei beatnik, dei maestri di vita, degli asociali, dei girovaghi usciti dai binari per una notte o ritiratisi a vita. Con l'intensità di uno che si trovava in mezzo a loro, Gatewood ha vissuto il mutamento dell'America, la svolta della nostra società occidentale. Dopo tutte le insurrezioni, le mode, le rivoluzioni, pare che l'uomo sia tornato al proprio punto di partenza: All'origine di tutte le cose c'è l'individuo, che rimane, quando tutto il resto se ne è andato.

La drammaticità dell'isolamento sociale ed il riunirsi nuovamente in gruppi, insieme pare che si viva meglio, viene ricordata da un Charles Gatewood visivamente assorto in una fotografia recepita da alcuni estranei come "mostro". La parola "mostro" deriva da "monstrare" (latino = mostrare) e trae origine dal linguaggio degli oracoli degli antichi romani. Mostruosi erano ritenuti tutti i fenomeni naturali non spiegati dalla scienza e che rientravano nella categoria dei fenomeni che incutevano timore: temporali, inondazioni, terremoti, ma anche aborti e essere deformi, che venivano ritenuti messaggi lanciati da potenze sovrumane. Noi li chiamiamo mostri, ovvero ci vogliono mostrare qualcosa.

Se confrontiamo le prime fotografie di Gatewood con le sue opere più tardive, notiamo che quelle odierne hanno un effetto vistosamente "trash", se viste superficialmente; "trash" nella stessa misura in cui trentacinque anni fa il mondo borghese recepiva l'intera cultura beat. Oggi sono gli spauracchi borghesi di icone storiche a loro tempo onorabili, eppure riesce difficile osservare con gli stessi occhi i nuovi fenomeni contemporanei ed accettarli, specialmente se non corrispondono ai nostri modelli di valori estetici e morali. La bellezza e la morale non hanno validità universale, ma sempre e solo una idoneità situazionale.

Da oltre trent'anni Gatewood fotografa stili di vita alternativi o marginali. I "suoi modelli" si muovevano liberamente e si esibivano direttamente, non lo facevano per il danaro, bensì per il desiderio di essere documentati. Così diventavano immagini autentiche, che un ambiente borghese poi non sopporta così tanto, poiché chi rabbrividisce facilmente, teme la vera vita. Il milieu libertino di Gatewood emana una aroma diverso dal mondo deodorizzato degli studi fotografici climatizzati.

Le fotografie di Charles Gatewood sono estratti dello stato di salute dell'uomo; come tali non sono scure, bensì costantemente sulle tracce della vita.

L'editore

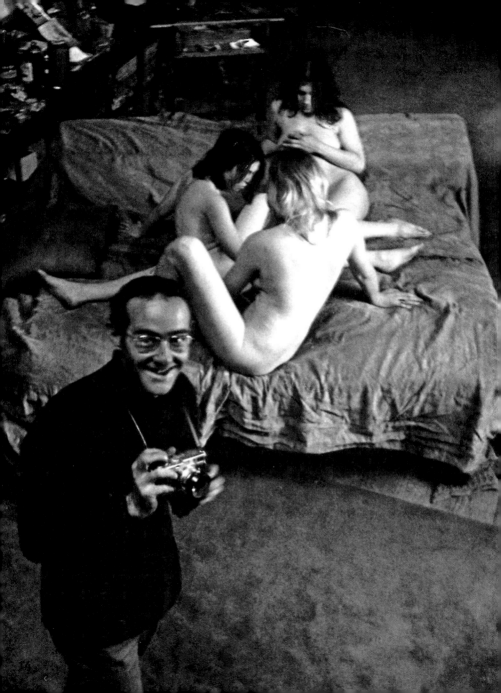

Pictures that kill
by John Held, Jr.

Charles Gatewood's photographic exhibitions are often accompanied by explicit warnings. A flyer for a l993 show in Portland, Oregon announced, "THIS IS NOT AN EXHIBIT FOR THE FAINT OF HEART OR THOSE EASILY OFFENDED--IT SHOWS THE IMPACT OF THE OUTER LIMITS OF PHOTOGRAPHY."

"I like the idea of liberation through excess," said Gatewood in the film 'Dances Sacred and Profane.' It relates directly to the idea of inversion...It's what Jesus was talking about when he said, 'The meek shall inherit the earth,' what Dylan was talking about when he said, 'To live outside the law you must be honest,' and what Leary was talking about when he said, 'You have to go out of your head to use your mind.' Sometimes you have to go crazy in order to be sane."

Gatewood was educated at the University of Missouri as a cultural anthropologist. There he became friendly with fellow student George W.Gardner, who already as an undergraduate had published his photographs in Life magazine. In 1963, as Gardner showed Gatewood his fine art prints in a student coffeehouse, Gatewood experienced an epiphany. "That moment changed my whole life. It was more stimulating than anything I learned in college."

Graduating with a BA in Anthropology and a minor in Art History, Gatewood went on to complete an additional year in the social sciences, but by then his interests had changed. "Academic life was boring," he says. "I wanted adventure, excitement."

Gatewood laughs as he remembers a defining childhood experience. "I was nine years old, crawling under the dressing rooms at the public swimming pool to pick up coins that had fallen through the cracks in the floor. Hearing voices, I looked up. Suddenly a woman screamed. As I quickly crawled out, I scraped my head and back.

harles Gatewood at work by George W. Gardner, New York 1969

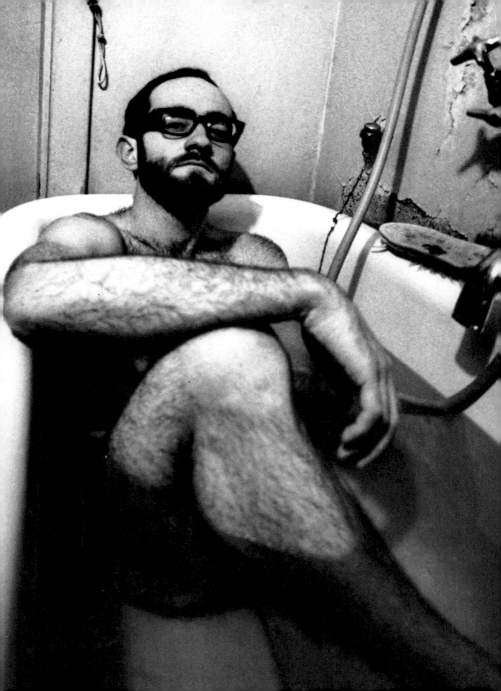

I was frightened and bleeding, clutching a fistfull of coins. I knew I was doing something sneaky and forbidden and sexual. It all came together at that moment: money, sex, blood, filth, fear and guilt--and the intoxication of that mix."

"I've always liked to look at forbidden things," says Gatewood. "In high school, I would peek at my parents' dirty magazines. In college, I lived across the street from a girls' dormitory. In those days the dorms had hours: girls had to be in at 10:30 on weeknights and 12:30 on weekends, so at a certain time of night there was this rush to get in, undress and go to bed. Every night there was a wonderful parade of naked bodies. I called Gardner and asked him to come over with a telephoto lens. We never did take the voyeur pictures, but George showed me more photographs and I knew I was hooked on photography."

Gardner's photographs appealed to Gatewood because of their similarity to anthropological fieldwork. They told stories, revealing complex relationships and vast bodies of information--all caught in split seconds. Gatewood had intuited that his career would merge his behavioral fascinations with art; now he had found his medium. His approach was simple: he bought a good 35mm camera (a Leica), and began photographing the dramatic changes of the 1960's. To this day, Gatewood remains unburdened by a desire for fancy equipment. It is the photographs that matter, he says, and besides, in the mystery lands he explores it's best to keep things simple and unobtrusive.

In 1964 Gatewood left Missouri and moved to Stockholm, Sweden, to explore enlightened socialism and to escape the Viet Nam war. He studied sociology at the University of Stockholm while apprenticing with a group of documentary photographers, and later worked as a darkroom technician for a Swedish news organization. He found the Swedes progressive and tolerant, but longed for "good old American SOUL."

Gatewood returned to America in 1966, moving to a cheap apartment on New York's Lower East Side. Following a year as a studio assistant, he printed stationary and cards announcing CHARLES GATEWOOD FINE ART PHOTOGRAPHY and launched one of the most unusual careers in the history of the medium.

The Sixties were exploding, and New York was buzzing with tumultuous social upheaval. Gatewood quickly began making a living as a photojournalist, shooting rock musicians for *Rolling Stone,* social problems for *Saturday Review* and protests for the *New York Times.* "I've worked," he says," for everyone from *Time and Business Week* to sex magazines where I was paid in rolls of quarters. I've also sold literally thousands of photographs to textbook publishers. Of course, a lot of the stories I got called for tended to be weird. The *New York Times* used to phone me for anything involving sex or drugs, Times Square porno stories, junkies in Harlem anything that was dangerous or slightly bent. They called me the 'bent photographer.'"

lf-portrait, Stockholm 1966

Gatewood was also philosophizing on the troubled times he observed. " I'd done a lot of thinking about America while I was living in Europe - the hippies versus the straights, and so on. So when I started taking pictures, I wanted to ask: Who was freaky? Who was crazy? Then one day I realized that all this American energy and craziness came together every year in New Orleans, in a great drunken street party called the Mardi Gras. So in 1970 I went to Mardi Gras for the first time. I've been back at least fifteen times."

Gatewood's Mardi Gras photographs joined other examples of bizarre American behavior in his first book, *Sidetripping* (1975), which included a poignant text by beat writer William S. Burroughs. "I kept wondering," says Gatewood, "what kinds of pictures Burroughs himself might take if he were a photographer. Burroughs was into dark satire, and so was I. And the whole beat movement was about becoming one with the action. I know my own work is flowing when I lose track of time and become one with my subjects. I feel a click, and suddenly there's no time, no space, no deadline. Everything is flowing. I go into a zone. I get high."

Gatewood's first important exhibition took place in 1972 at Manhattan's prestigious Light Gallery, and contained most of the *Sidetripping* images. In his review of that show, New York Times critic A.D. Coleman wrote: "Charles Gatewood's photographs...can be placed within a definite photographic tradition one which begins, perhaps, with a hoard of unsung news photographers; reaches its first culmination point in Weegee; its second in Robert Frank, Lee Friedlander, and Diane Arbus; and is currently being expanded by such younger photographers as Geoff Winningham, Paul Diamond, Les Krims, Gatewood's cohort George Gardner, and Gatewood himself. But that tradition is not itself the subject.

"The subject matter of all these photographers is people; their concern is the social landscape...and their approach is simply to seek out the most extreme manifestations of our cultural consciousness--those places and events where we let it all hang out and record it. Their art is Stendhal's: 'A mirror held up along the highway.' And they may, in fact, represent the only form of 'pure' photography still vital today."

Following the publication of *Sidetripping*, Gatewood quickly became known as a "freak" photographer. Yet Gatewood, tired of in-your-face photography, pulled back from his bizarre subject matter. He instead worked to finish his photographic essay "Wall Street," and to convince himself and his wife Virginia- that he was not consumed by the increasing weirdness of his photographic fascinations. Soon, however, he was back in Mondo Bizarro territory, going even deeper into Manhattan's secret netherworlds.

In 1977 Gatewood's wife filed for divorce. "He often spent his days and evenings taking-- and posing for--photographs of an unpublishable nature," said the divorce papers. Gatewood's heavy drinking and drug use were also cited as reasons for the split. Gatewood, devastated, sublet his New York loft and bought a house upstate, near Woodstock. In Woodstock Gatewood poured his personal pain mixed with frightening

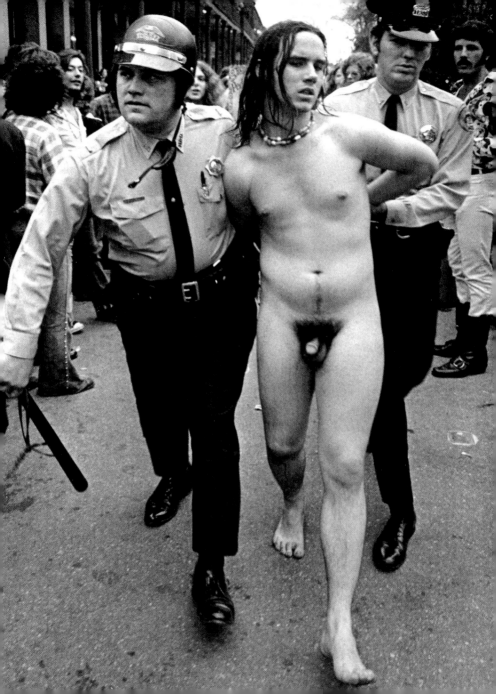

relevations of his dark side explorations into a new photography book, *Forbidden Photographs*. There, in words and pictures, he described his fascination with outlaw artists Spider Webb, Marco Vassi and Annie Sprinkle, and his nights at New York's infamous Hellfire Club:

> *A dingy S/M basement bar on Ninth Avenue. No sign; just the number: 28. Spider is giving this costume party benefit to legalize tattooing in New York City. Everyone will be here. Center stage is a huge blowup of our latest collaboration: TATTOOED FETUS.*
>
> *"Whadda ya think, Chaz? Shall we pass out blindfolds and play Pin the Tail On the Fetus?*
>
> *Marco, dressed in a lavender jockstrap, cringes at the thought.*
> *"That's disgusting. I'm not going to have anything to do with this. I'm going to stay in the back rooms and eat shit all night. Perverts!"*
>
> *"OK," says Spider. "I thought that game might be a wee bit heavy. So I brought along this basket of tomatoes. We'll have a little theater along with the art show."*
>
> *Annie squats on the bar, pissing all over some guy. Three others ravish some girl in the corner. A pregnant witch named Original Sin throws the first tomato at the fetus photograph. SPLAT! Someone offers me a hit of LSD: I hear the Devil talking. SPLAT! I refuse, remembering the last time I mixed street acid with hard booze and made a complete fool of myself. No thanks.*
>
> *I have been sober for weeks, but whiskey flows in my veins tonight. I wander through the crowd, flashing pictures. A hooded leatherman silently pantomimes smashing my camera if I take his picture. I move on. In a hallway near the back rooms and glory holes, a paunchy middle-aged man sniffs popper and jerks off, lost in his own private reverie. My flash explodes; the image is blinding."*

Inspired by their limit-pushing collaborations and their mutual interest in publishing, Gatewood, Sprinkle, Vassi, Woodstock writer Michael Perkins and New York City editor Mam'selle Victoire joined Spider Webb's newly created R. Mutt Press. The name was a tip of the hat to Marcel Duchamp, who had tweaked the nose of art world society by submitting a urinal signed R. Mutt at the 1917 exhibition of New York's Society of Independent Artists. Art, said Duchamp, could be ANYTHING.

Annie Sprinkle was a young porn starlet, photography student, and self-styled "post-porn modernist." Spider Webb was a flamboyant tattoo artist with an MFA degree, who invited Gatewood to take and edit photographs for his influential books *X-l000* (1977), *Pushing Ink: The Fine Art of Tattooing* (1979), and *Tattooed Women* (1982).

Hellfire Club, New York 19

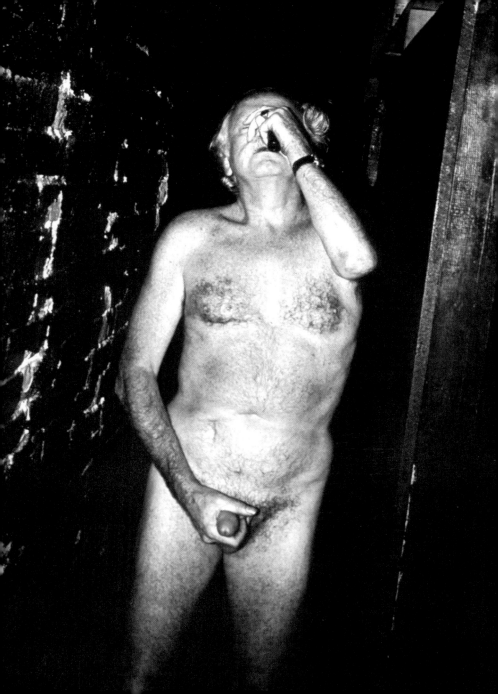

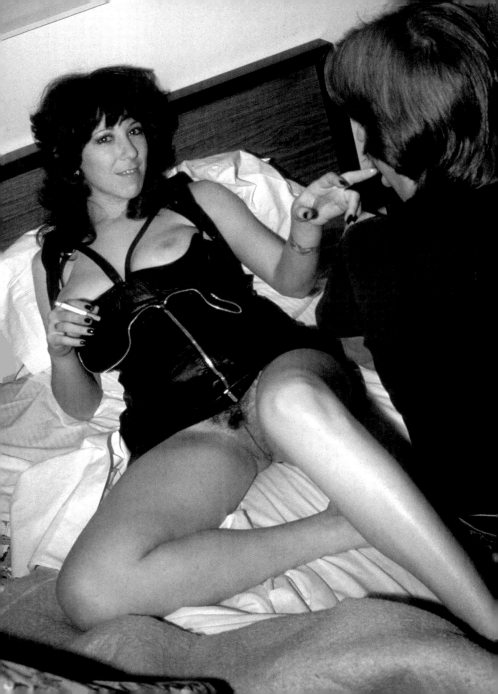

Marco Vassi was busy expanding pornographic writing into new realms of metaphysical concern. Michael Perkins was a brilliant poet, novelist and critic of erotic literature, and Mam'selle Victoire was the pseudonym of one of Manhattan's best (and wildest) erotic editors. Gatewood remembers the R. Mutt group energy as "awesome."

"We helped each other in so many ways. The talent and knowledge of the group was totally amazing. I consider my time with the R. Mutt gang my essential post-postgraduate education. And, except for Marco Vassi who died of AIDS in 1989 our relationships continue to produce amazing fruit."

"There was something special in the air," continues Gatewood. "William Burroughs once said that the artist can be like an antenna, receiving frequencies that other people aren't tuned into. That's what I've tried to do. For example, through my work with Spider Webb, I saw the whole Modern Primitive movement coming. I thought it was incredibly important and meaningful, but people laughed at me. I consider that work prophetic, because all of my subject matter public nudity, exhibitionism, heavy piercing, full body tattooing, S/M has entered mainstream culture in a big way, and I was there to document its beginnings."

The next book to appear under the R. Mutt Press imprint was Gatewood's *Wall Street*. With the help of two fellowships from the New York State Council on the Arts, Gatewood self-published *Wall Street* in 1984. "*Wall Street* showed the dark side of the financial district. I gave a copy to my brother-in-law, a Wall Street executive, for Christmas. He never spoke to me again."

Wall Street went on to win the coveted Leica Medal of Excellence for Outstanding Achievement in Humanistic Photojournalism. The dark, moody photographs were exhibited at New York's Stieglitz Gallery, to considerable acclaim. "*Wall Street* caused some fuss in the art world, sure," says Gatewood, "and if I'd stayed in that formal groove my work would have been more accepted. But instead I went even deeper into freak territory."

Freak territory! Gatewood's work was now frequently compared to that of photographer Diane Arbus, yet there were important differences. "Lots of Arbus' subjects," says Gatewood, "were deformed or mentally impaired. My subjects are choosing their lifestyle. If you want to call them freaks, they're freaks of choice, not freaks of nature."

One important "freak of choice" encountered by Gatewood at this time was Fakir Musafar. When Gatewood read about the self-styled "Modern Primitives" in *Piercing Fans International Quarterly* in the late seventies, he knew they were destined to meet. "In those days extreme body piercing was a very esoteric thing to do, very closeted. Fakir would travel from town to town, hosting piercing salons. We met at one of those salons at Annie Sprinkle's house in 1980."

nie Sprinle, New York 1980

"Fakir was leaving his body, doing pagan rituals, talking to the Great White Spirit while hanging from flesh hooks, doing time travel, and exploring past lives through all kinds of body play-sensory deprivation, cutting, branding, deep body piercing, using pain as a vehicle to higher consciousness. Fakir's body rituals are visceral, highly physical. His is not so much an abstract intellectual journey, but rather a series of intense physical experiences that lead him to new spiritual peaks."

Soon after their meeting, Musafar invited Gatewood, and filmmakers Mark and Dan Jury, to document his Sundance ritual in the Black Hills of Wyoming. The resulting film, "Dances Sacred and Profane," documents three years in Gatewood's life, beginning at New York's Hellfire Club, then following Gatewood to Chicago, New Orleans Mardi Gras, the Smithsonian archives in Washington D.C., a nudist camp in Indiana, a Gatewood lecture in San Francisco, and a photographic workshop in Maine. Fakir's Sundance ritual provided the climax to the thought-provoking film, which gave many their first taste of the emerging Modern Primitives movement. Gatewood's enthusiasm for "liberation through excess" was never so clear as in the film. "I've been with a man who leaves his body and talks to God," he told one audience. "Think about that. I certainly have."

While working on "Dances Sacred and Profane" in San Francisco, Gatewood introduced Fakir Musafar to V. Vale and Andrea Juno, publishers of *Re/Search Editions*, a small but influential publishing house that chronicled essential subcultural happenings. Vale and Juno immediately realized the importance of the ideas Gatewood and Musafar were presenting, and, after gathering photographs from Gatewood and others, and conducting many in-depth interviews with other body-modification enthusiasts, they published the seminal *Modern Primitives* issue in 1989. The book quickly became the Bible of a new youth movement, sparking a new wave of artistic tattooing, piercing, scarification, and radical body play that continues worldwide. To date over 80,000 copies of *Modern Primitives* have been sold. Assuming a widely shared readership, this means over a million people have spent time examing the same radical ideas that Fakir Musafar, the R. Mutt Press gang, and Gatewood were touting only a few years earlier.

Gatewood acknowledges that his role as documentarian and catalyst for the Modern Primitives may have been his most influential achievement to date. "Many people are instinctively looking at so-called primitive behaviors to answer modern questions. This has caused no end of alarm to the establishment. They take this behavior as threatening-- which it is. Most of us feel alienated and brainwashed, sick of television culture. The Modern Primitive movement is about re-connecting. It's about taking control of our own lives and deciding for ourselves what's real and what's important. It's about reclaiming our minds and bodies from Big Brother. The core idea is magical transformation."

Fakir Mustafar, Palo Alto - California 198

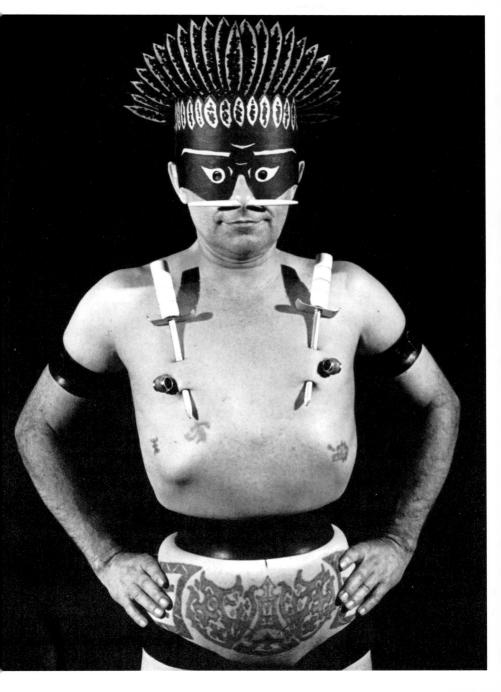

"For years magazines like *National Geographic* have shown tattooed and pierced men, and naked women, and it's been considered OK because the subjects were black or brown or yellow and lived in far-away, primitive places. But now that the sons and daughters of *National Geographic* readers are getting tribal tattoos and genital piercings, all hell is breaking loose. I think it's great."

In 1987 Gatewood achieved his own personal transformation: he quit drinking and hard drugs, sold his Woodstock house and moved to San Francisco, to be closer to the movement he had helped create. There he continues his unique visual research, documenting underground scenes in photography and video (recent books include his own *Primitives* (1992), *Charles Gatewood Photographs: The Body and Beyond* (1993), and *True Blood* (1997). "For what I do, San Francisco is Mecca," he says. "Often my subjects call me and beg me to work with them. I feel absolutely and totally at home, doing what I love to do, photographing people who are pushing limits and breaking taboos."

Gatewood, of course, has broken a few taboos himself. One of his most infamous photographs is "Tattooed Fetus," which he did in collaboration with Spider Webb. "It was scary," Gatewood recalls. "Spider's hands were shaking. 'We're gonna burn in hell for this,' he said, 'but I want to show that art can be ANYTHING.'" Duchamp would have been proud.

Gatewood says "Tattooed Fetus" created more controversy than any other picture he's ever taken. "The *Village Voice* ran the photograph to announce a show that Spider Webb and I were having, and people freaked out. The *Voice* received more angry letters and phone calls than at any time in their history. The art gallery got calls from the New York State Attorney General's office, and after some bomb threats, cancelled the show. It was a big deal."

Friends were just as susceptible to revulsion as adversaries. Following a San Francisco exhibition featuring the Gatewood work, a woman acquaintance called Gatewood to comment. "She really wanted to 'help' me see the evil of "Tattooed Fetus," but I refused her "help." "Look," I said. "You saw the explicit picture on the announcement. You knew the show included radical work. You came, you looked, you felt strong emotions. The work stimulated you. You thought about it for a long time--you went through a whole process. That's what radical art is all about. This work was meant to upset you, and maybe change some of your ideas. You shouldn't get upset that you got upset. That's part of the process."

"I'm an expressionist," says Gatewood. "I want my pictures to SCREAM. I want my pictures to punch the viewer in the nose. I want to make pictures that people will remember as long as they live." "I want to see how far I can take the expressive power of the black and white photograph. William Burroughs once said that if he could write a sentence exactly right, it could kill the person who read it. Not that I'm anxious to kill people. But I would like to be able to change a person's thinking in one split second, and have that picture stay with them forever."

Keath and Susan, San Francisco 1991

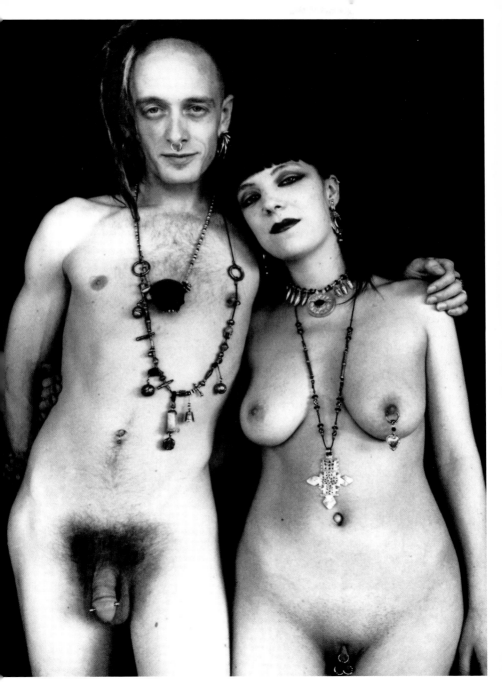

Roots

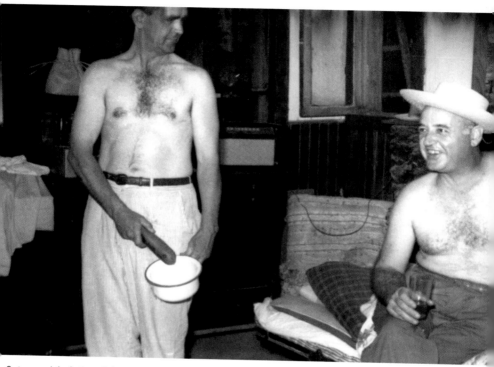

Gatewoods's father John (right) and friend, Missouri 1949

Gatewood's mother, Clarene, with unidentified man, Missouri 195

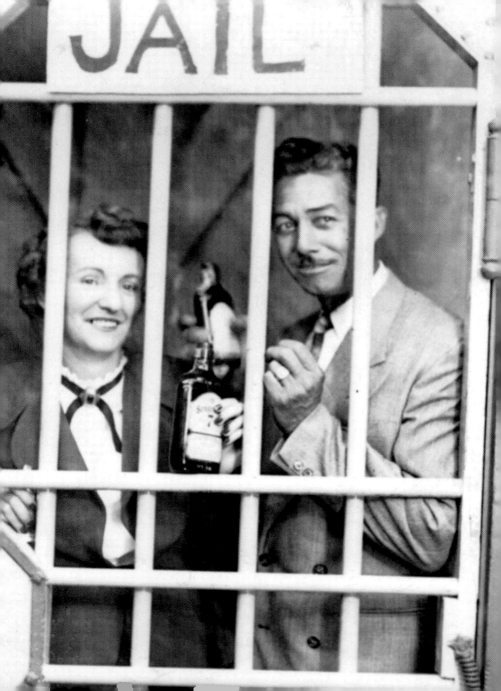

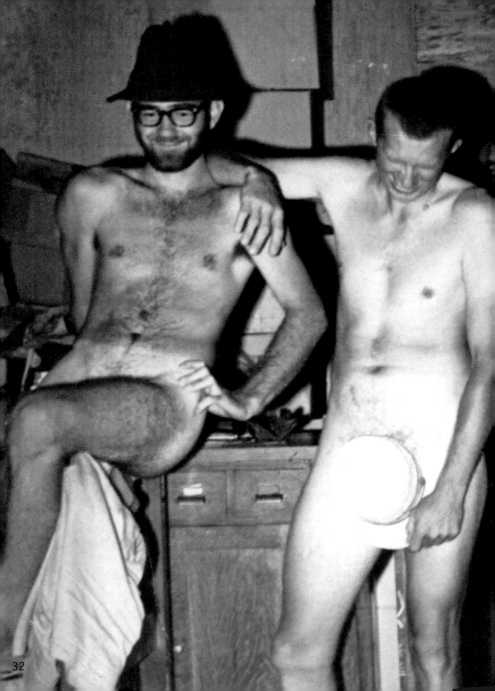

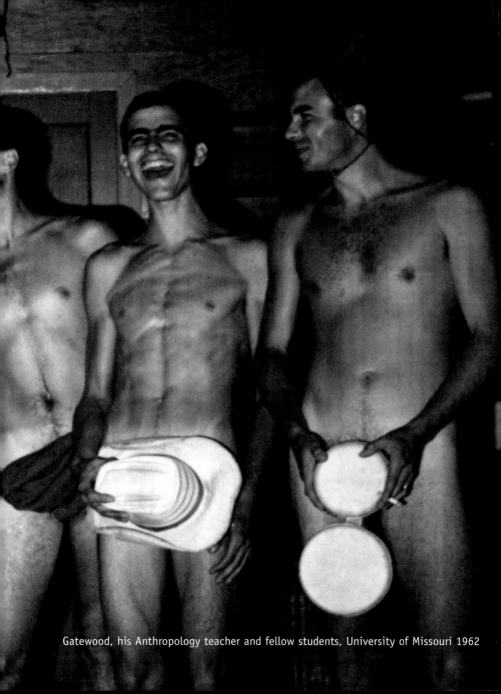

Gatewood, his Anthropology teacher and fellow students, University of Missouri 1962

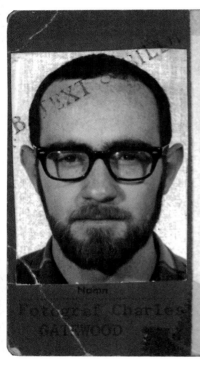

PRESS- 1966
till 1/5

legitimation Nr 23

Pressfotograf C.Gatewood

Charles R. Gatewood
Innehavarens namnteckning

Utställd av

AB TEXT & BILDER

Redaktionen

Stockholm den 12/1 1966

Direktionens namnteckning

Early work

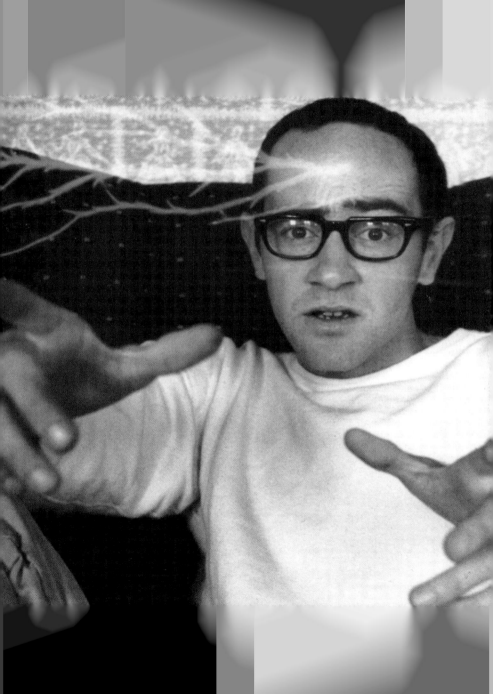

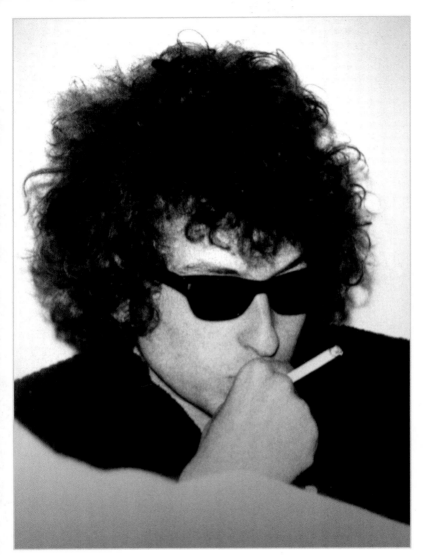

Bob Dylan, Stockholm 1966

Allen Ginsberg, New York 19●

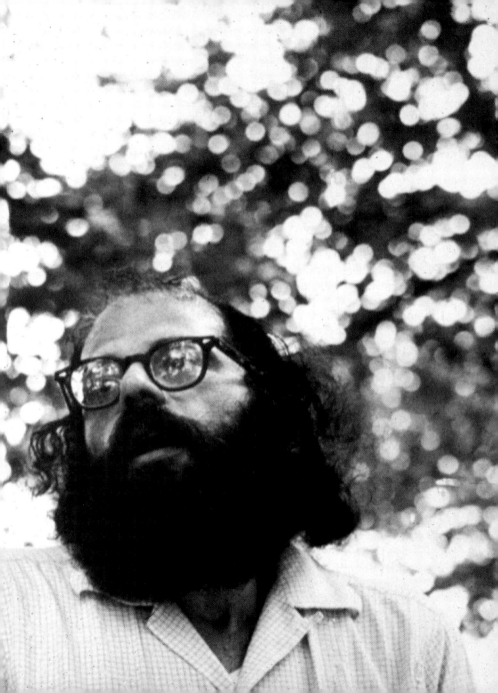

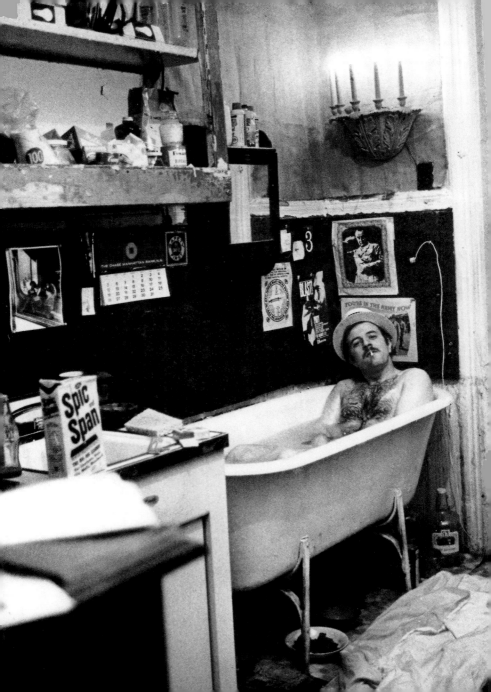

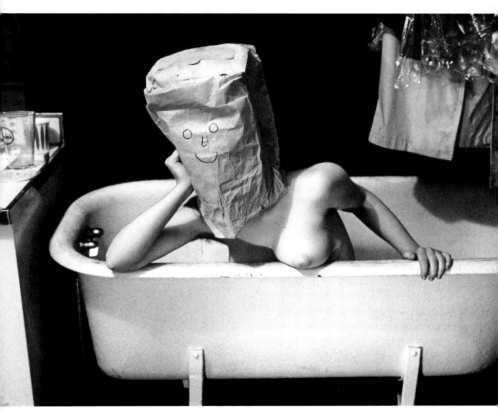

Suzy, New York 1966

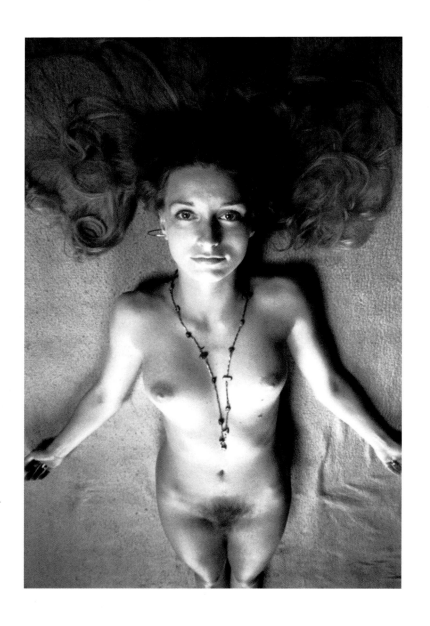

Bonnie, New York 1969

Gypsy, New York 196

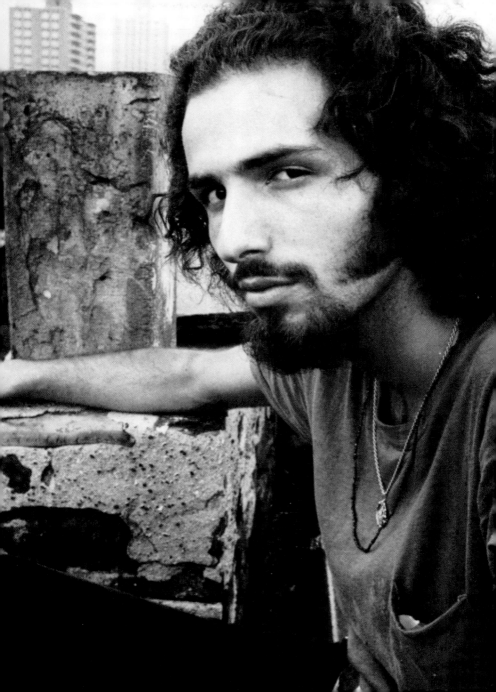

Fort Dix,
New Jersey
1969

46

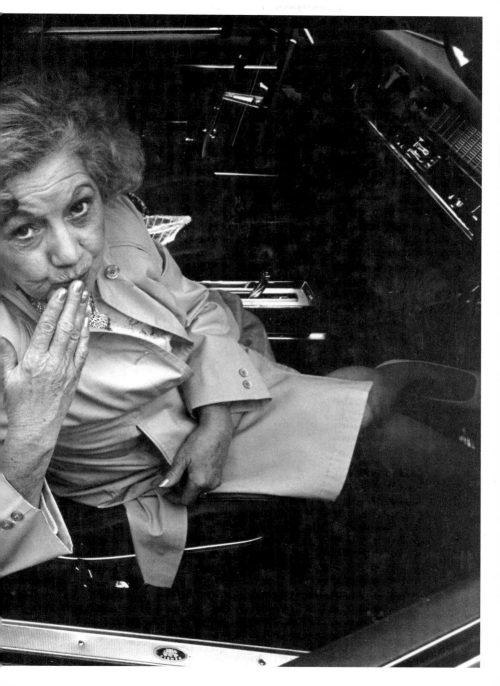

Tyson, New York 1969

48

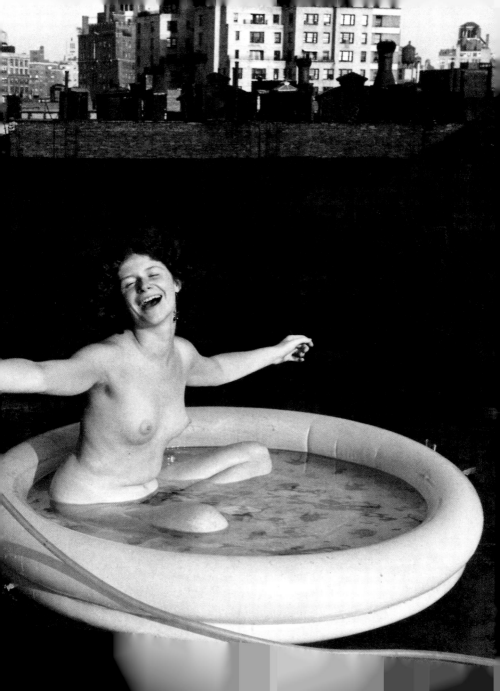

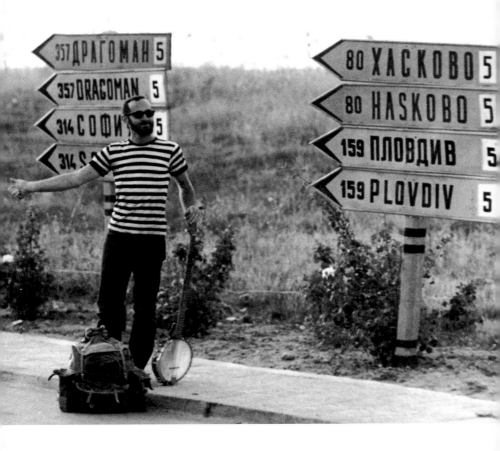

Self-portrait, Bulgaria 1965

Travels

Corpus Christi, Texas 19

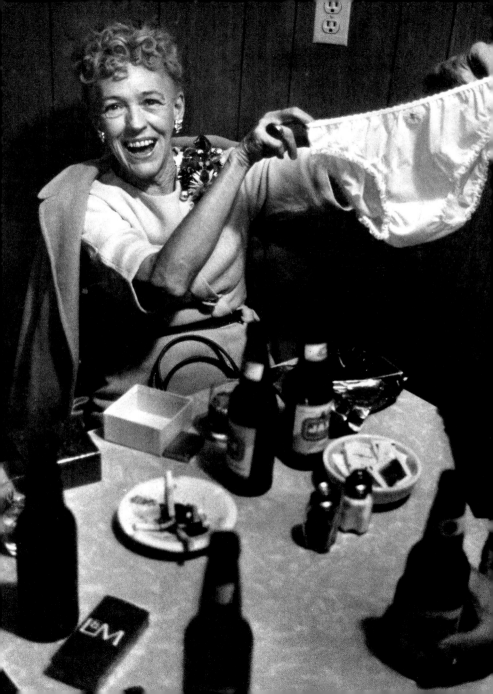

Reynosa, Mexico 1968

Reynosa, Mexico 196

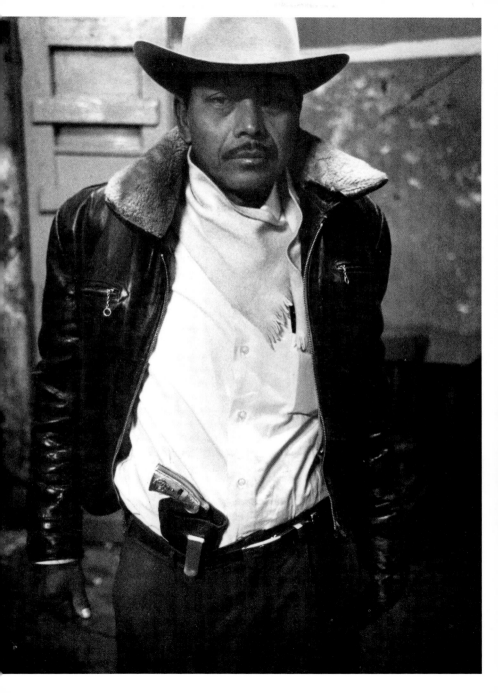

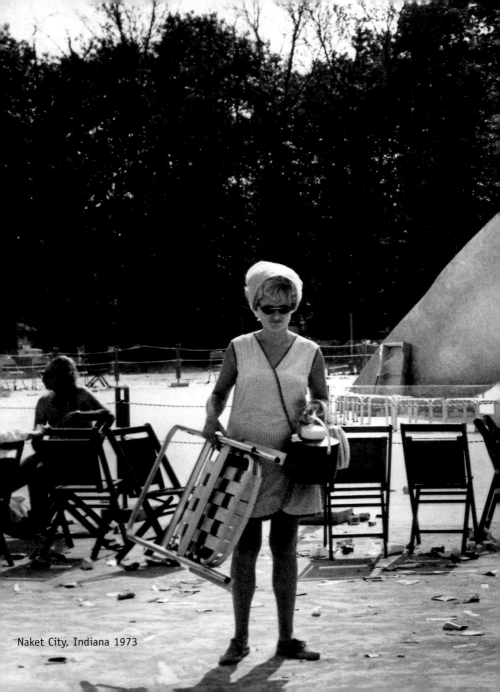

Naket City, Indiana 1973

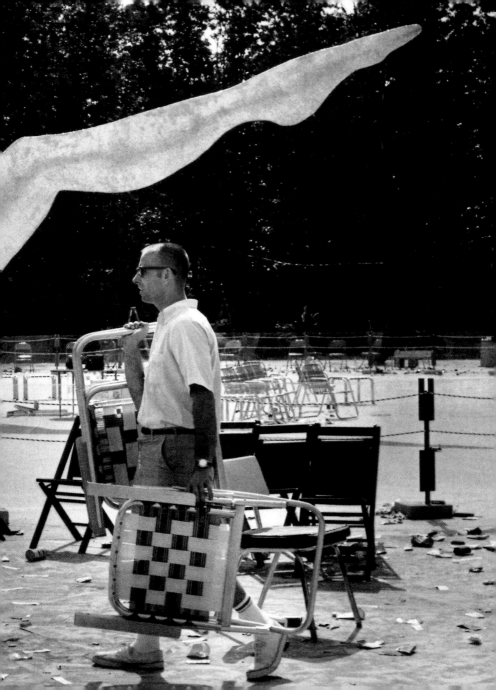

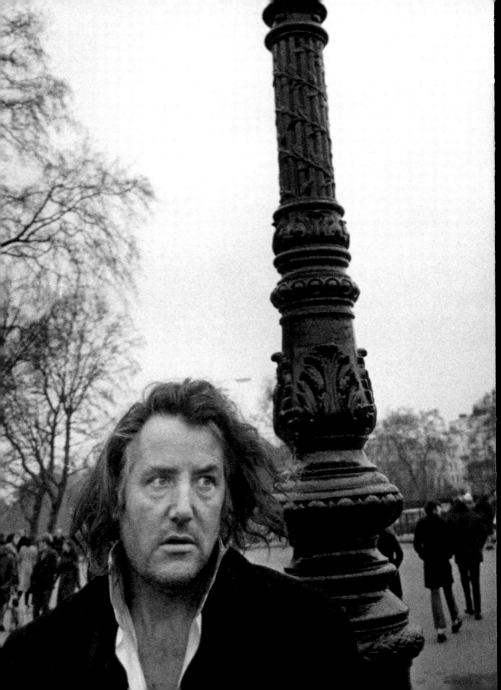

Boy in mask, Minneapolis 1969

ndon 1972

Patrick, Chatham - New York

Steve, Texas 19

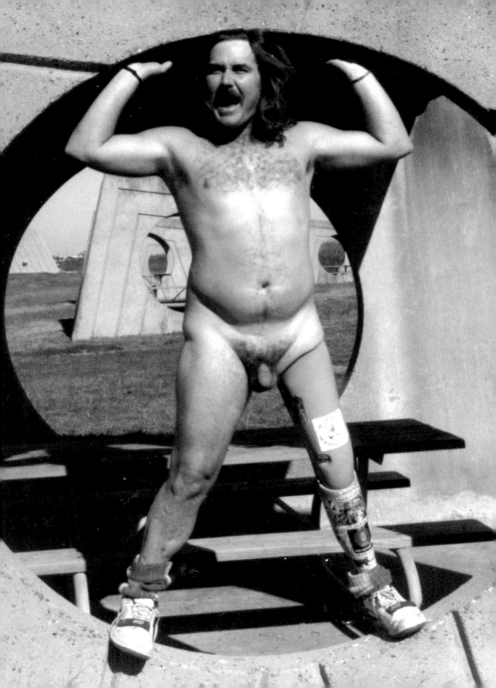

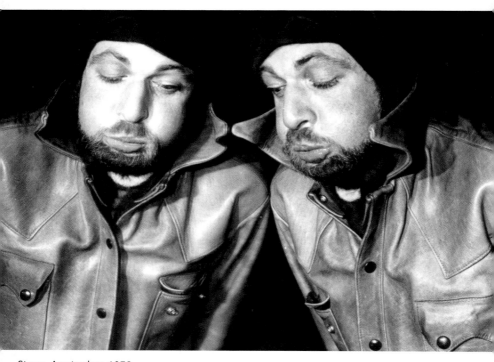

Steve, Amsterdam 1978

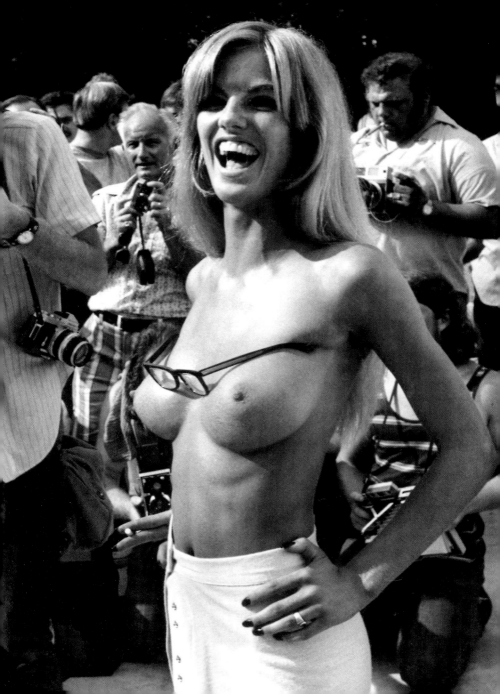

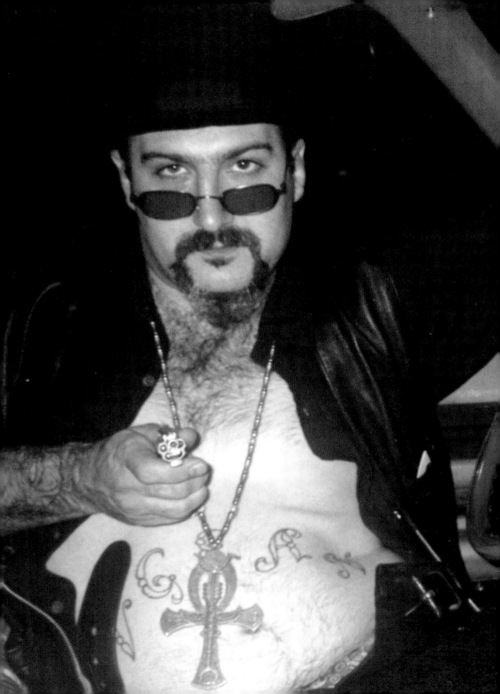

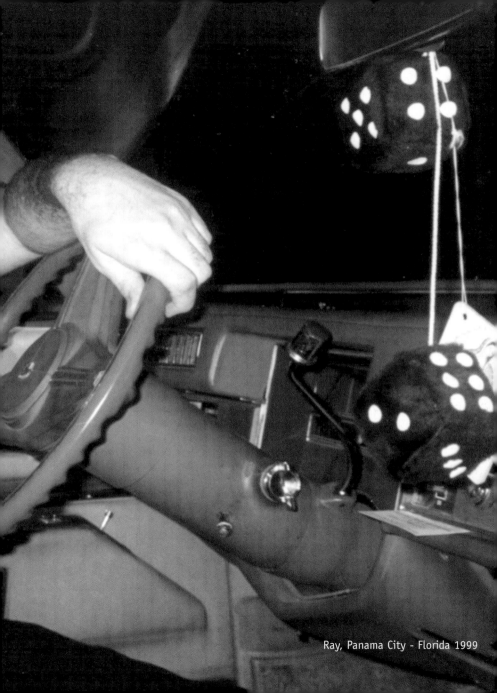

Ray, Panama City - Florida 1999

Wall Street

LIVERIES
ENTRANCE

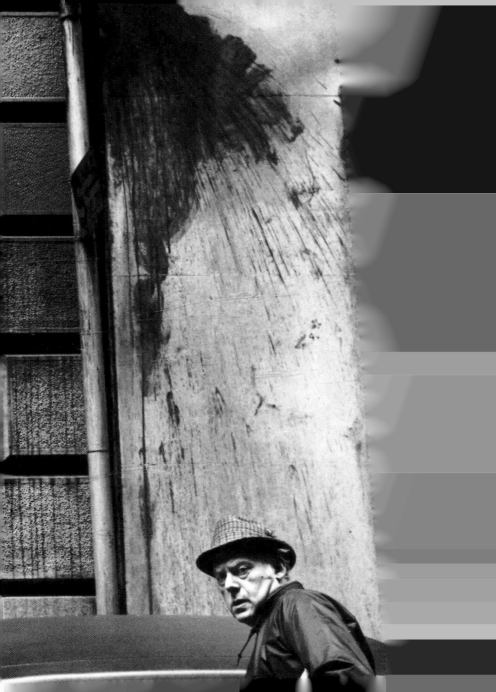

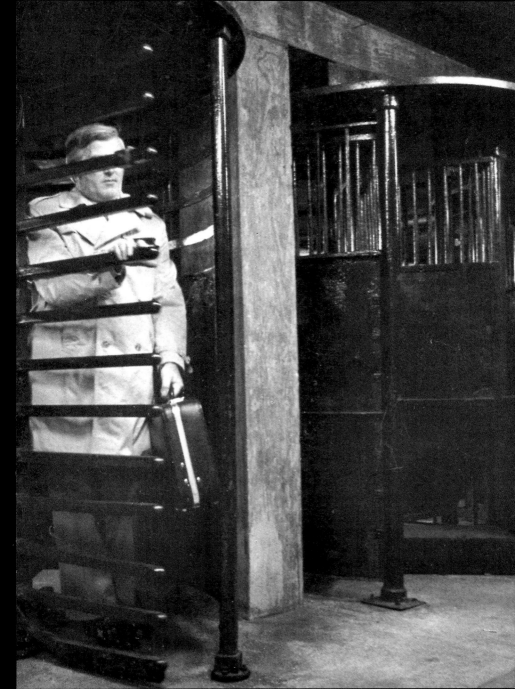

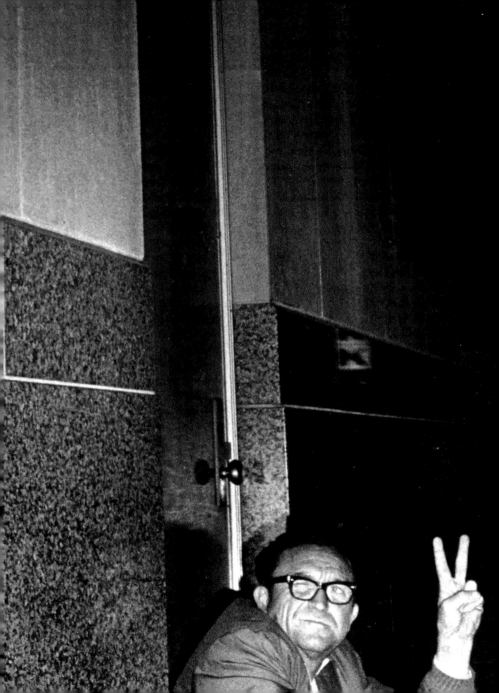

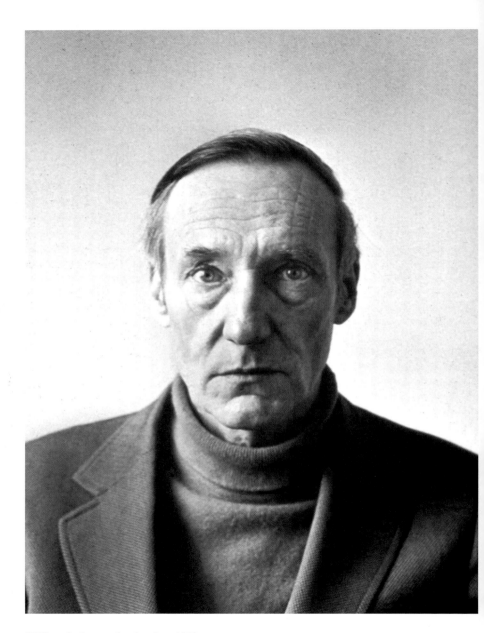

William S. Burroughs, London 1972

Charles Gatewood

10 Glasco Turnpike

Woodstock NY 12498

April 1,1972
8 Duke Street
St James
London S.W.1 Flat 18
England

Dear Charles:

The photos of Brion and me and the dream machine are absolutely
superb.

Delighted to see your work so well reviewed. The reason I have
been slow about writing the introduction is that I was looking for
just the right angle which I think has at last been found and you
will recieve the introduction and the dummy within ten days at
most. ,I wanted to really say something not just a blurb but
something that will lead people to see the pictures.

I may be coming to New York very soon in which case I will bring
the dummy with me. IN any case you will have both dummy and
introduction within ten days.

All the best to you and Bob. The interview looks great. Many
thanks for Tulsa

 Best regards

 william
 William

William S. Burroughs

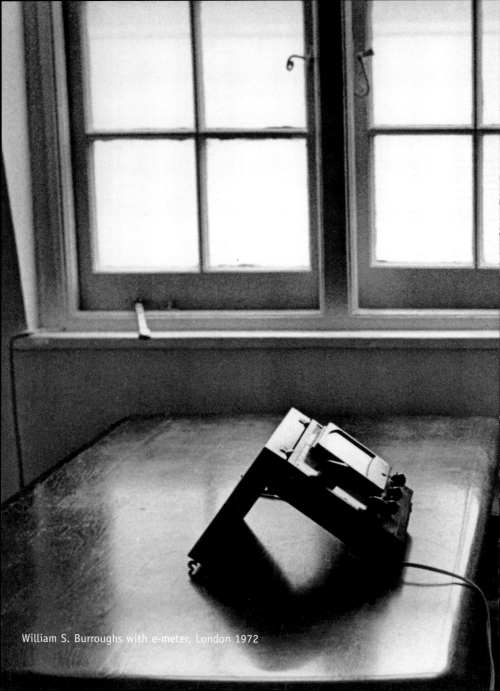

William S. Burroughs with e-meter, London 1972

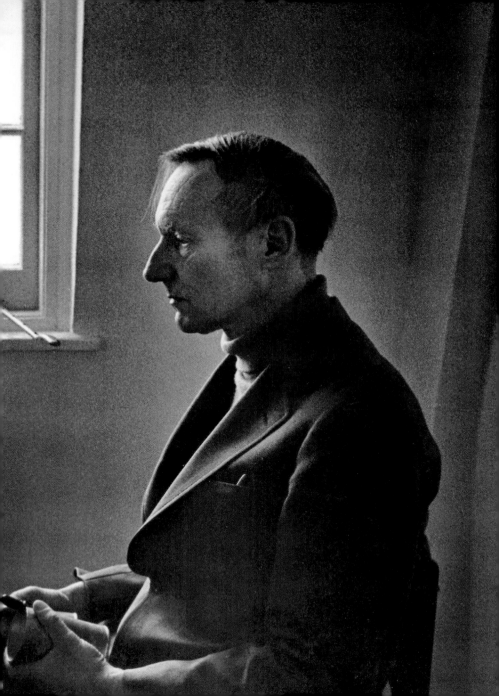

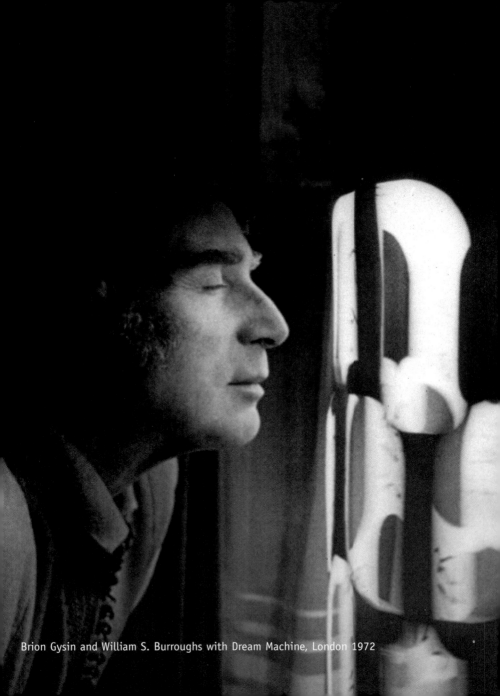

Brion Gysin and William S. Burroughs with Dream Machine, London 1972

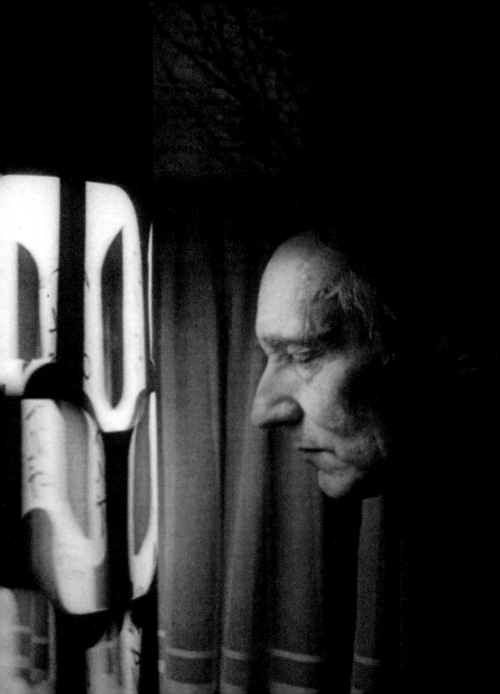

Sidetripping

"Charles Gatewood the sidetripping photographer takes what the walker didn't quite see, something deja vu back in front of his eyes. The photo has precipitated an erasure failure film flakes falling now he sees something he did not see before since it was marginal to his scanning pattern."

-*William S. Burroughs*

Cockette, New York 19[cut off]

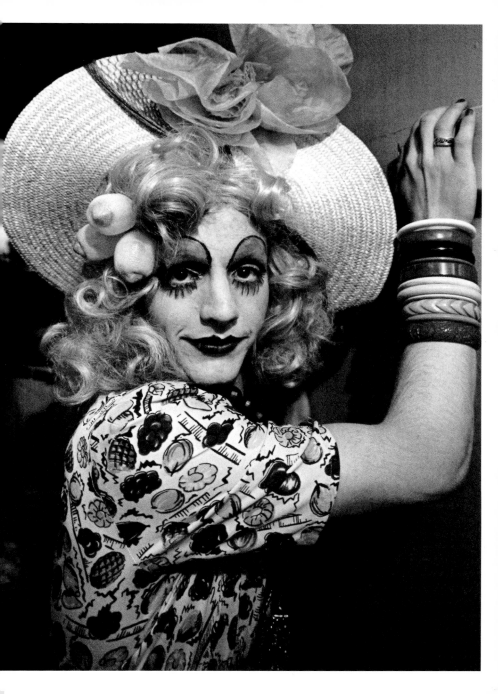

Patrick, New York 1971

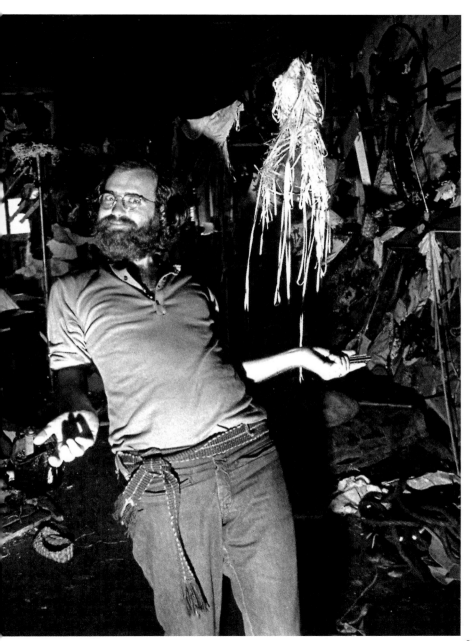

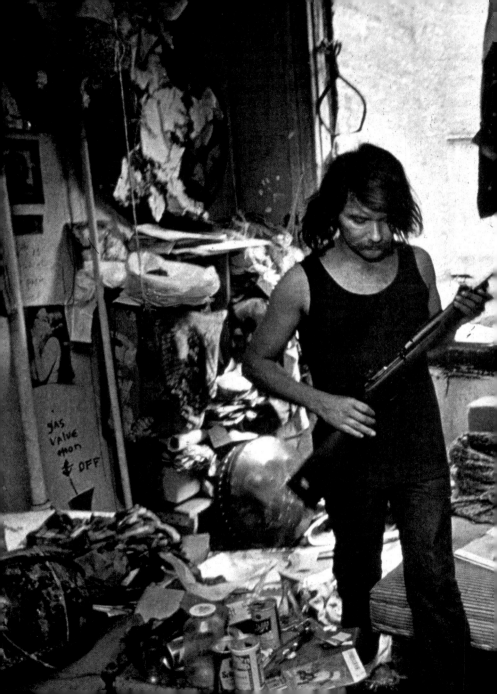

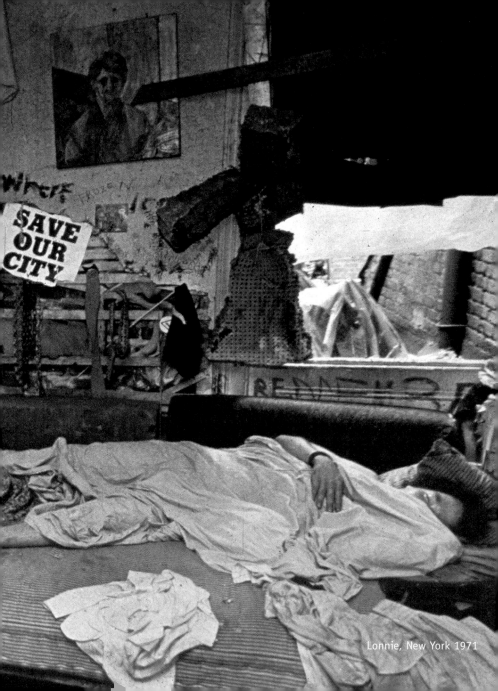

Lonnie, New York 1971

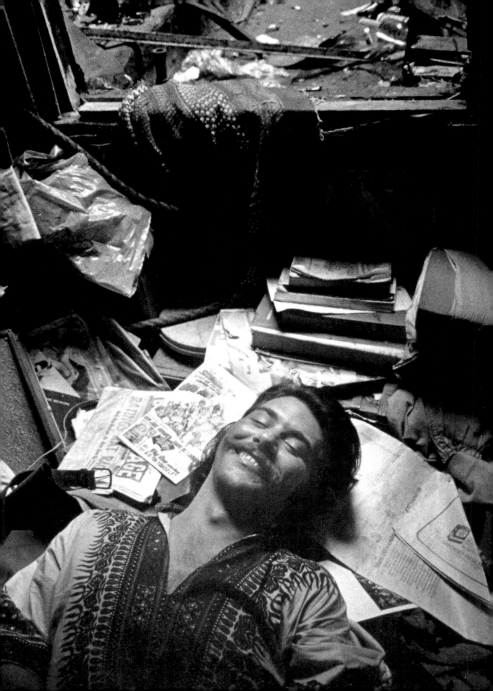

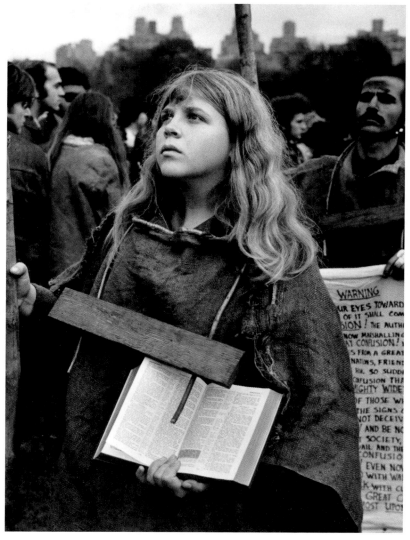

Children of God, New York 1973

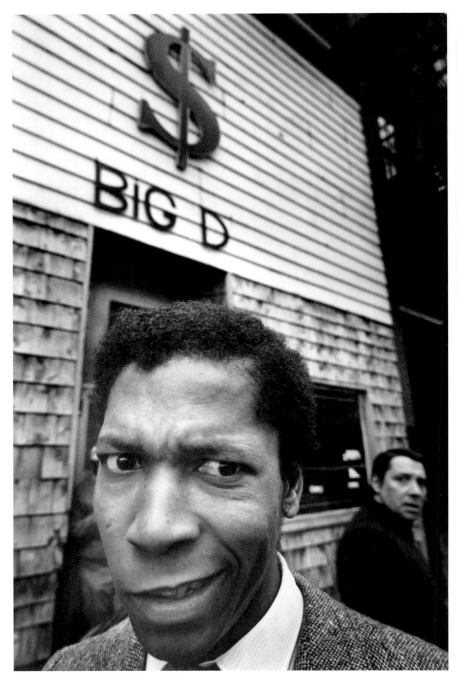

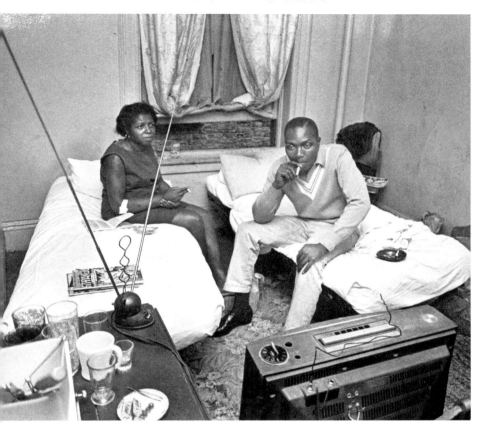

New York 1971

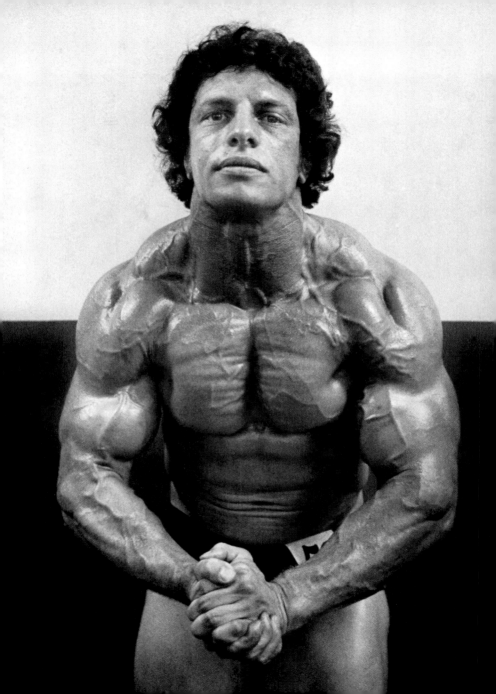

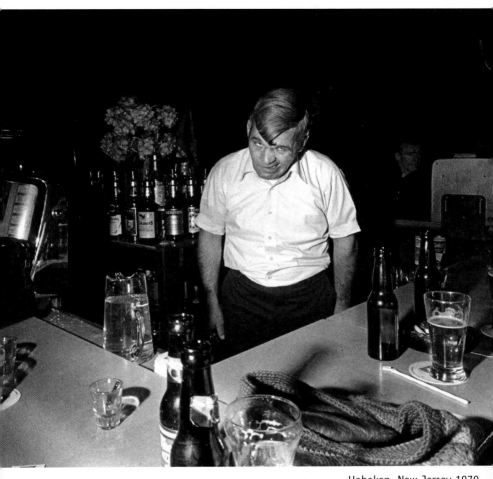

Hoboken, New Jersey 1970

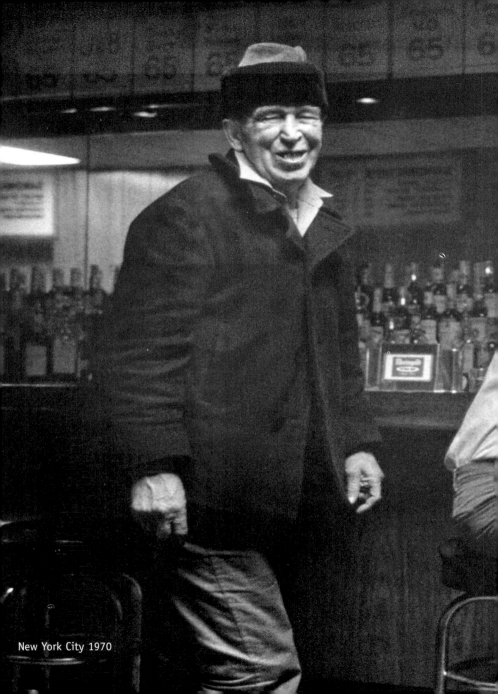

New York City 1970

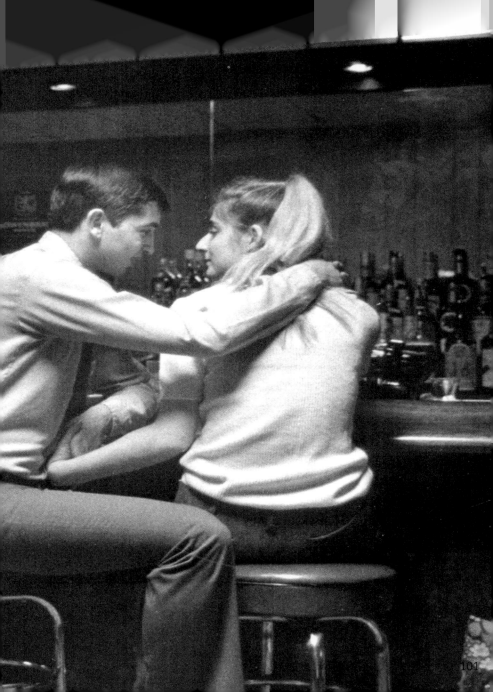

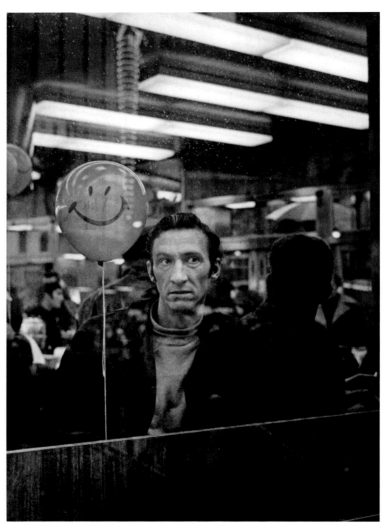

New York 1972

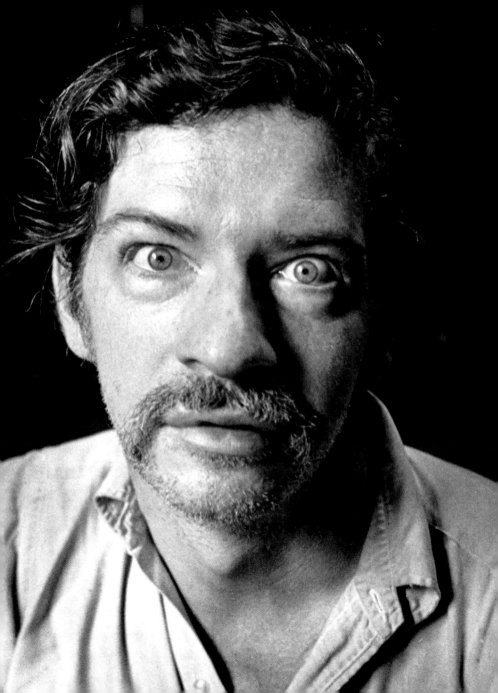

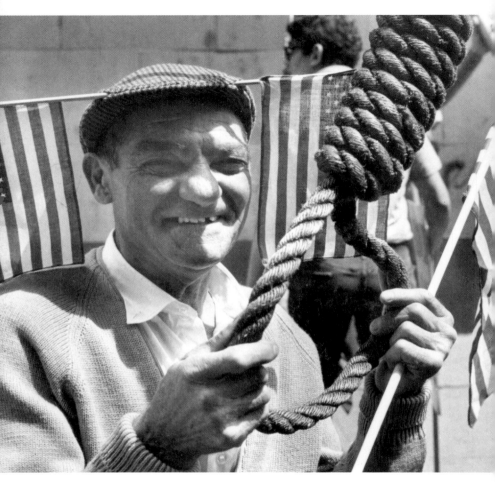

New York 1970

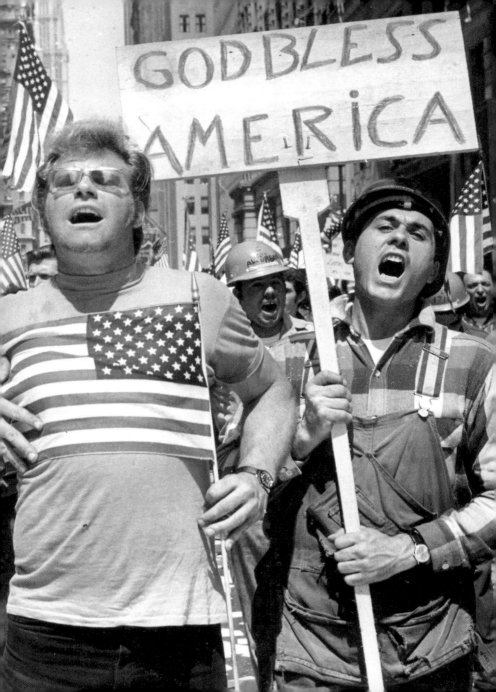

If we worry about what's going to happen to us, we couldn't accomplish anything.... Justice is gonna come when the mass of people rise up and see justice done.... The more they try to come down on us, the more we'll expose them for what they are......

PIGS

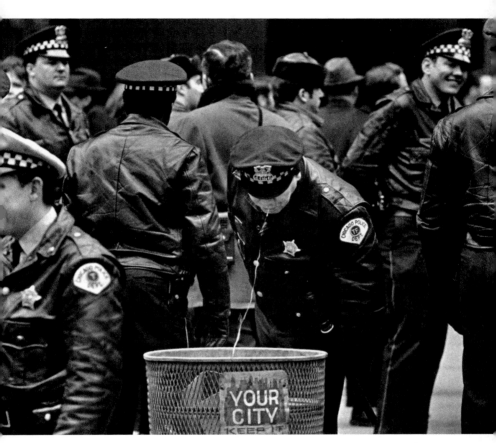

Chicago 1970

v York 1969

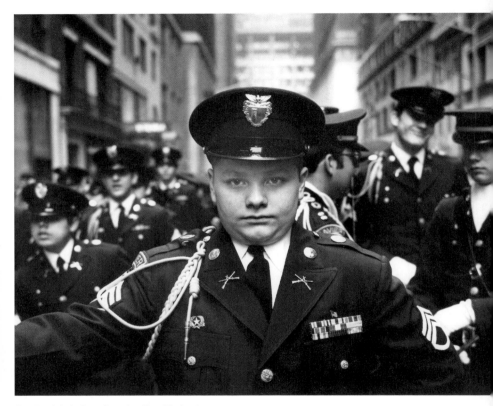

St. Patricks's Day Parade, New York 1971

Yippie protest, New York 19

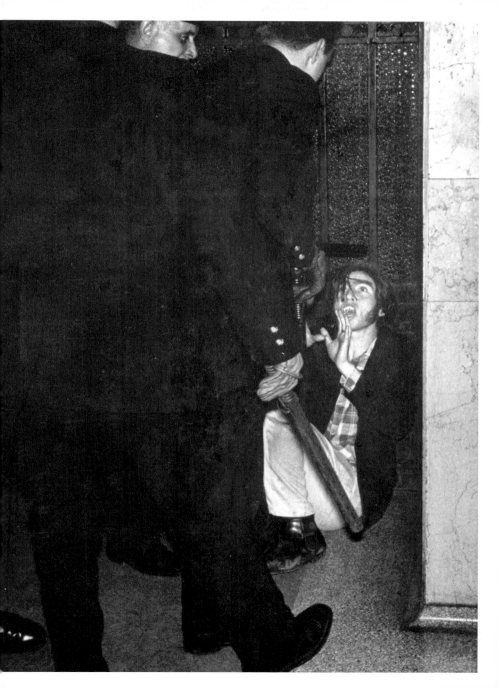

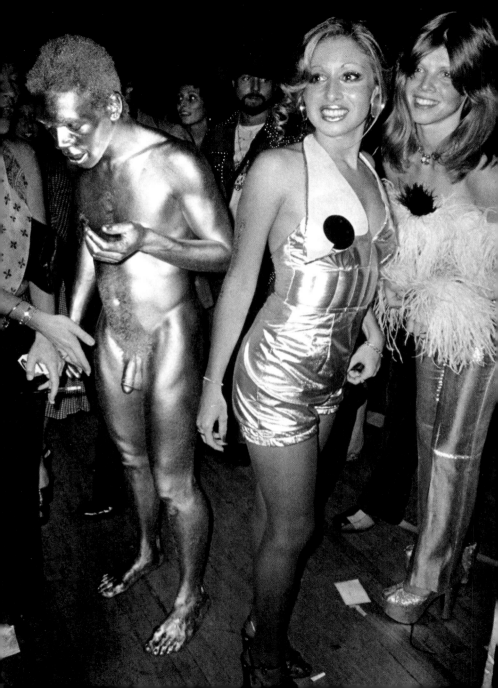

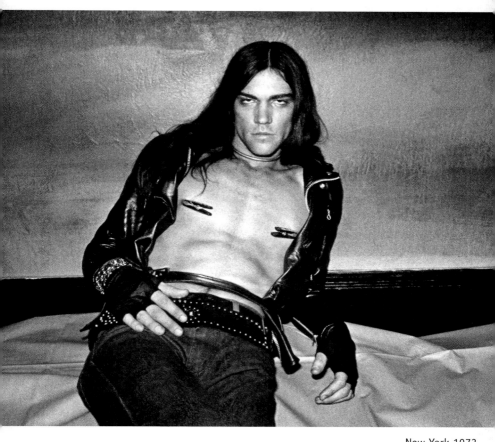

New York 1973

w York 1973

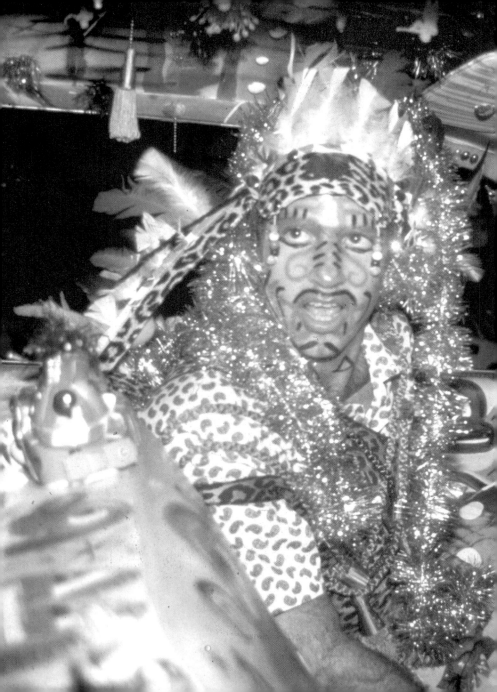

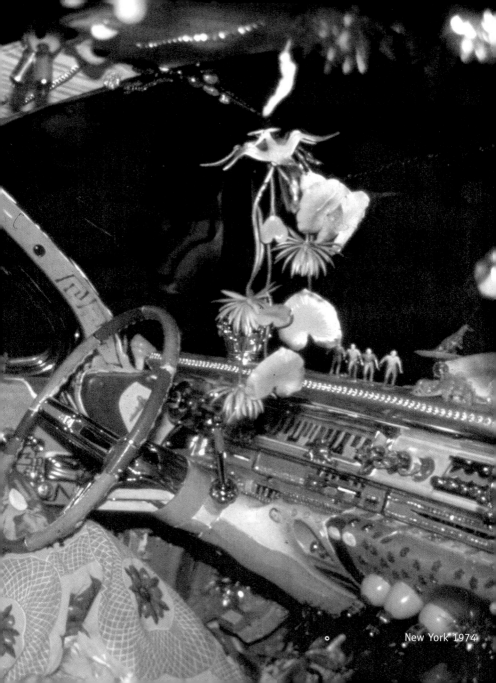

New York 1974

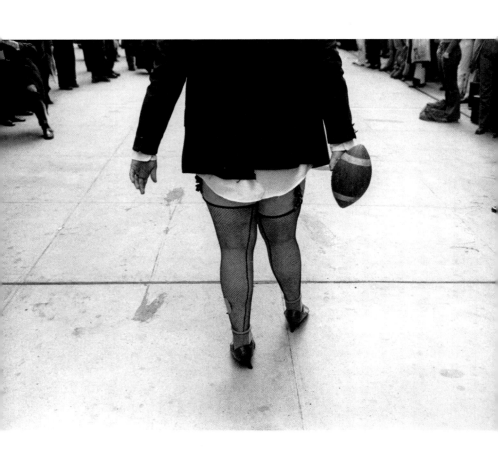

New York 1970

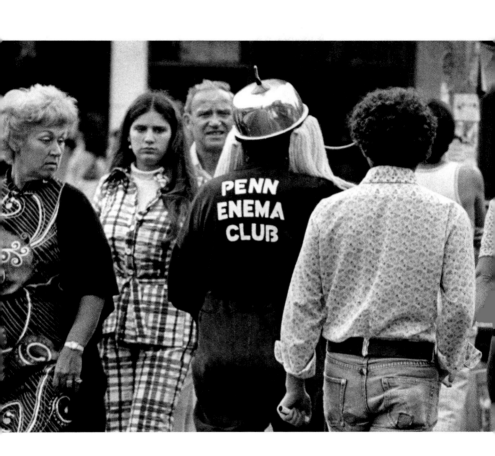

New York 1972

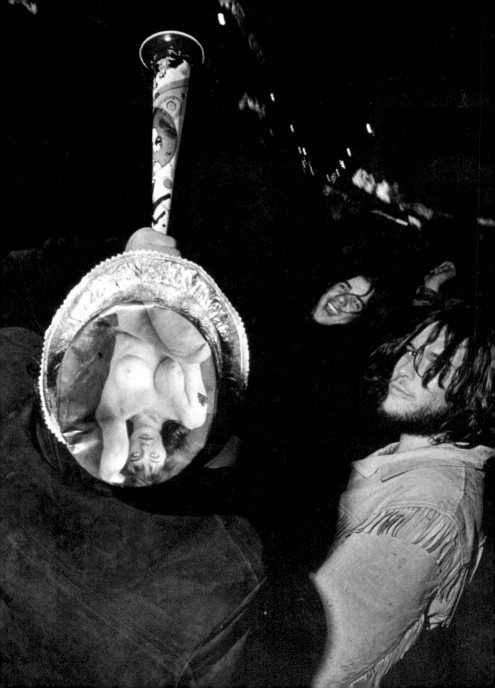

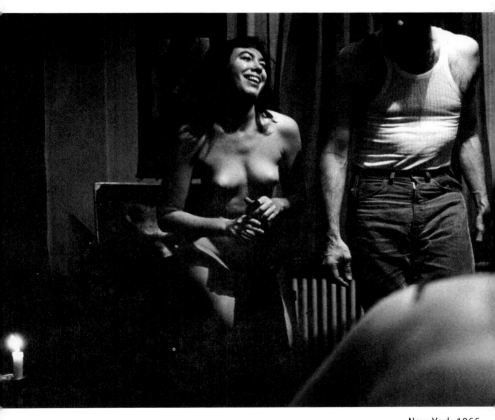

New York 1966

w Year's Eve, New York 1970

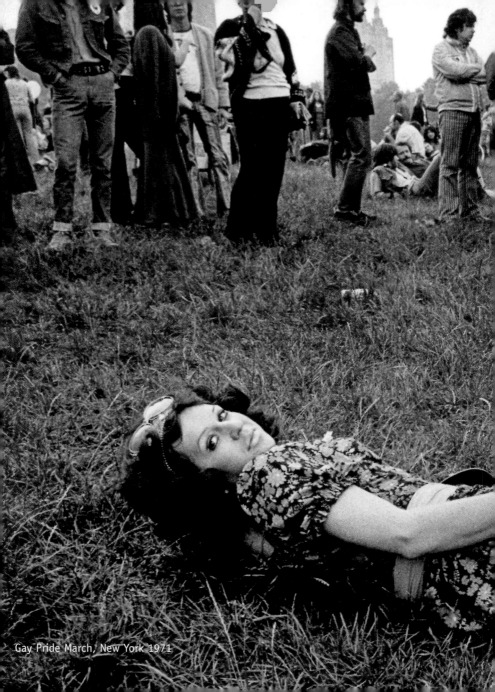

Gay Pride March, New York 1971

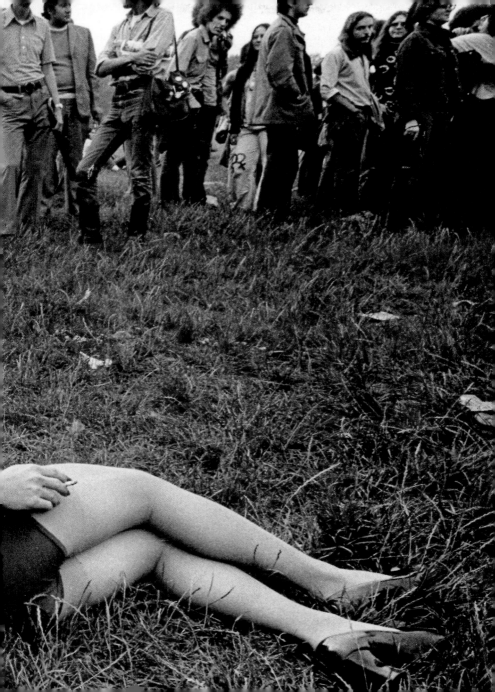

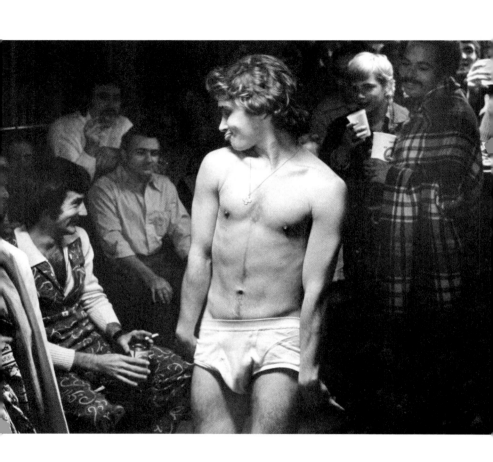

New York 1973

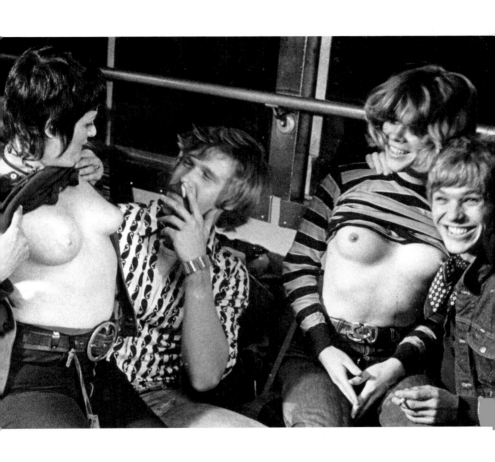

New York 1973

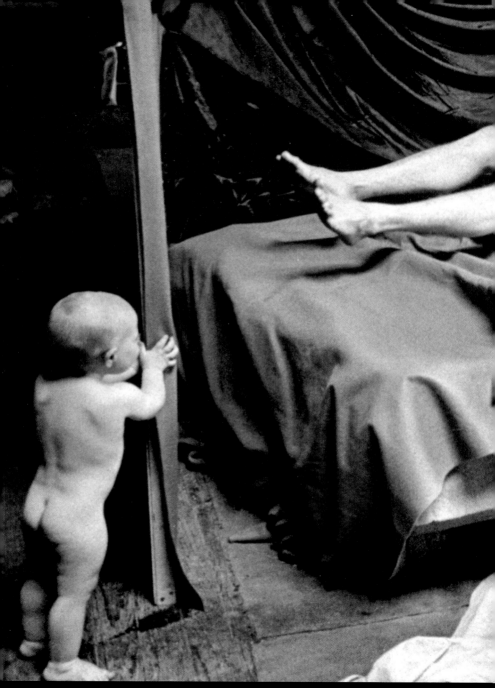

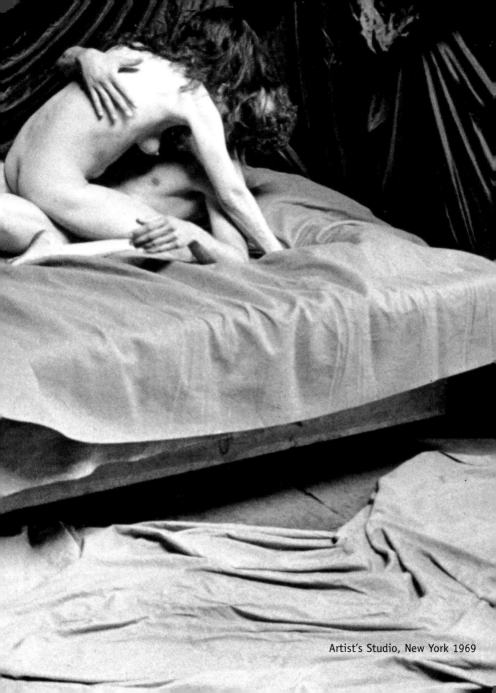

Artist's Studio, New York 1969

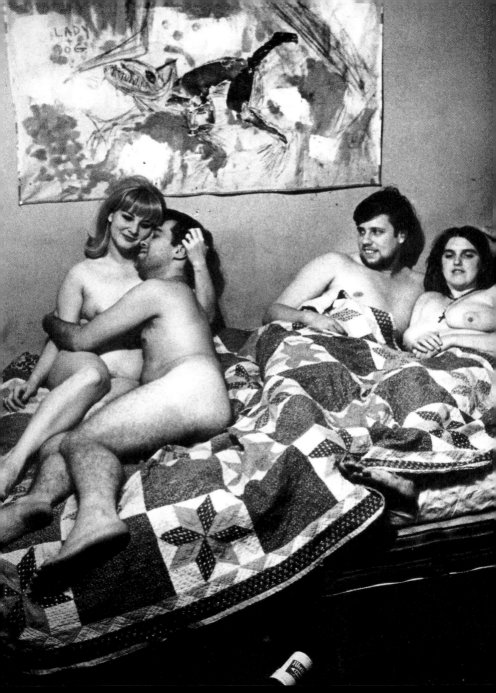

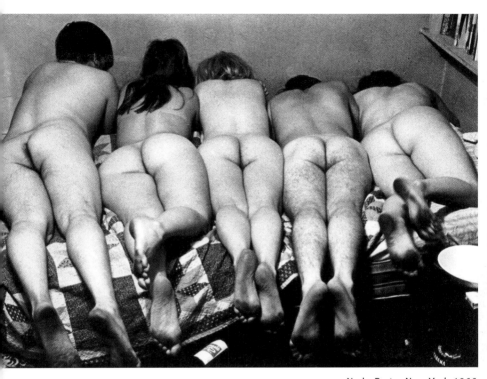

Nude Party, New York 1966

de Party, New York 1966

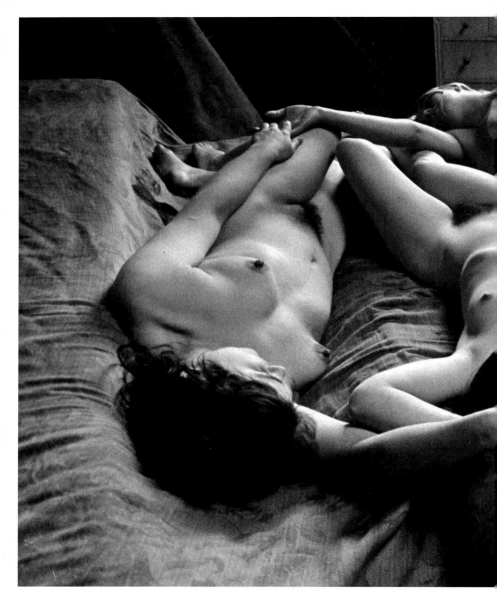

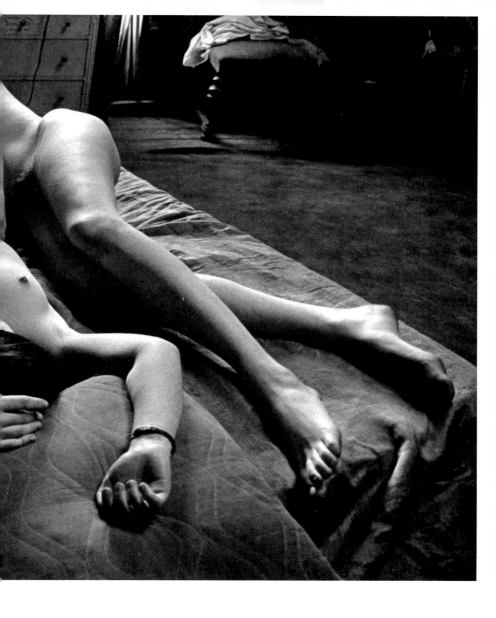

New York 1968

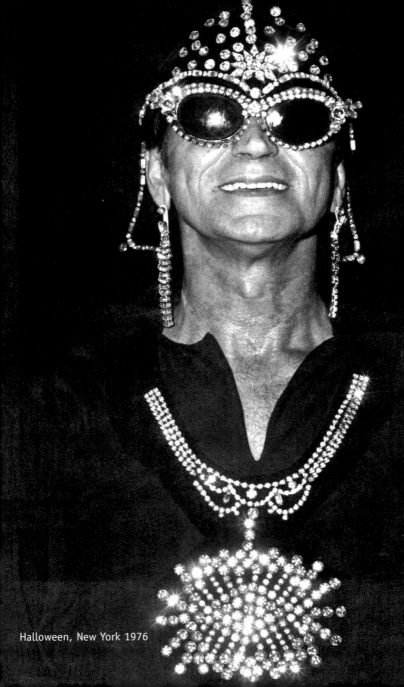

Halloween, New York 1976

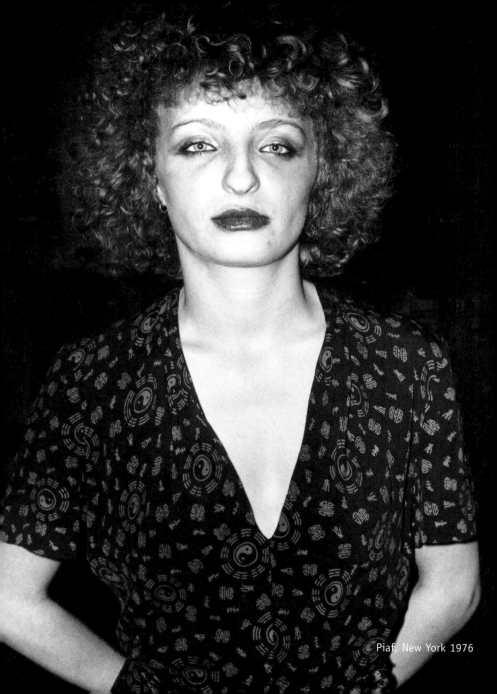

Piaf, New York 1976

Mardi Gras

New Orleans 1972

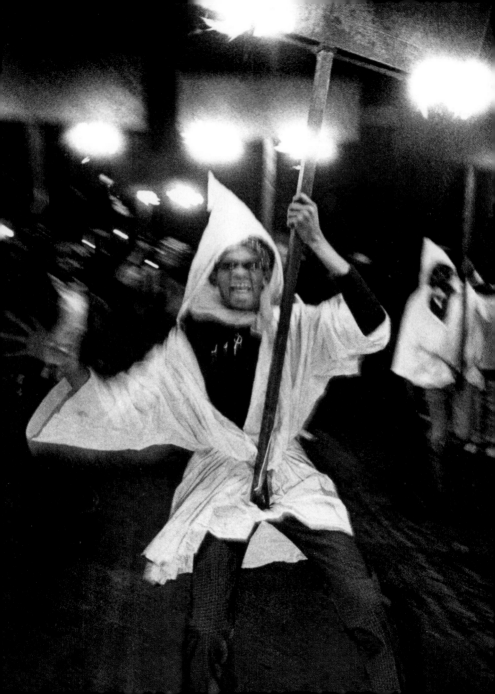

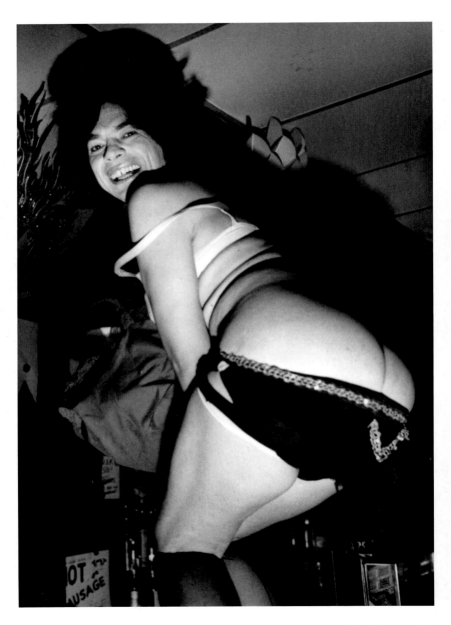

New Orleans 1970

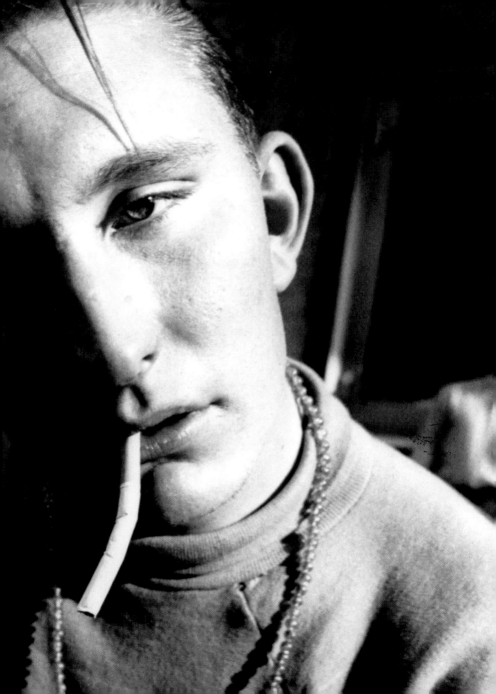

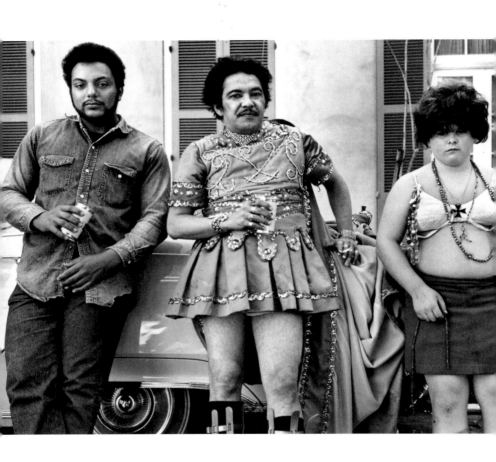

New Orleans 1971

136

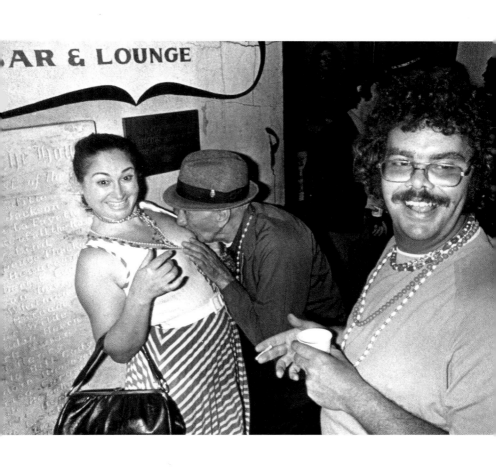

New Orleans 1973

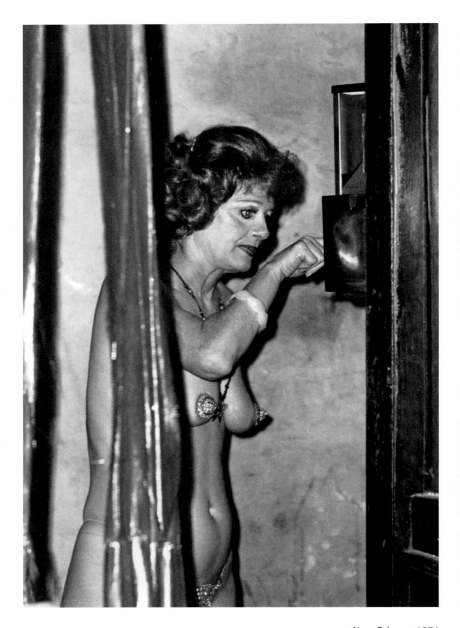

New Orleans 1971

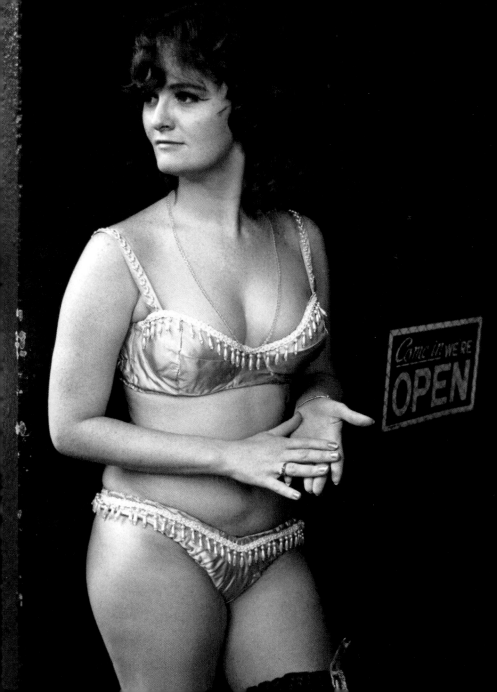

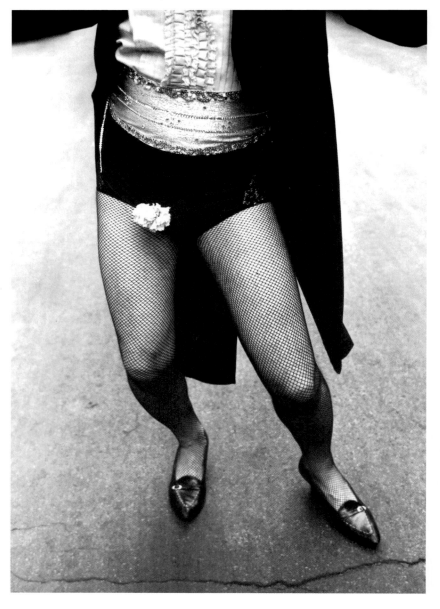

New Orleans 1977 New Orleans 1978

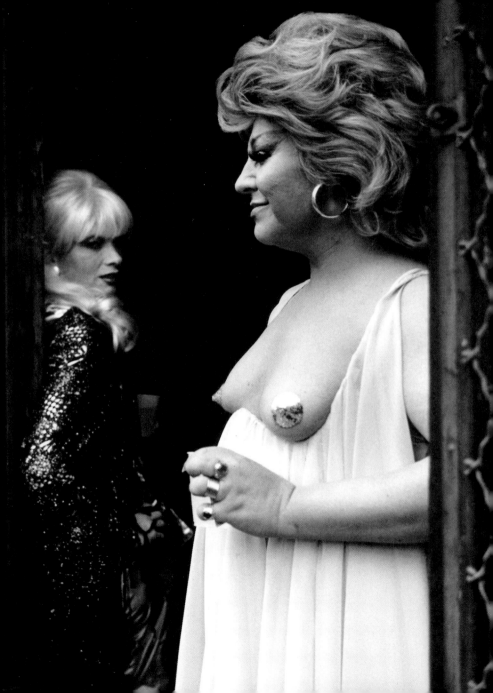

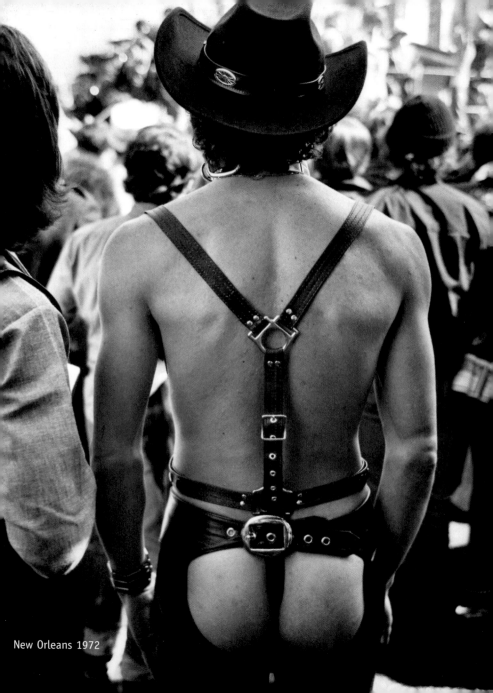

New Orleans 1972

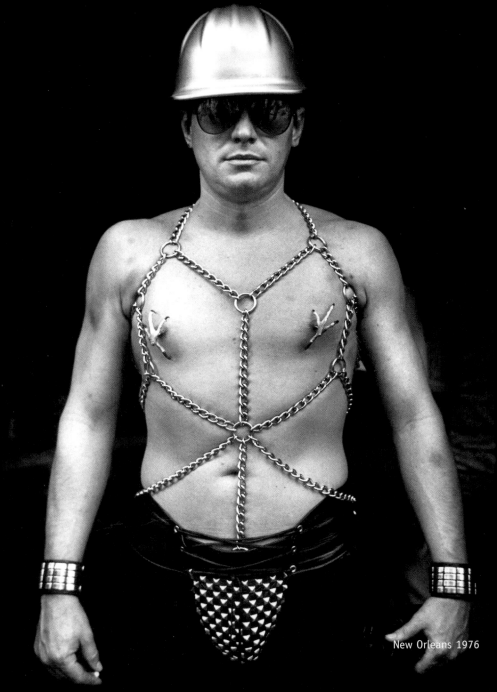

New Orleans 1976

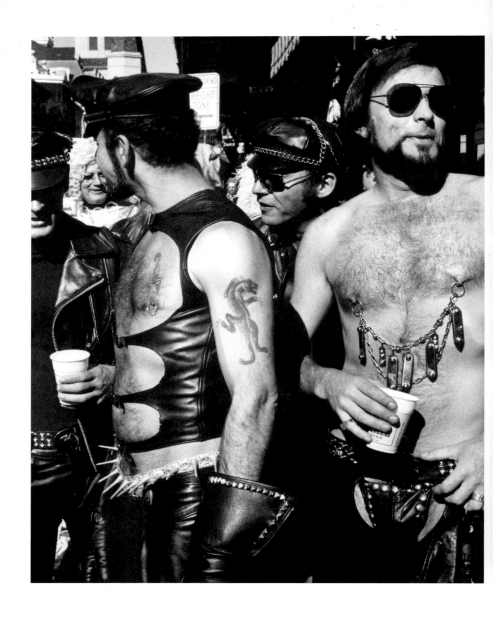

New Orleans 1974

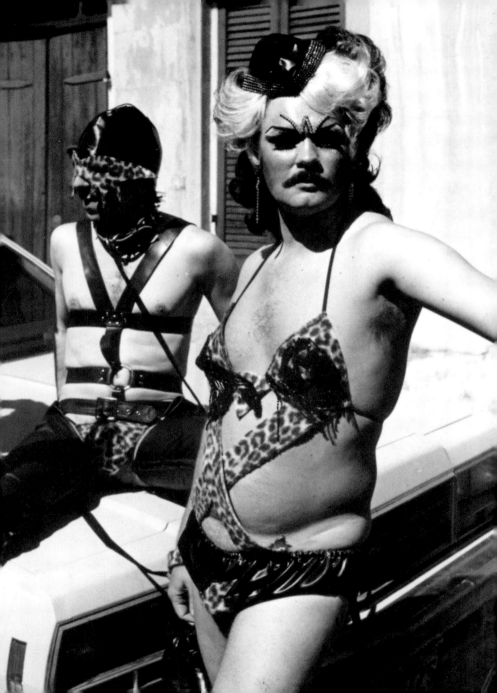

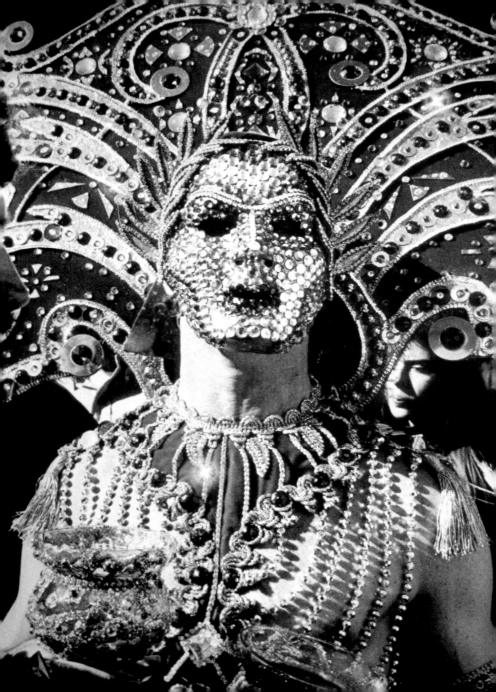

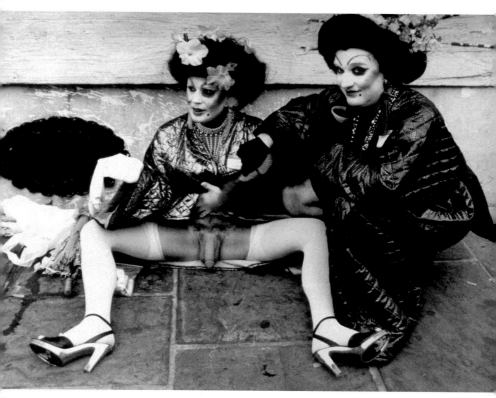

New Orleans 1992

Orleans 1973

147

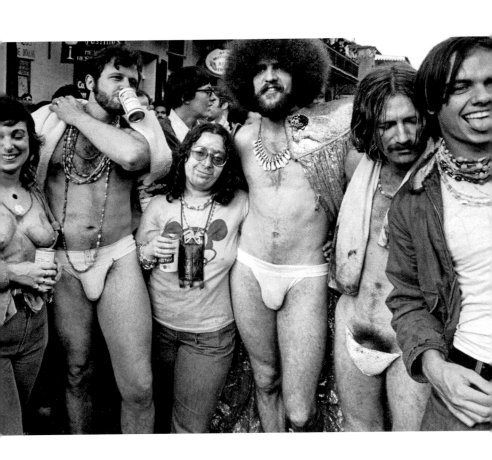

New Orleans 1971

148

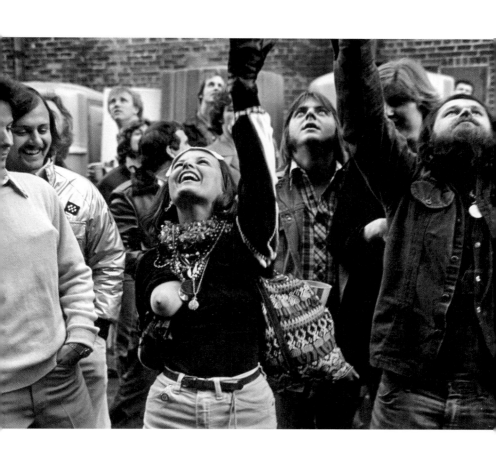

New Orleans 1980

149

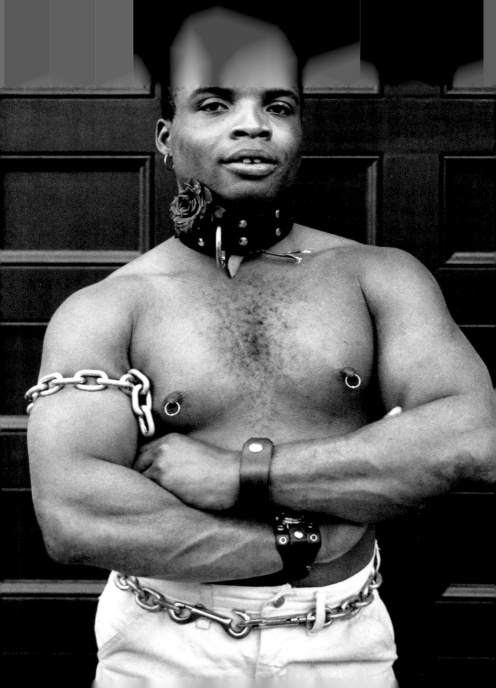

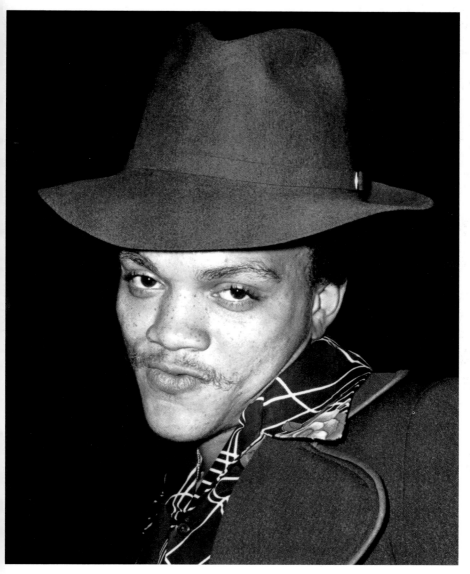

New Orleans 1972

New Orleans 1973

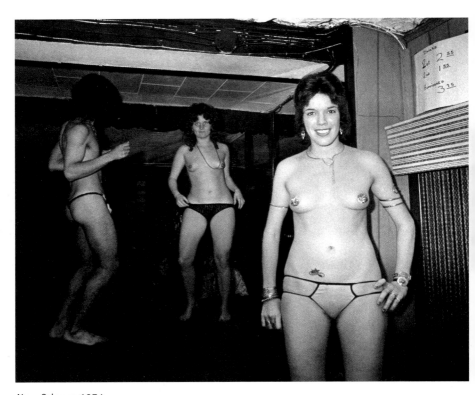

New Orleans 1974

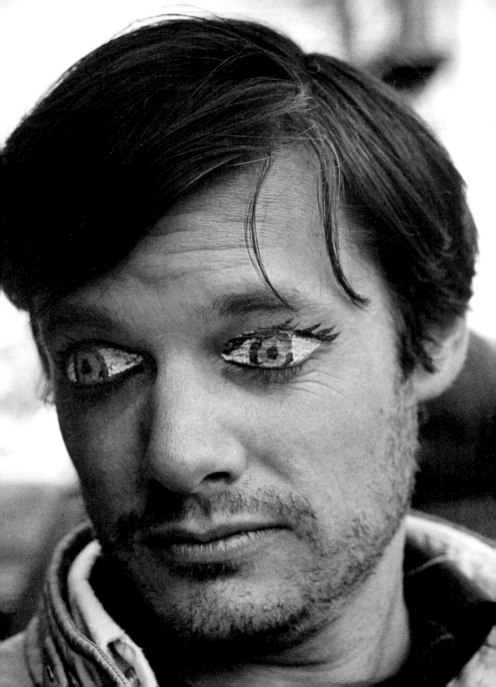

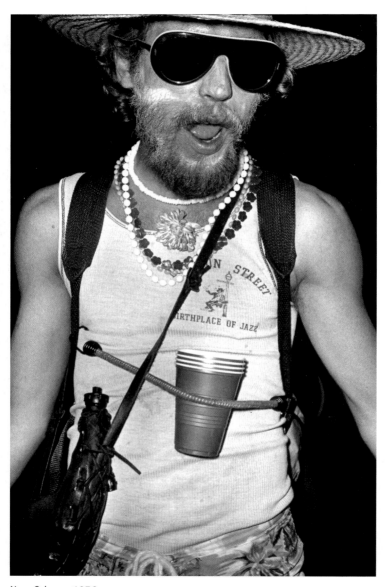

New Orleans 1976

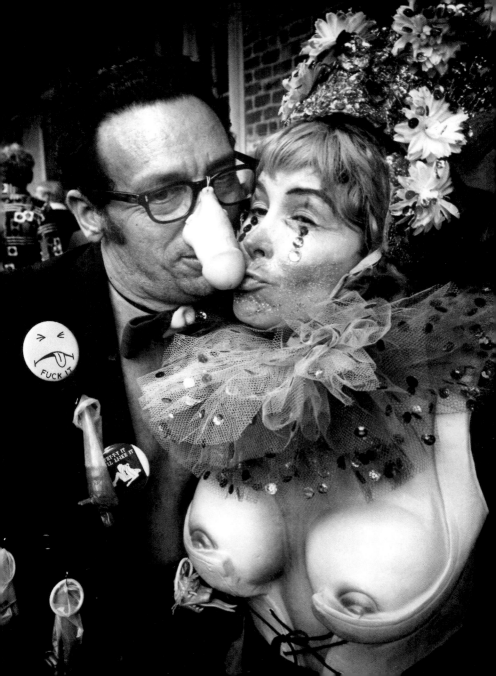

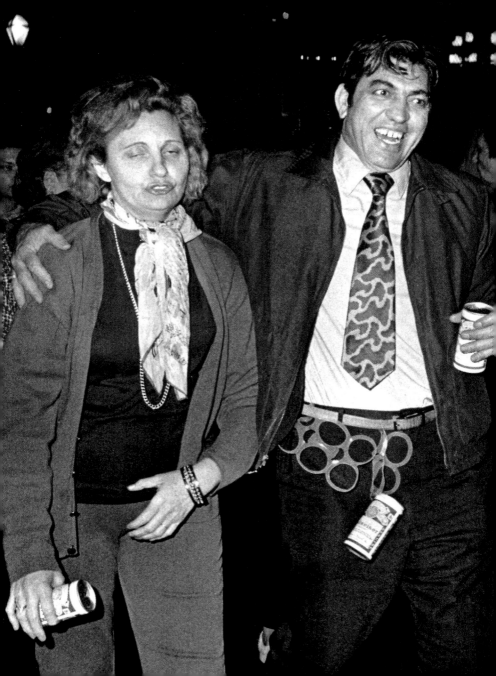

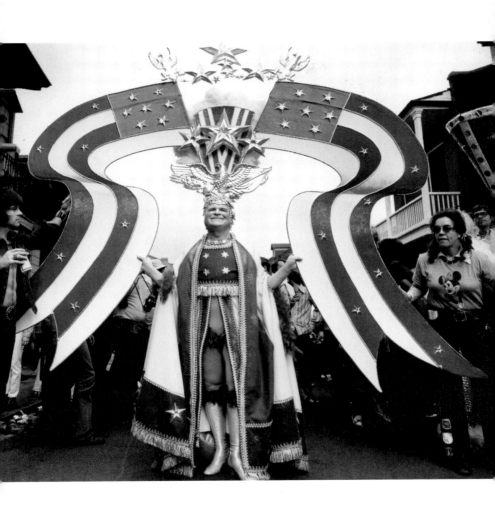

w Orleans 1972

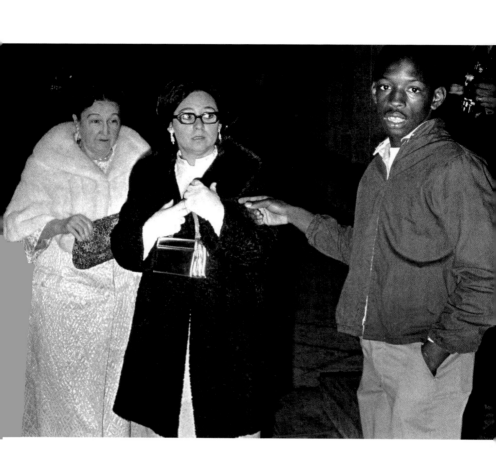

New Orleans 1972

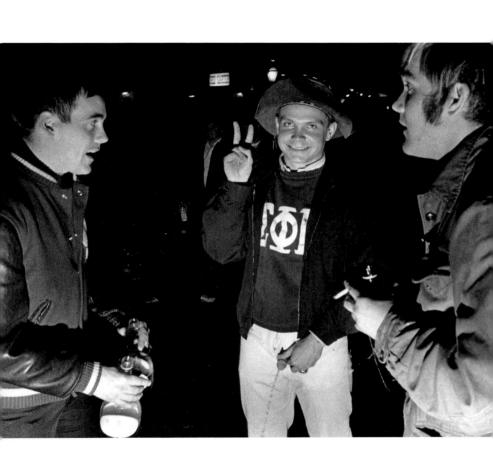

New Orleans 1970

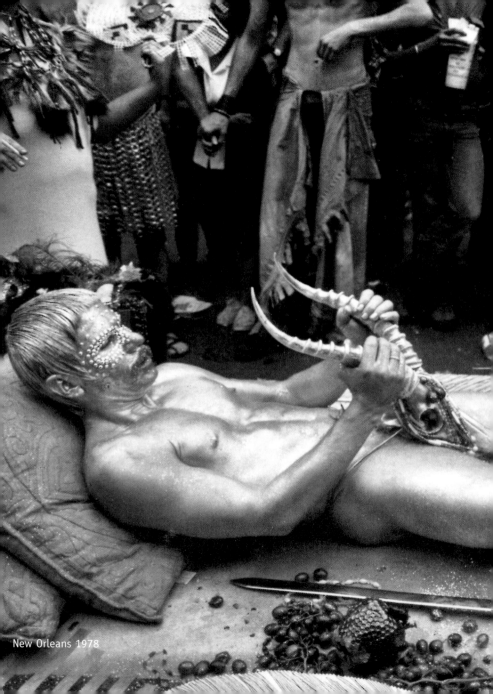

New Orleans 1978

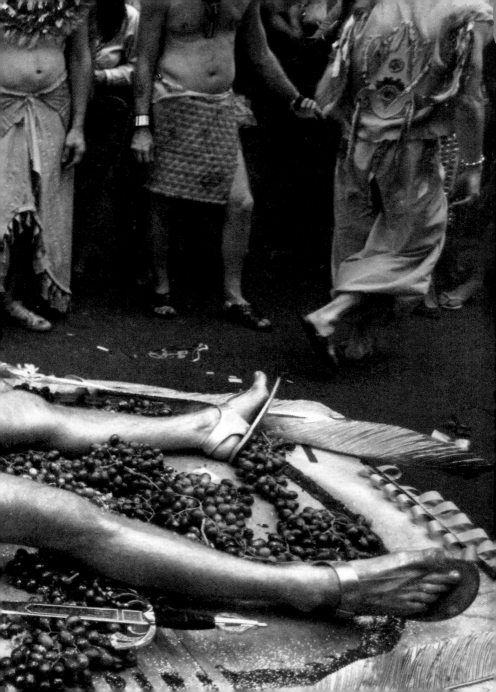

Forbidden
photographs

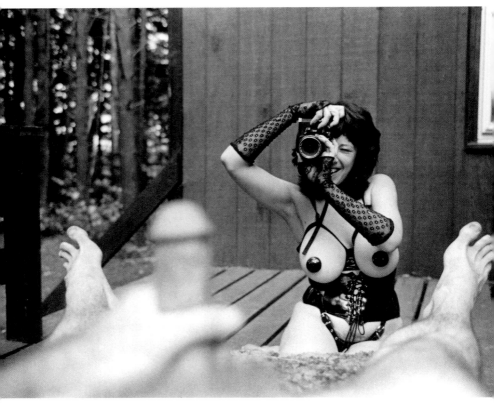

Annie Sprinkle, Woodstock - New York 1980

"He spent his evenings and nights getting pictures, or posing for pictures, of an unpublishable nature."

-Divorce Affidavit, Gatewood vs. Gatewood
Supreme Court, State of New York

FORBIDDEN PHOTOGRAPHS

I stand at the lectern, fielding questions. Silly questions. Easy questions. Boring questions. Then, The killer: Why, Mr. Gatewood? *Why* are you showing us this? WHY?

I crack a joke and give a smooth answer that says absolutely nothing. The more I explain the less I understand. The question stays with me. It follows me. Haunts me.

I lie awake smoking, thinking, chasing answers. My roots. Must be clues there. Go back to childhood. Study the past. Look back. Figure it out.

My roots - Ha! A long line of Southern misfits. I look for a connection. Whiskey and women. Intoxication. Pleasure. Pain. Ecstasy. Desire. Terror. An overwhelming need to get drunk, to stay stoned...

I think of Texas dirt farm country, where all boys "get in trouble" sooner or later. Bar fights. Dynamite. Guns. Stolen cars. Blacktop roads going nowhere. Police radios crackling. Bloodhounds barking in dark cotton fields. Sniffing turpentine. Robbing liquor stores. Knocking up dumb farm girls with names like Alma May and Betty Lou - all while under the influence, of course. I drift into an alcoholic haze. My thoughts flow together. I think of my poor mother, born to suffer, born to a long tradition of poor white southern sadness. Bad genes, weak chins, cheap whiskey. Yesterday´s guilt, today´s sorrows, tomorrow´s fears.

Born to lose. No exit.

I think of my father. More clues appear. A traveling salesman. Once respectable, well dressed, succesful. A nice house, two kids, a dog, a cute young wife from Texas waiting at home...

But there are too many sorrows. Too many hangovers. Too many lonely nights. One night he passes out on a motel bed, cigarette in hand, and dies in smoke and flames. The casket is closed at the service. "You wouldn´t want to see him like that." Sad, tired, and alone, I know him now through old photographs. He is forty-two years old - exactly my age - at his death.

My stepfather is a horror show. Unchecked syphillis, brain damage, big trouble when intoxicated. A case of Jim Beam bourbon in the trunk of last year's Cadillac, a box or fresh seegars in the glove compartment. A honky-tonk shitkicking wife-beater. Mr. Yahoo...

I split. Do not look back. I am a skinny, shy, sensitive day-dreamer. I shuck my taboos from Stockholm to Tangier, play to my senses, begin drinking and taking drugs. I find I have an addict's personality. I overdo everything. I have spent the last twenty years looking for that *"click!"*

Few have seen the human wreckage as I have, yet I follow the pattern exactly: outwardly cheerful and successful, inwardly empty, sad, alone. Stoned and drunk. My body screams for mercy and I don't fucking care. I want *out of here*. I exist to be *higher*.

And every bit of trouble I experience - and there is plenty - is in some way associated with whiskey and women. Dope, sex, and cheap thrills.

The Demons of Desire.

And yet, and yet... a thousand scalding hangovers and bum trips later, I can still lie here and praise those drinks and drugs that brougth it all about. For my most amazing adventures, the peak experiences of my life - and there have been many - have also come when I was, in the best tradition of my ancestors. Stoned Out Of My Gourd.

I dream on in fantasies of transcendence: one fine day, having paid the full biologic price, having experienced about as much real experience as one body and soul can handle, I mellow into a wise and gracious old man, puttering about the flower garden under country skies, sitting in quiet contemplation by the fire, rocking on the porch swing, listening to the wind in the trees, happy, clear-eyed, finally at peace with myself, all the days of crazy far behind me.

And even now, as I entertain this gentle fantasy, the mind is fogged, the body aching from gallons of cheap wine, watching pale dawn through dirty windows, having just drunkenly tried to steer two girls into bed, girls who wanted nothing more than to smoke hash and listen to rock and roll records...

Gatewood's stepfather, Missouri 19

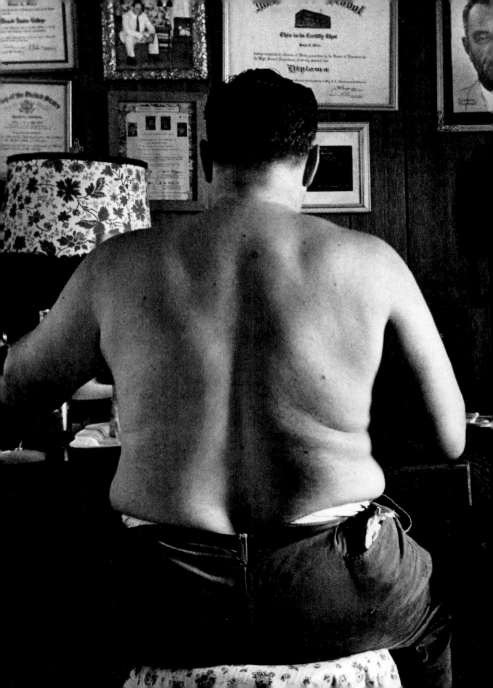

I drift along, pondering the questions. I ask myself for the thousandth time just what the fuck I´m doing with my life. Sometimes, on bad mornings, I feel like poor Gatsby, beating my paddles furiously against the current as I float backwards down the Big River. But, ah, my friends, I have followed my feelings. I have done it my own way.

This book is a last look back into a bad dream. The trip is over. No apologies. No guilt. No expectations. No blame. No regrets.

-Charles Gatewood,
from the introduction to Forbidden Photographs, 1981

Annie Sprinkle and Fakir Musafar, New York 19

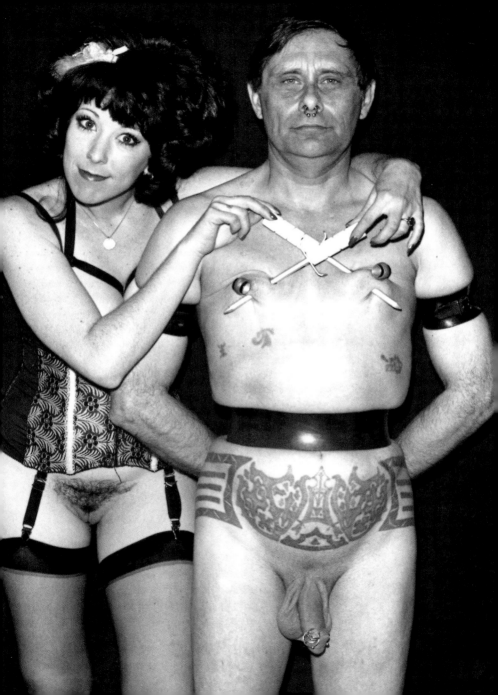

Human Pincushion, Syracuse, New York 19

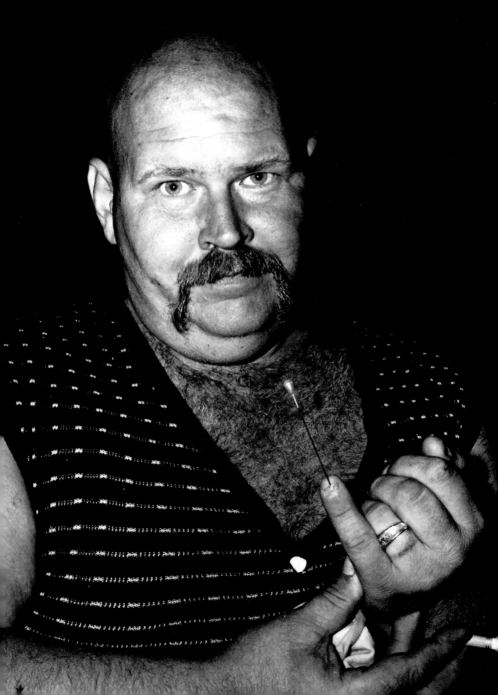

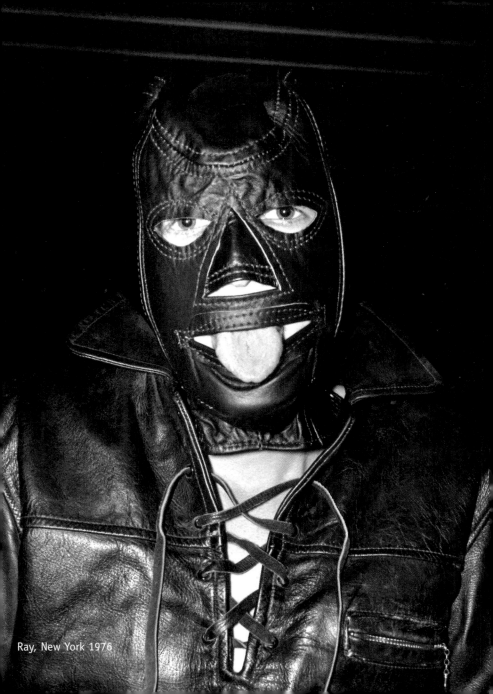

Ray, New York 1976

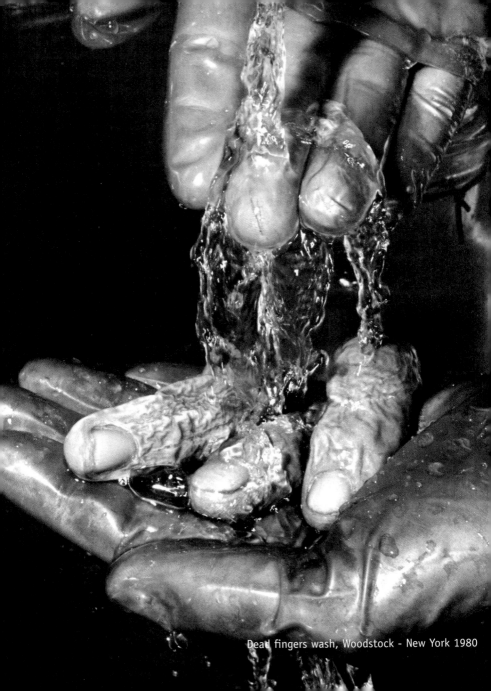

Dead fingers wash, Woodstock - New York 1980

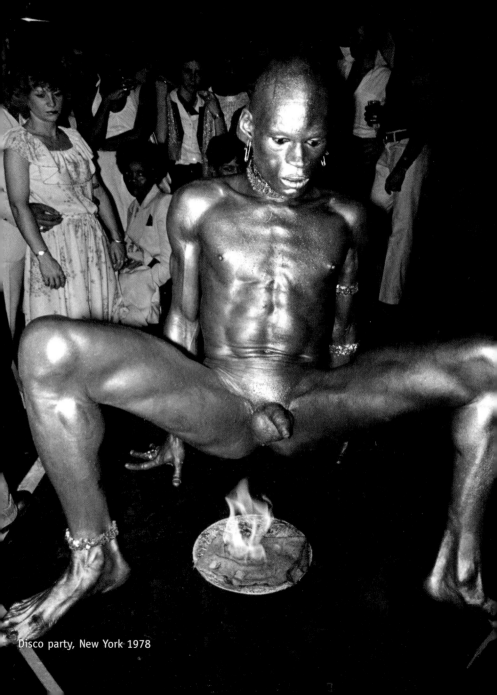

Disco party, New York 1978

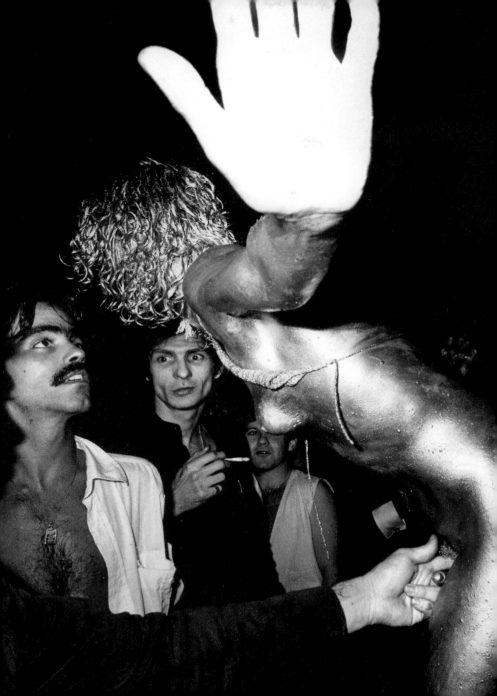

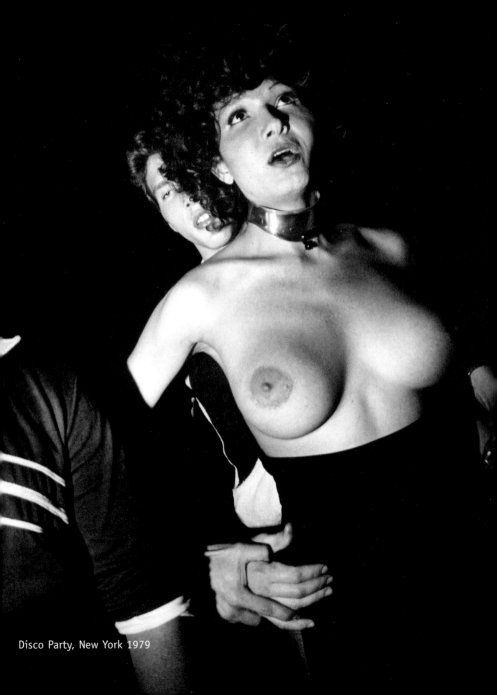

Disco Party, New York 1979

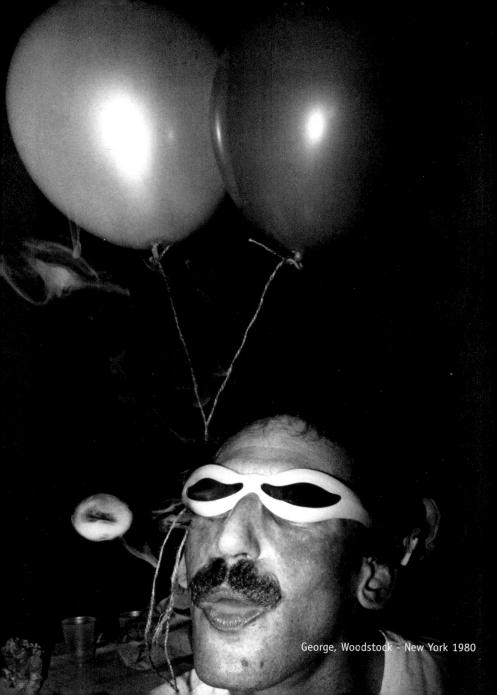

George, Woodstock - New York 1980

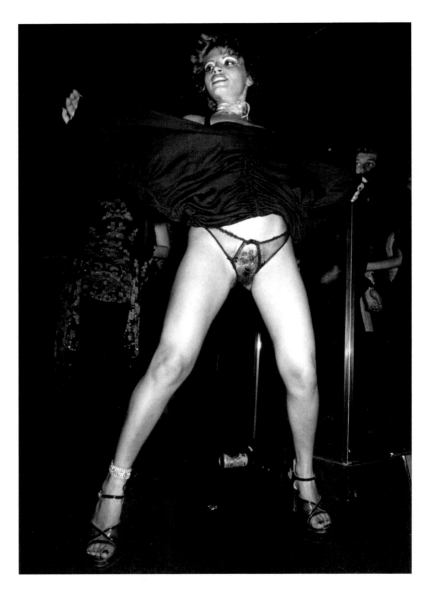

Disco party, New York 19

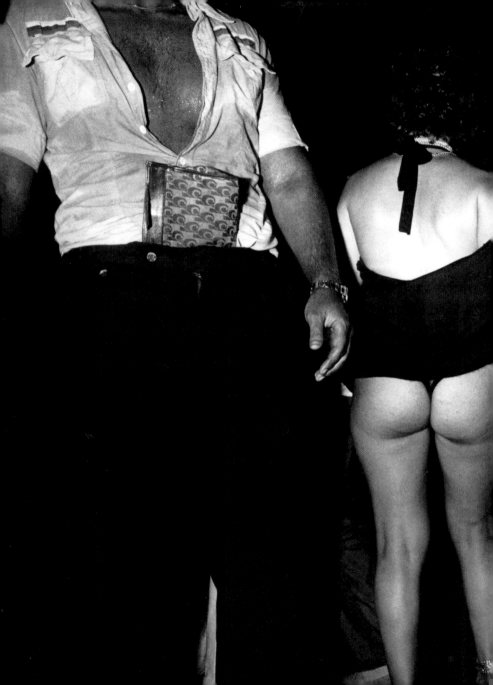

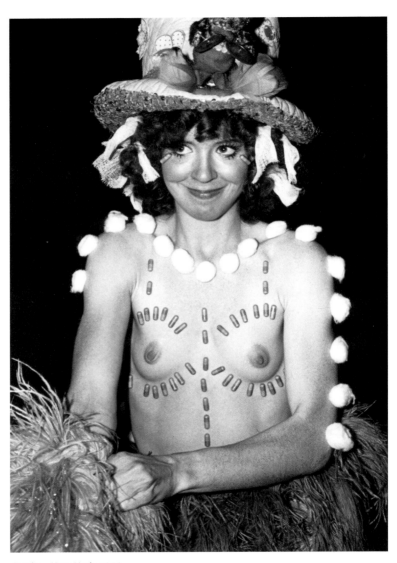

Annie , New York 1979

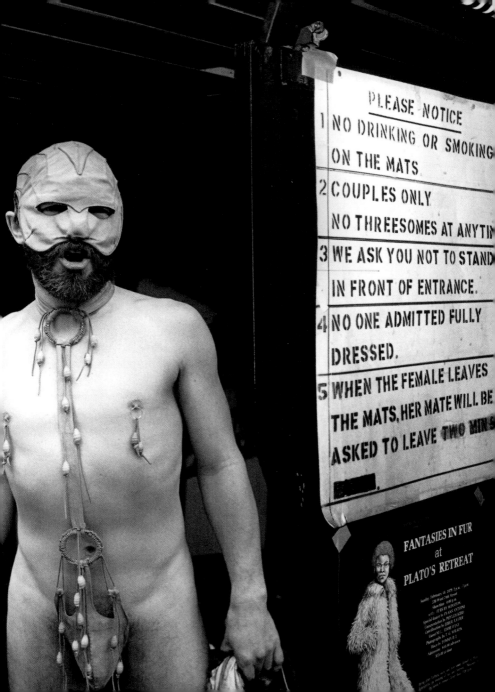

PLEASE NOTICE

1 NO DRINKING OR SMOKING
ON THE MATS

2 COUPLES ONLY
NO THREESOMES AT ANYTIME

3 WE ASK YOU NOT TO STAND
IN FRONT OF ENTRANCE.

4 NO ONE ADMITTED FULLY
DRESSED.

5 WHEN THE FEMALE LEAVES
THE MATS, HER MATE WILL BE
ASKED TO LEAVE TWO MINS

FANTASIES IN FUR
at
PLATO'S RETREAT

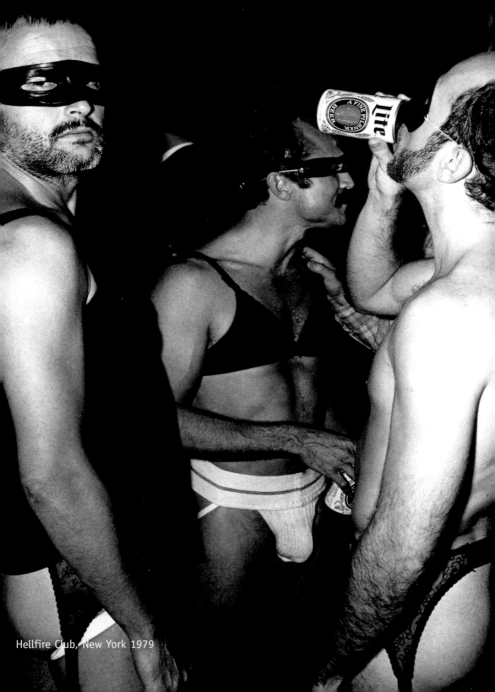

Hellfire Club, New York 1979

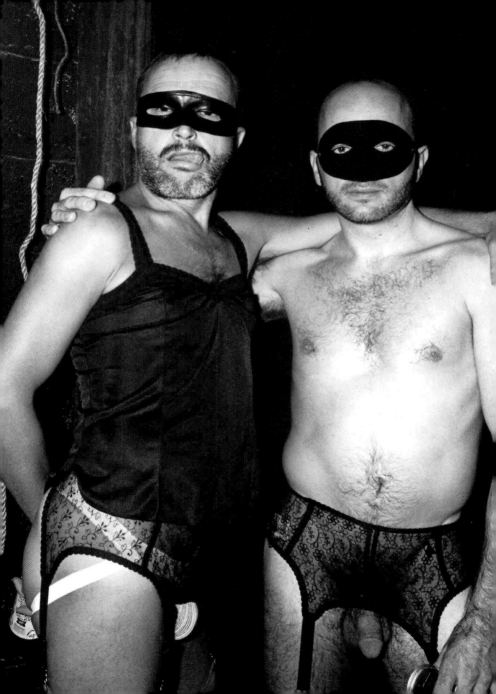

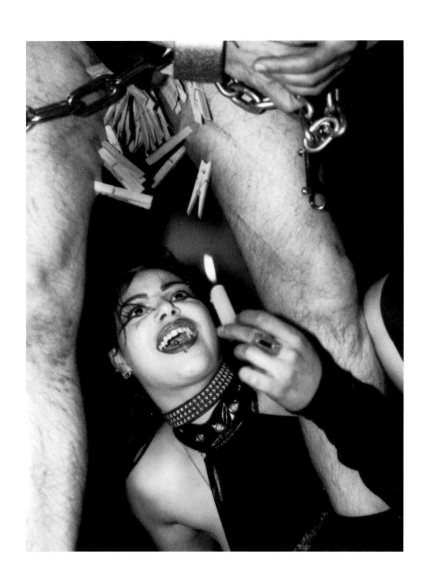

Anjelica, New York 1993

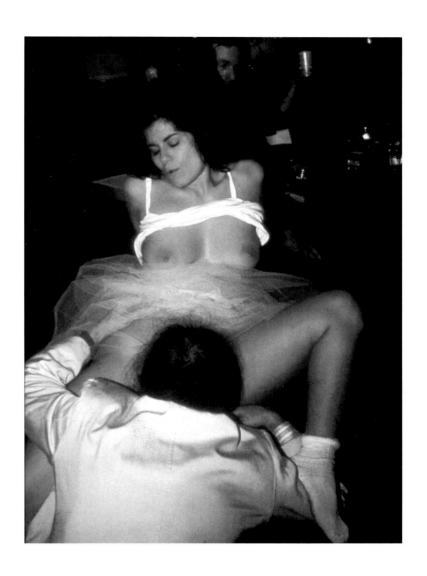

Veronica, Hellfire Club, New York 1979

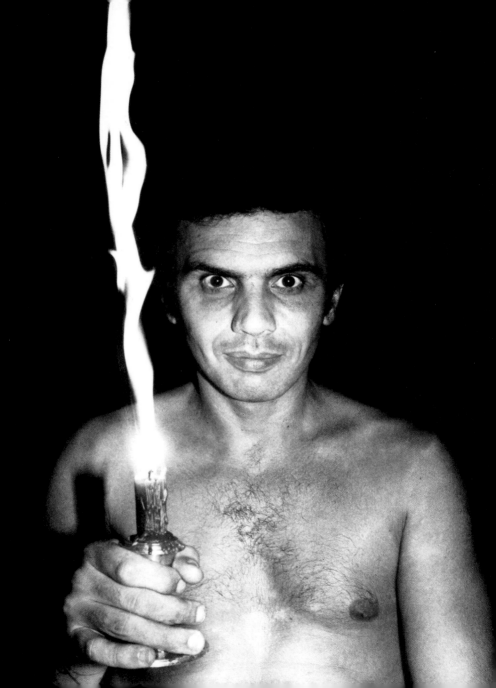

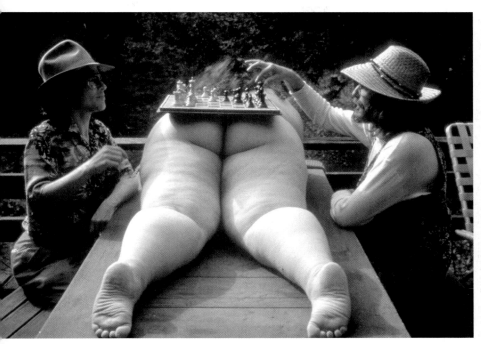

Woodstock - New York 1982

rco Vassi, Woodstock - New York 1980

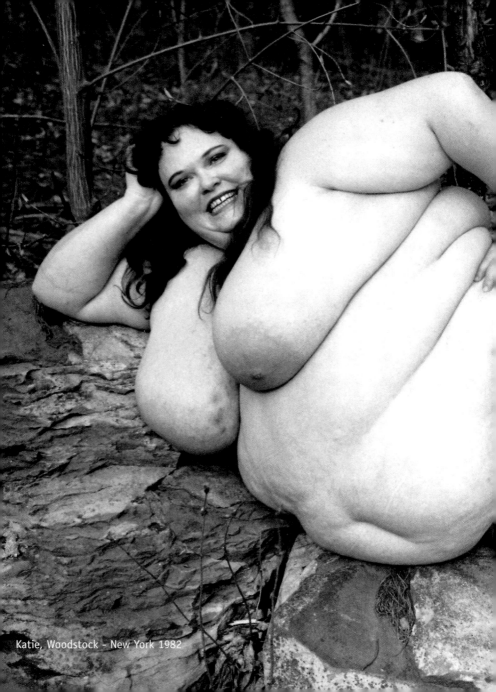

Katie, Woodstock - New York 1982

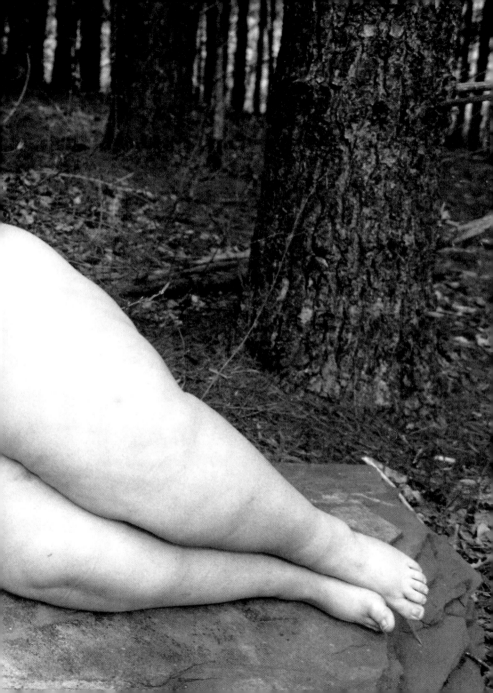

R. Mutt Press

*"R. Mutt press was truly my
post-post-graduate education"*

-Charles Gatewood

Spider Webb, Woodstock - New York 1

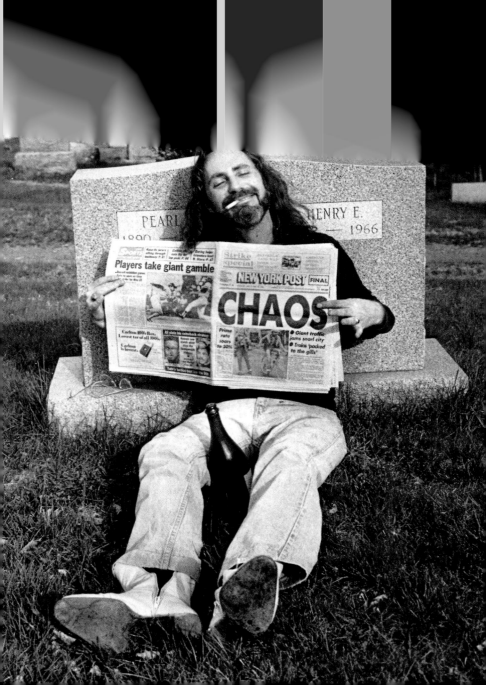

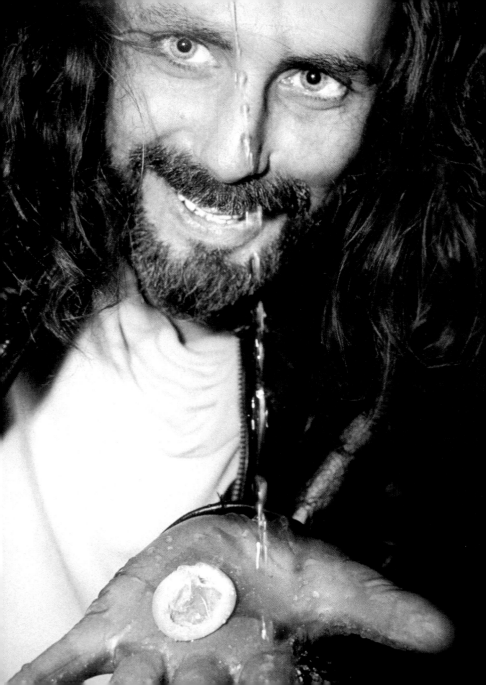

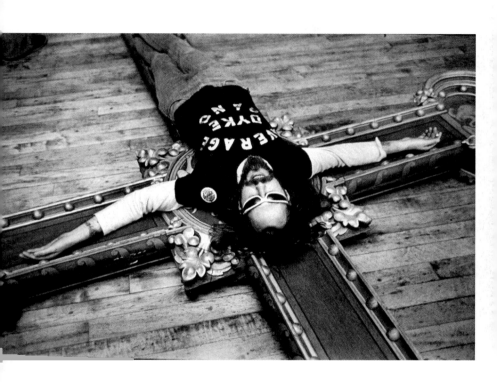

ider Webb, New York 1979

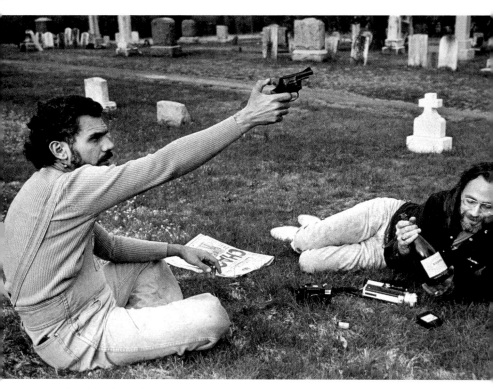

Marco Vassi and Spider Webb, Woodstock - New York

Mam'selle Victoria, New York 19

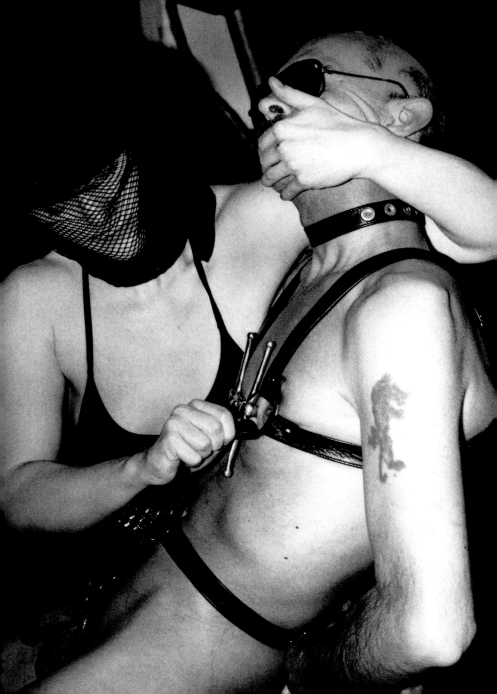

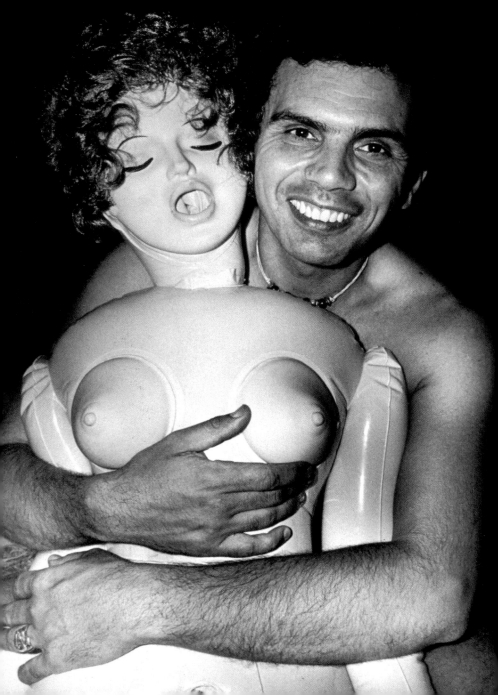

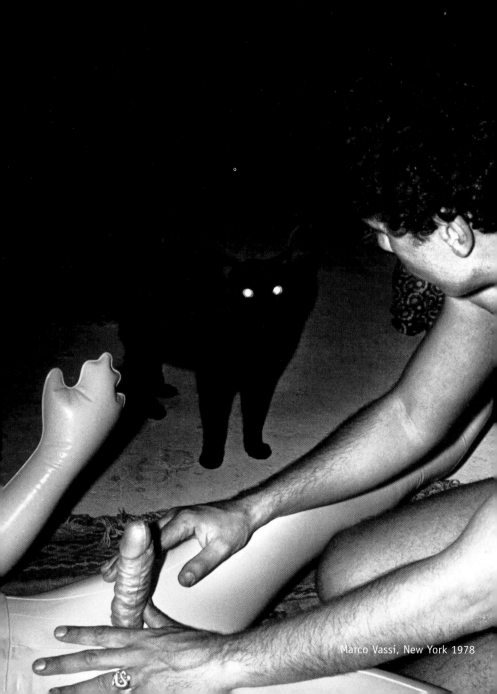

Marco Vassi, New York 1978

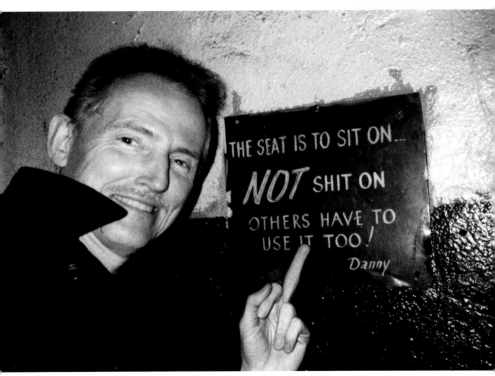

Michael Perkins, New York 1995

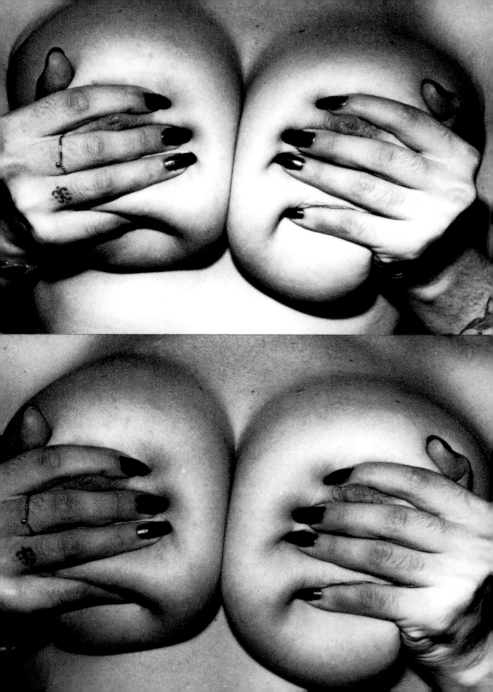

Modern
primitives

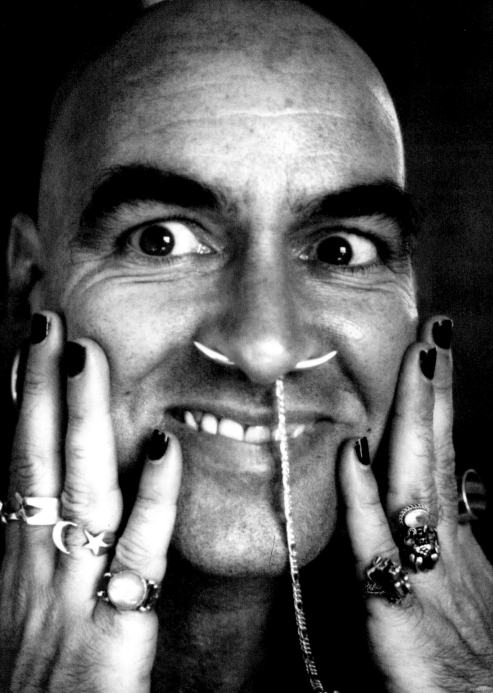

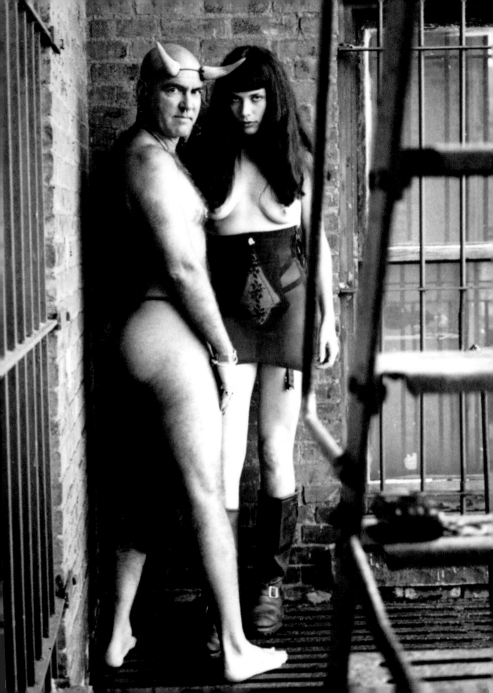

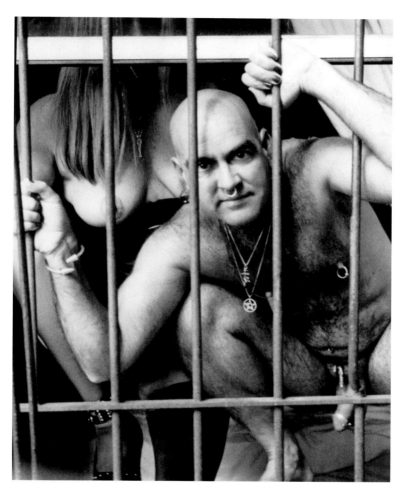

Zea and Dragon, New York 1997

gon and Marne, New York 1997

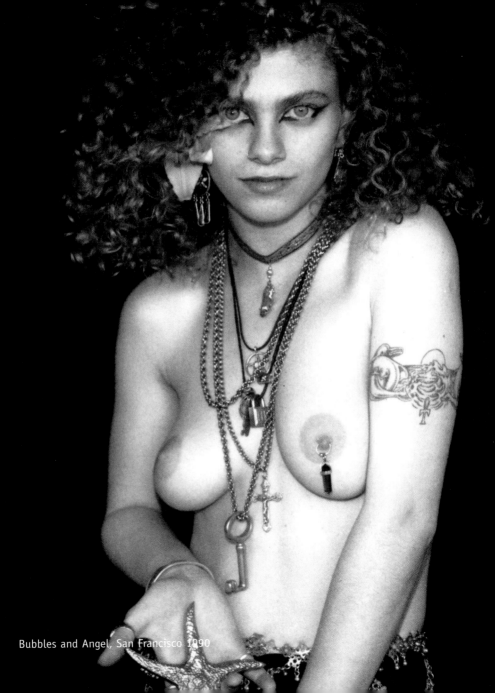

Bubbles and Angel, San Francisco 1990

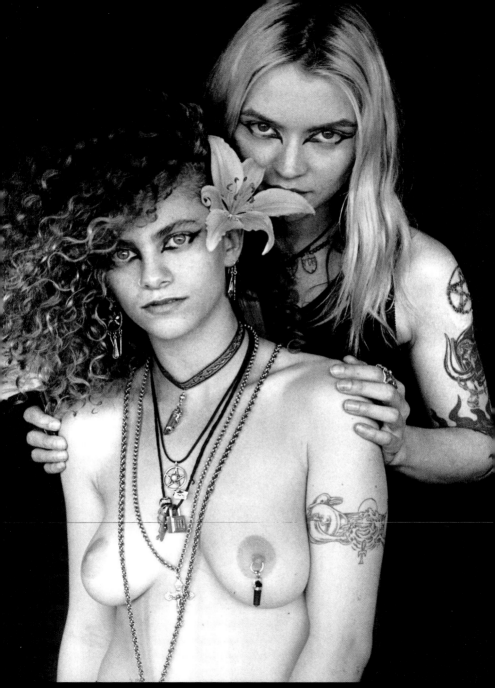

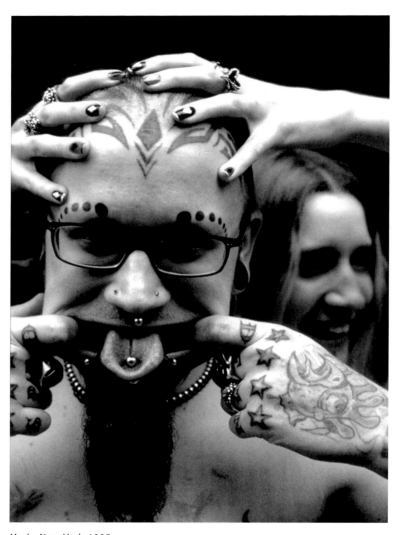

Mark, New York 1995

Efrain, New York 19

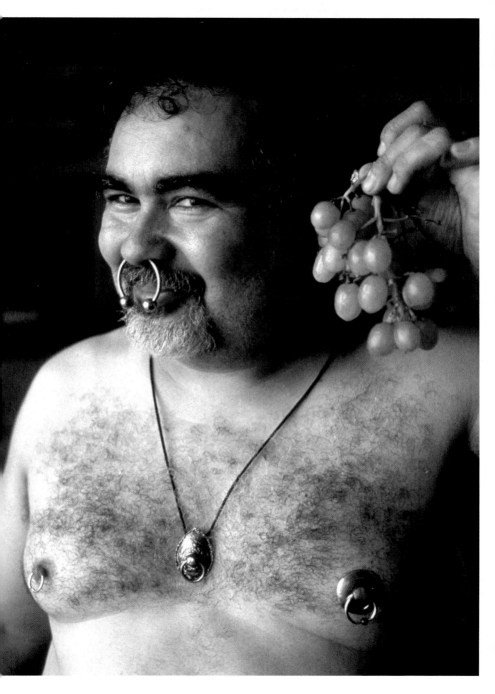

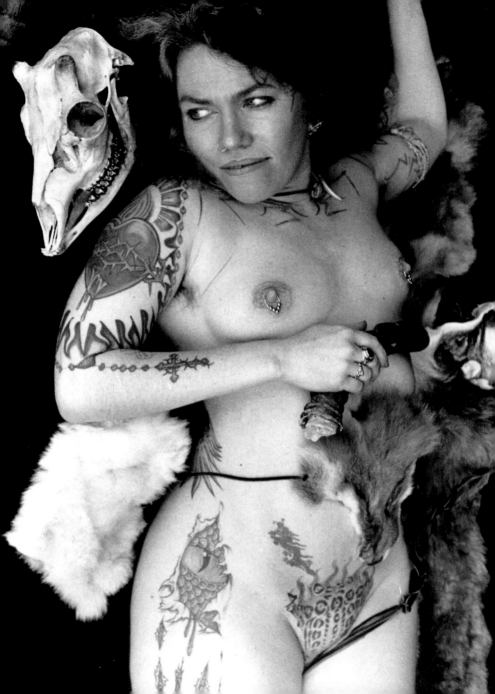

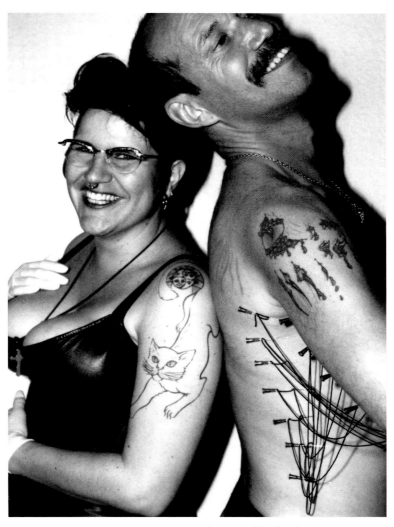

Jenny and Irwin, San Francisco 1991

ta, San Fransisco 1991

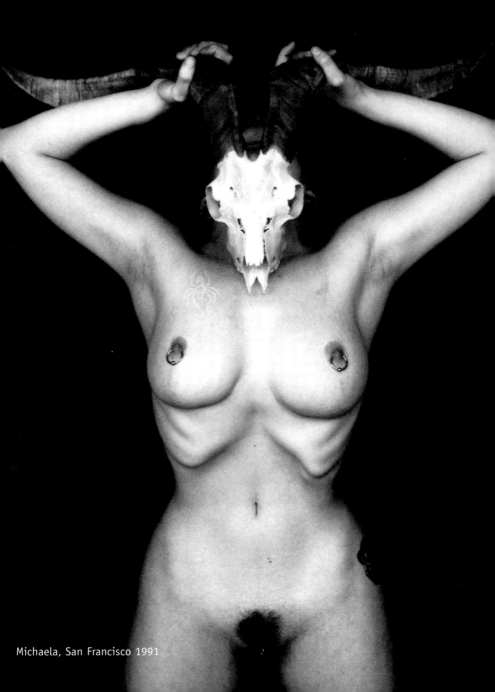

Michaela, San Francisco 1991

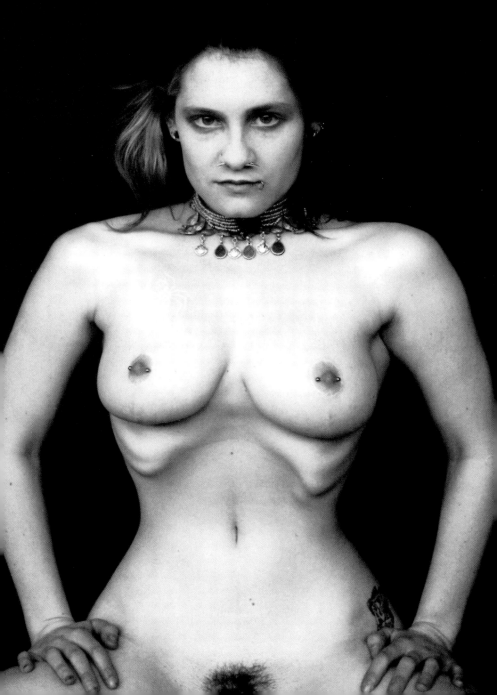

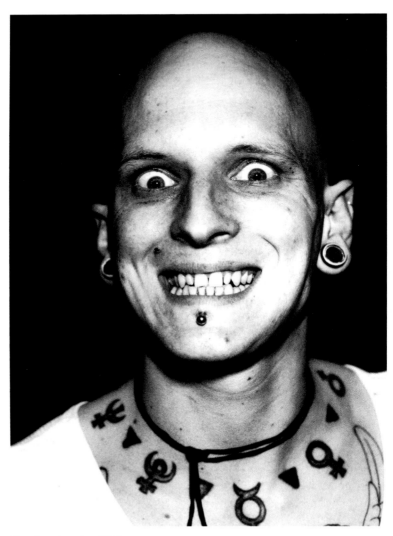

Alex, Los Angeles 1991

Mr. Moko, New Jersey 19

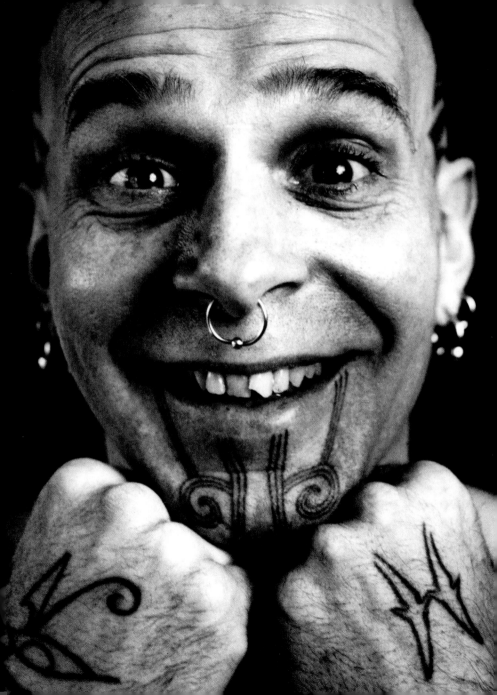

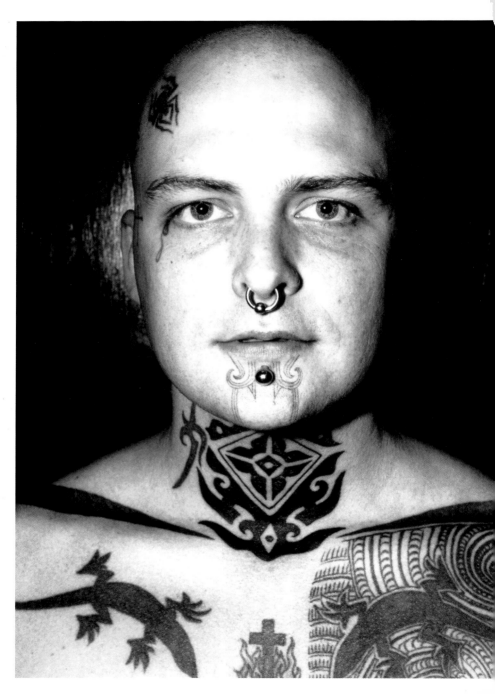

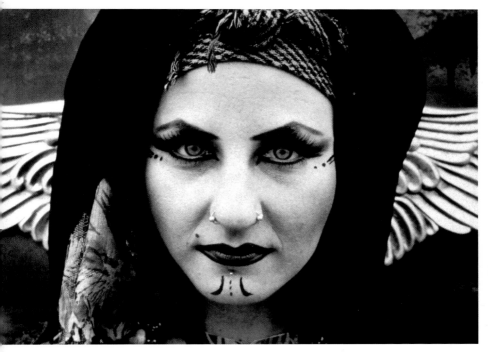

Carmen, San Francisco 1991

n Athey, Los Angeles 1991

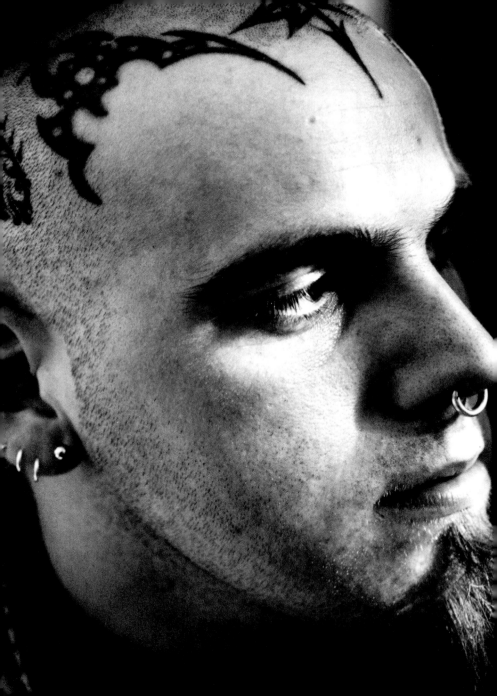

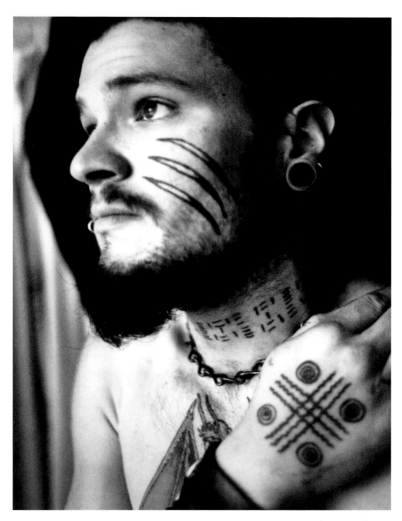

Brad, New Orleans

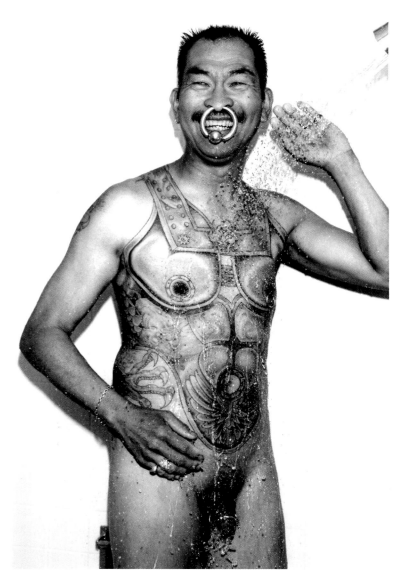

David, Los Angeles 1991 Jim Ward, Sundance ceremony, Wyoming 19

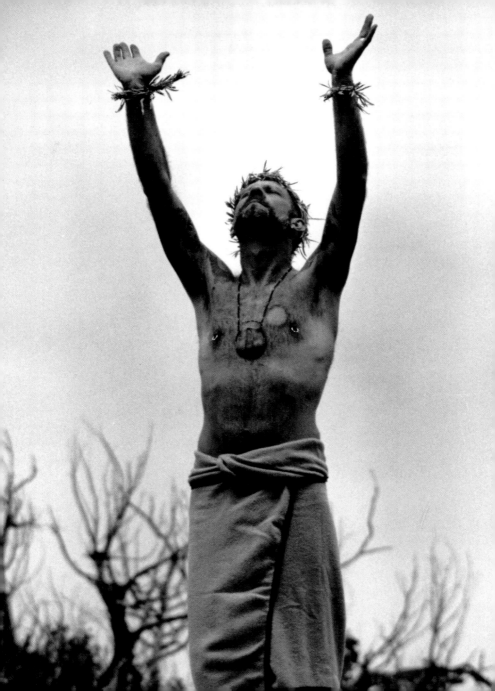

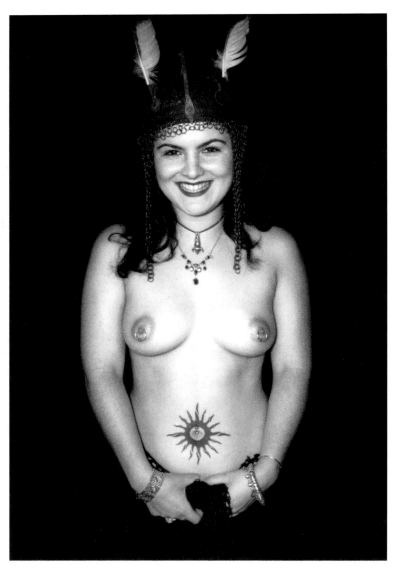

Vita, San Francisco 1991

Dona, San Francisco 1

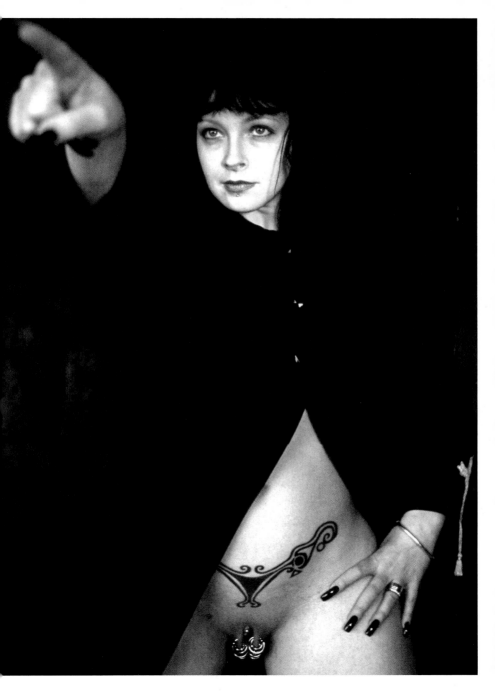

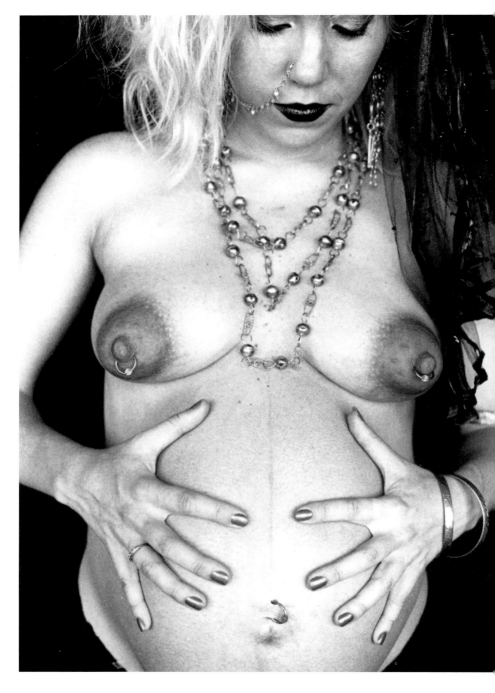

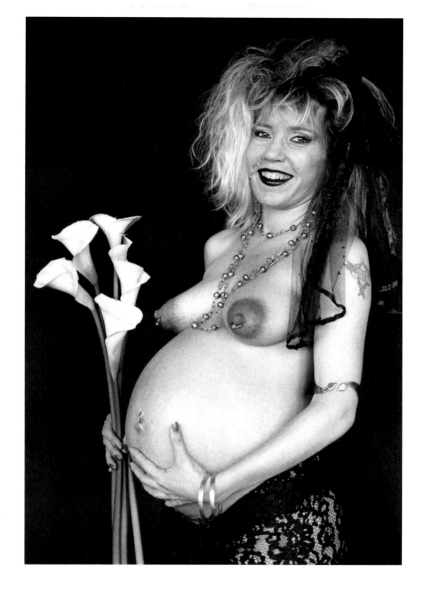

Daisy, San Francisco 1992

Piercing

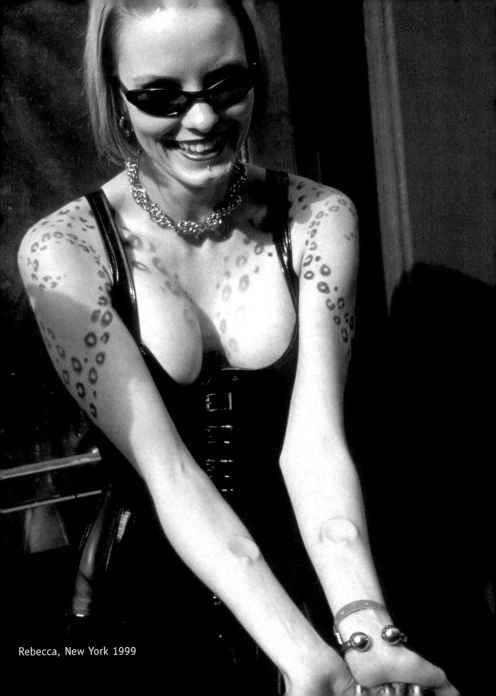

Rebecca, New York 1999

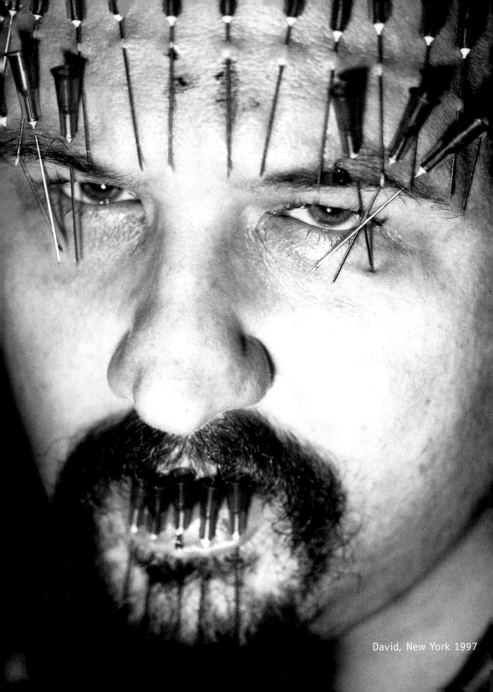

David, New York 1997

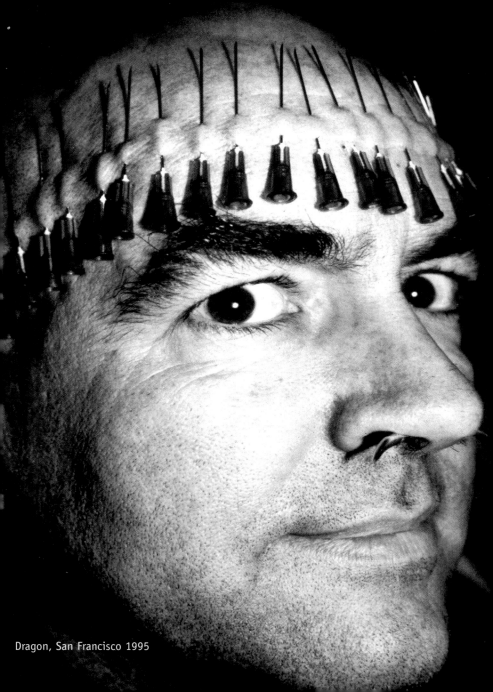

Dragon, San Francisco 1995

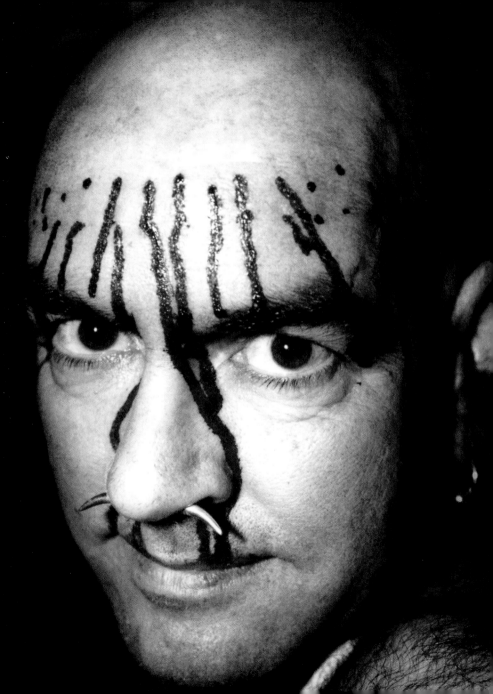

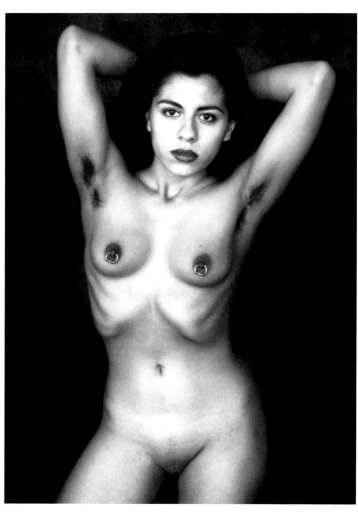

Jaann, San Francisco 1997

Jaann and Anabel, San Francisco 19

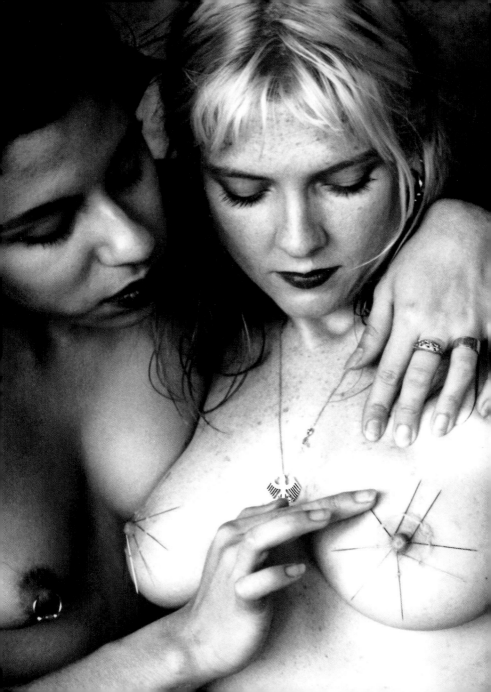

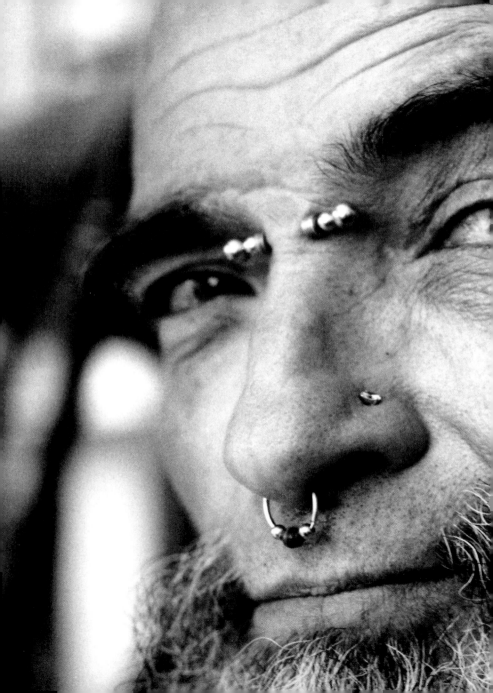

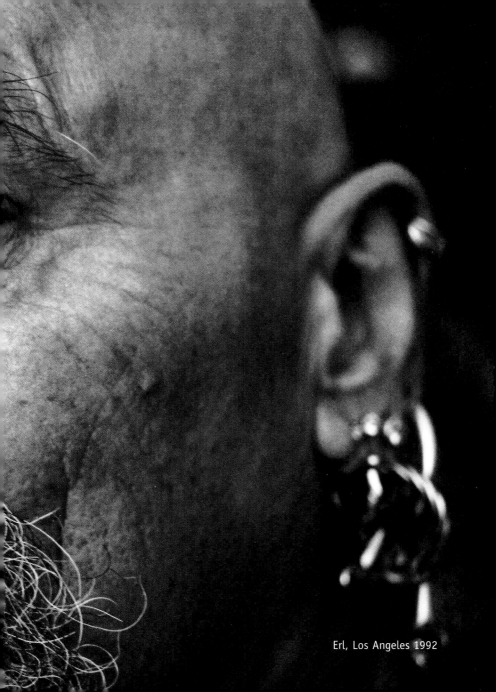

Erl, Los Angeles 1992

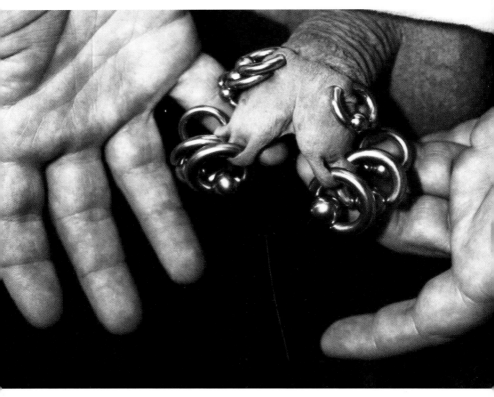

Todd, Los Angeles 1999

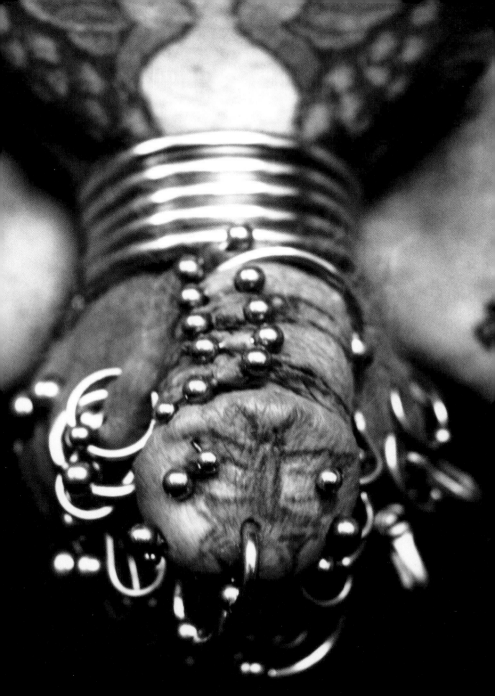

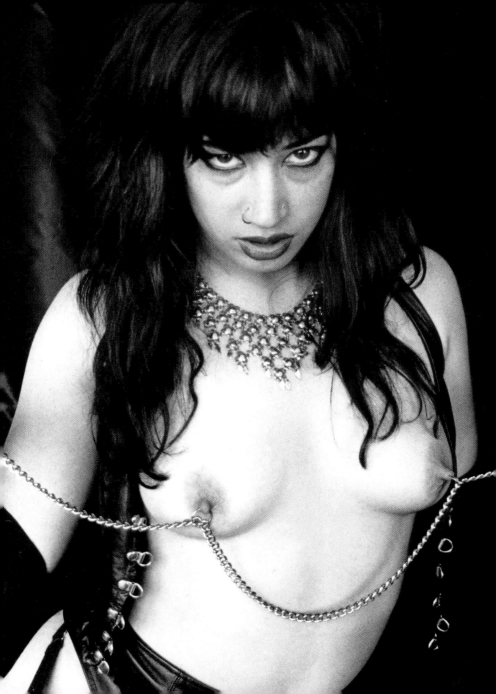

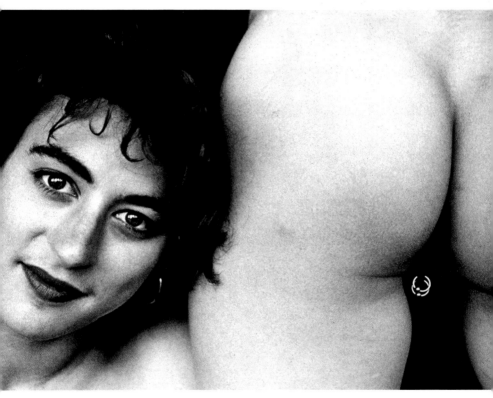

Juliette, San Francisco 1991

ki, San Francisco 1991

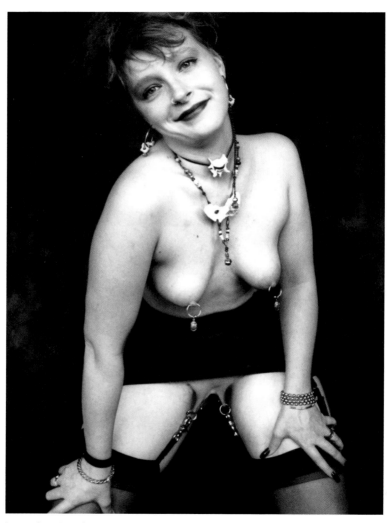

Dona, San Francisco

Angel, Los Angeles 1

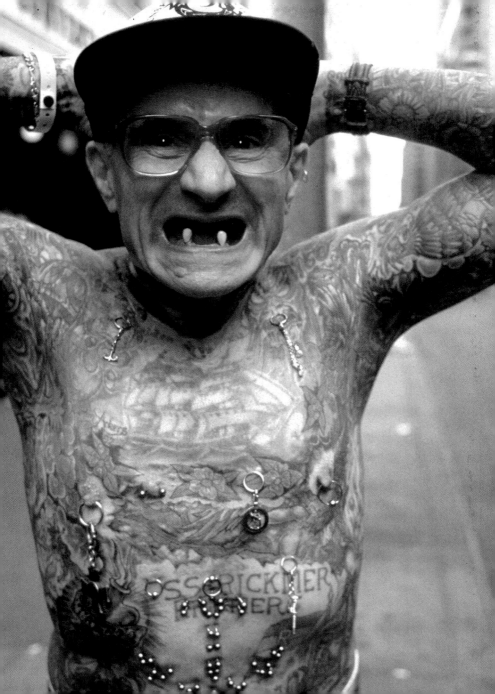

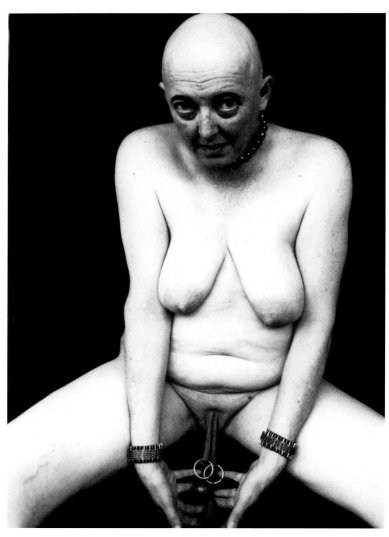

Noni, San Francisco 1991

Larry, San Francisco 1

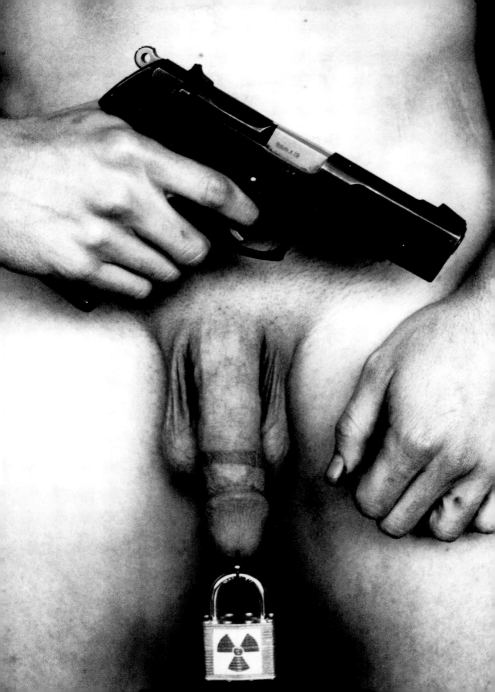

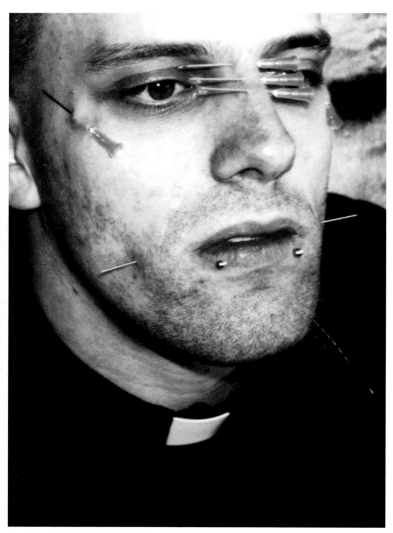

Shane, New York 1997

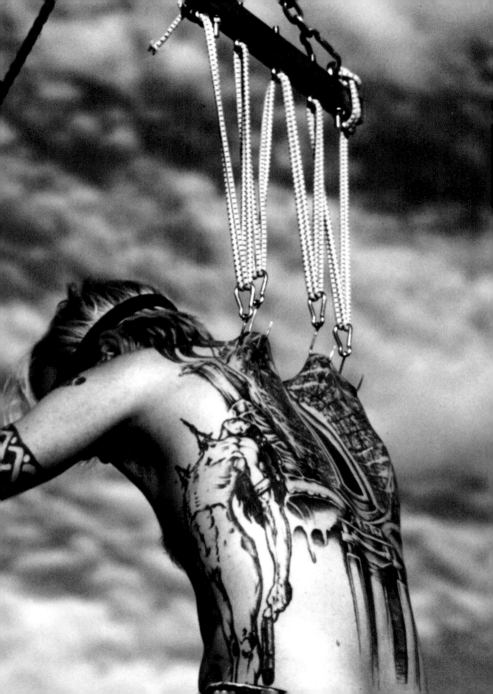

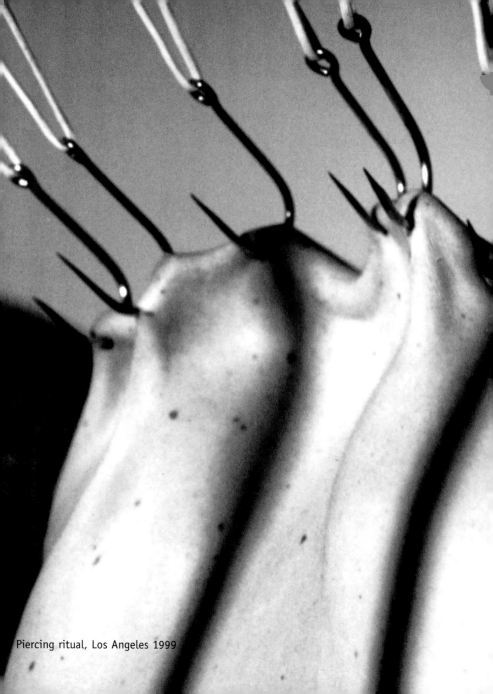

Piercing ritual, Los Angeles 1999

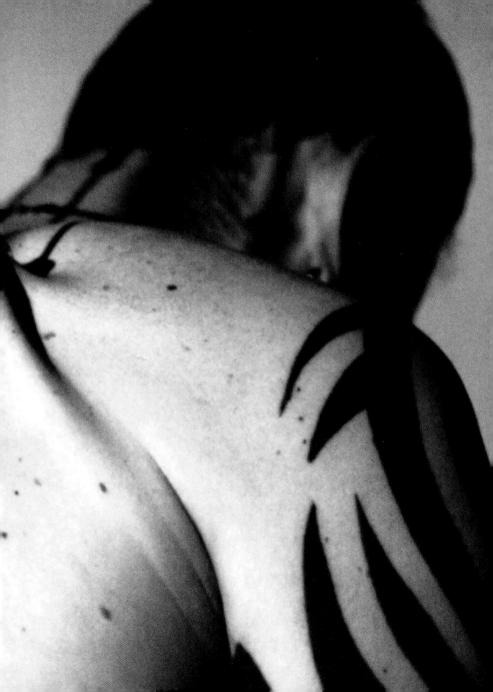

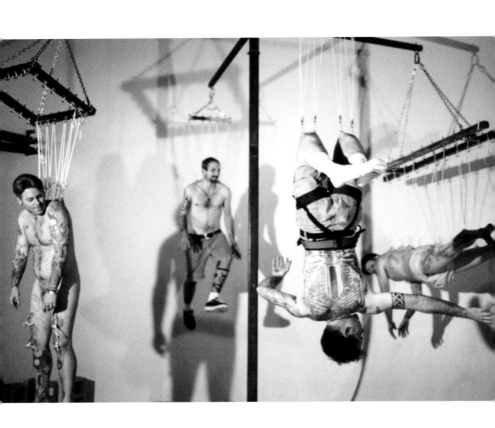

Piercing Ritual, Los Angeles 1999

250

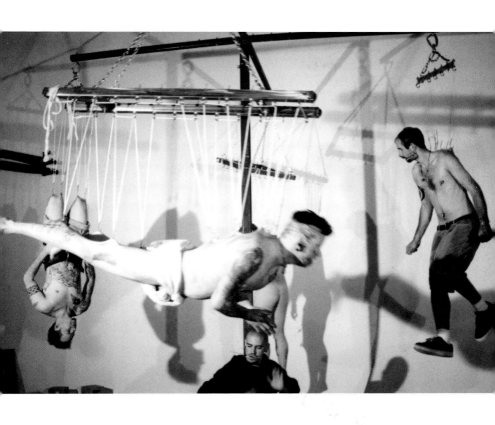

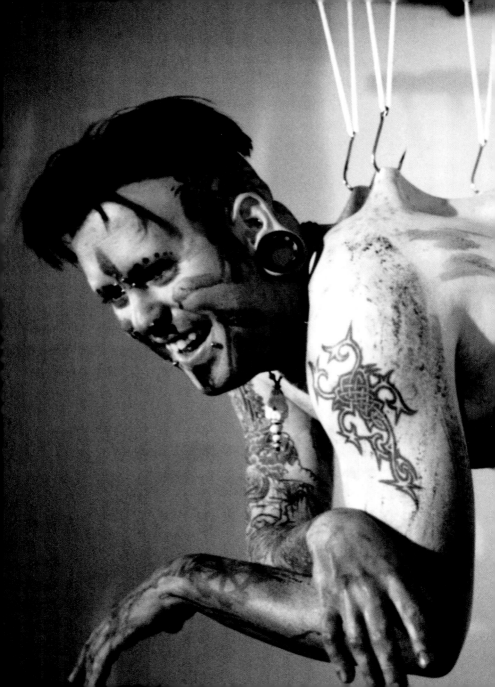

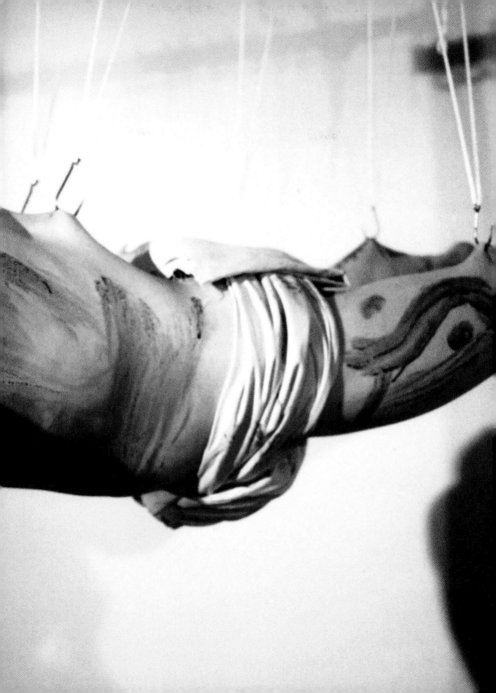

Tattoo

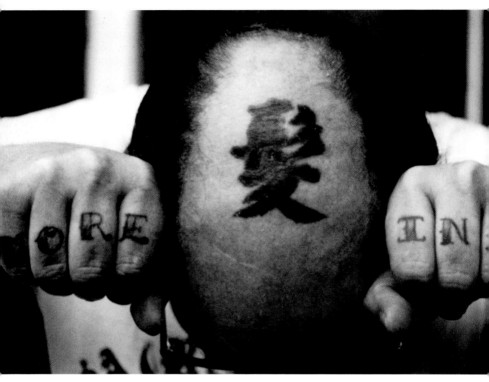

Porthos, San Francisco 1999

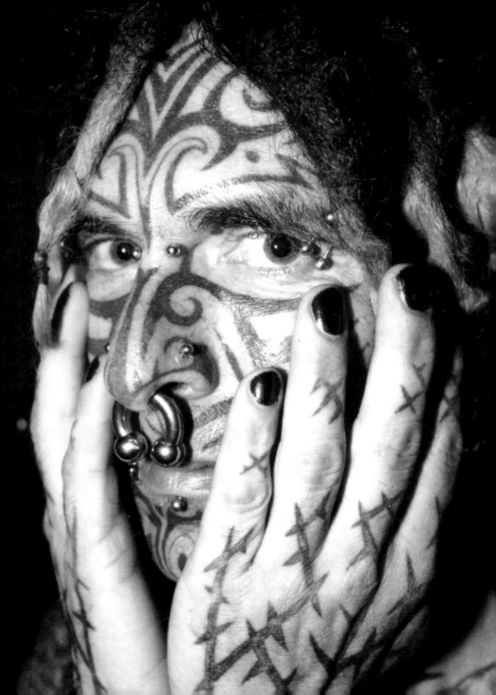

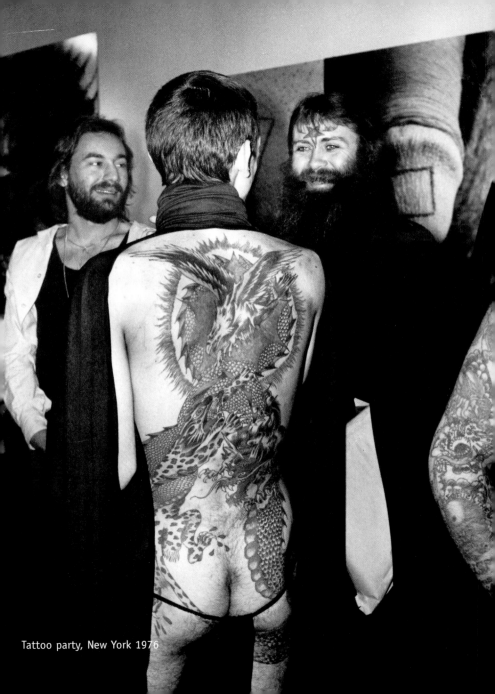

Tattoo party, New York 1976

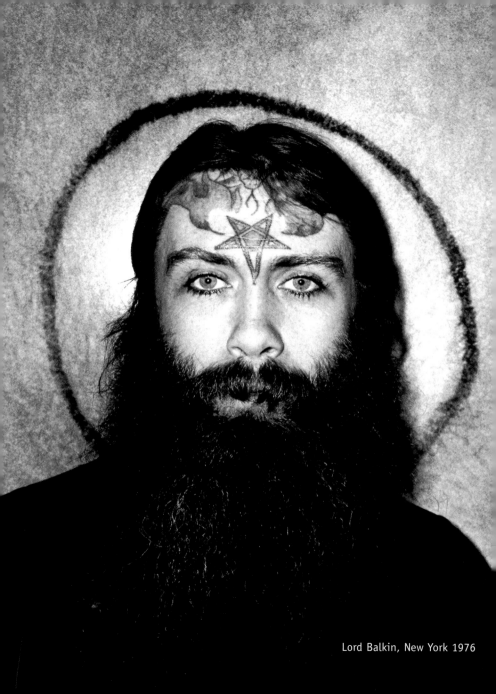

Lord Balkin, New York 1976

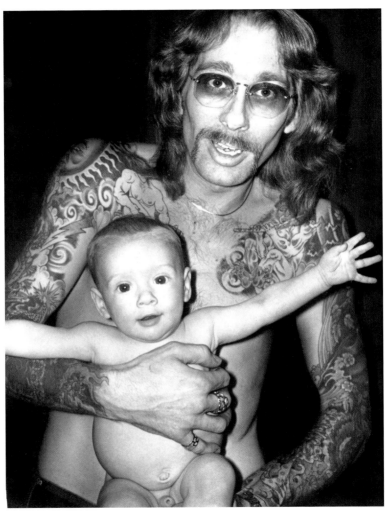

Tattoo Convention, Minneapolis 1978

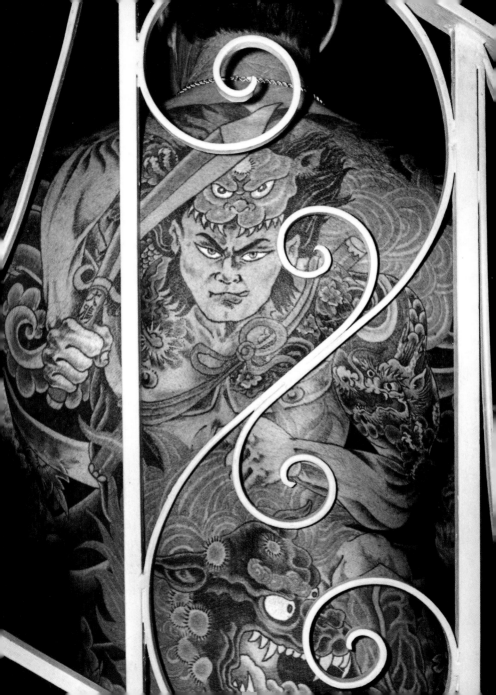

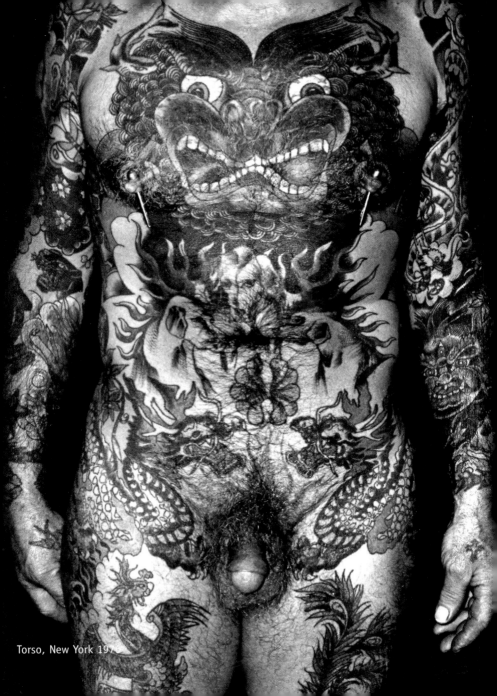

Torso, New York 1976

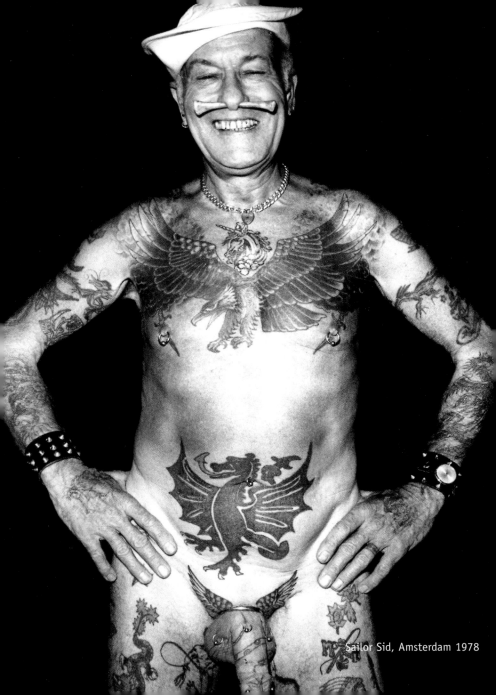

Sailor Sid, Amsterdam 1978

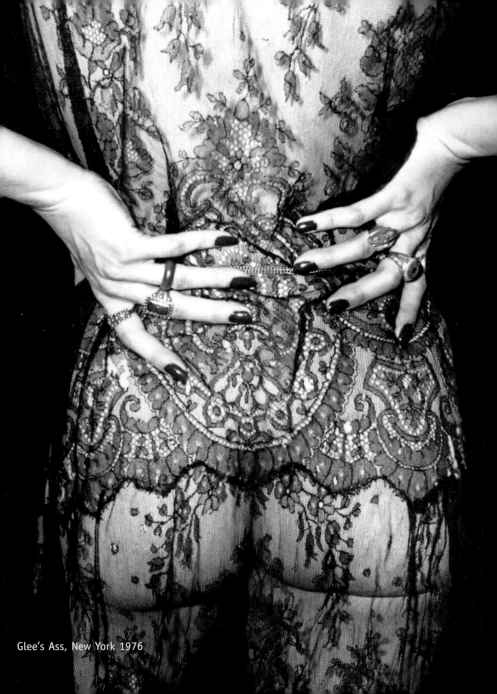

Glee's Ass, New York 1976

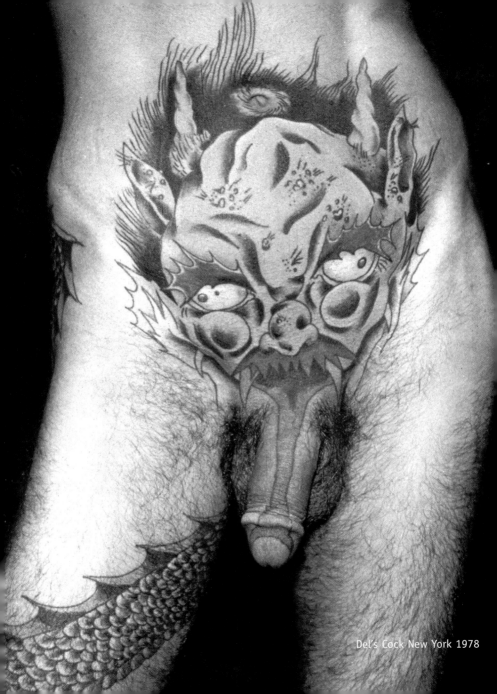

Del's Cock New York 1978

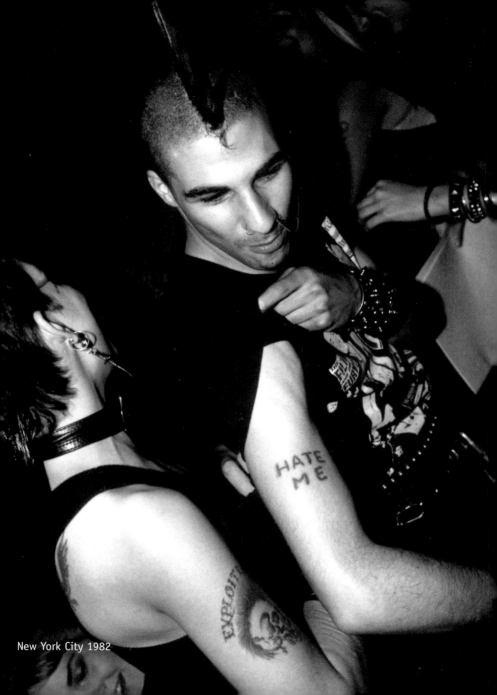

New York City 1982

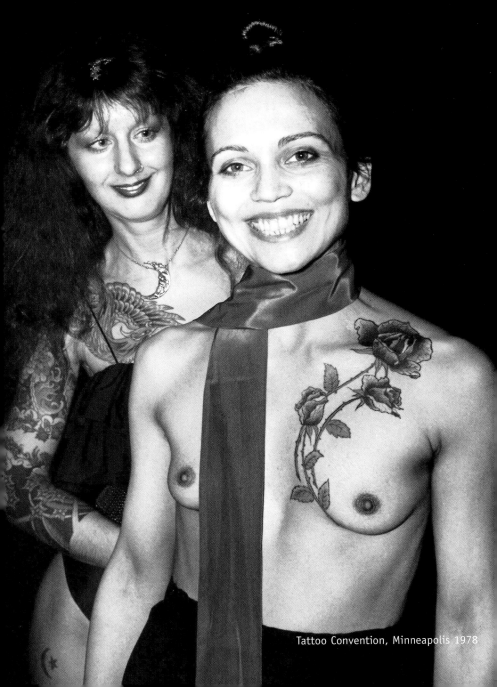

Tattoo Convention, Minneapolis 1978

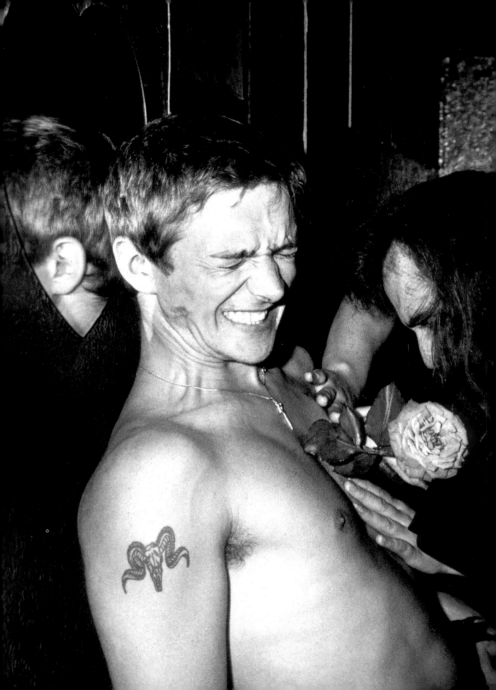

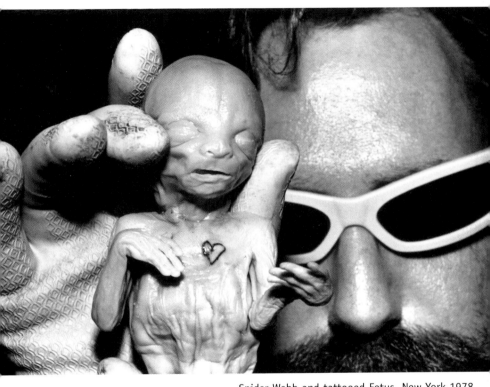

Spider Webb and tattooed Fetus, New York 1978

der Webb gives Hanky Panky the „Rose Tattoo", Amsterdam 1978

Marco Vassi, Woodstock 1980

Jimi, New York 1

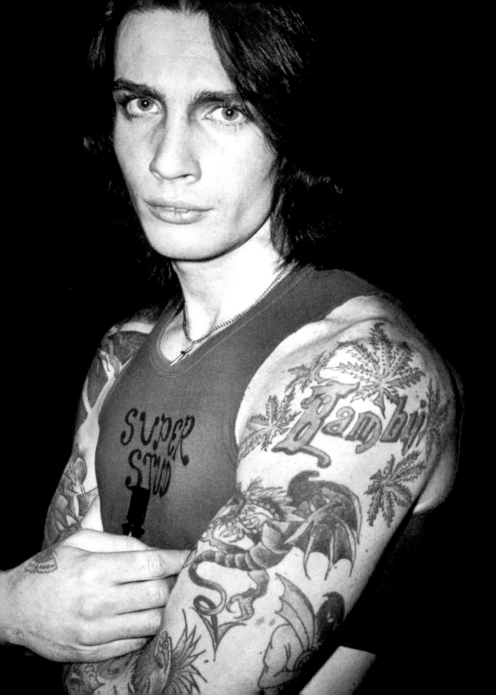

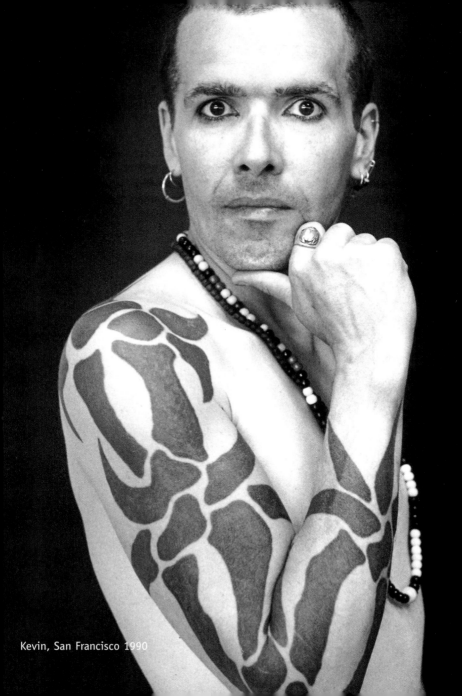

Kevin, San Francisco 1990

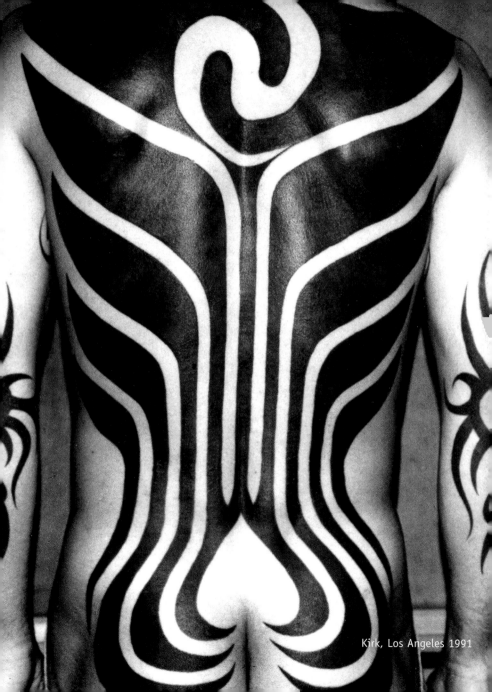

Kirk, Los Angeles 1991

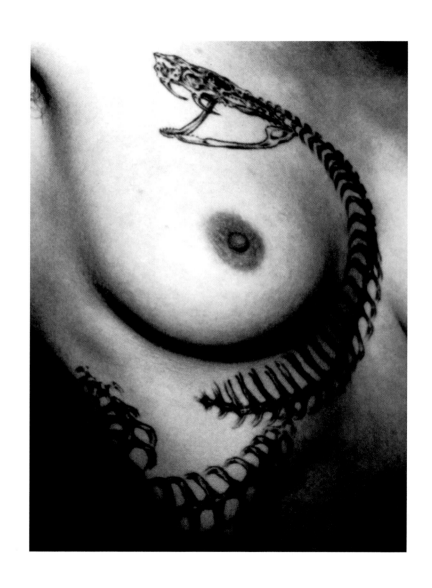

Sharee, San Francisco 1989

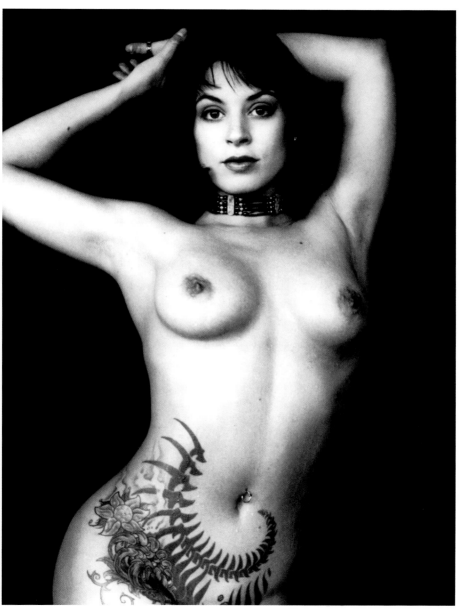

Jill, San Francisco 1993

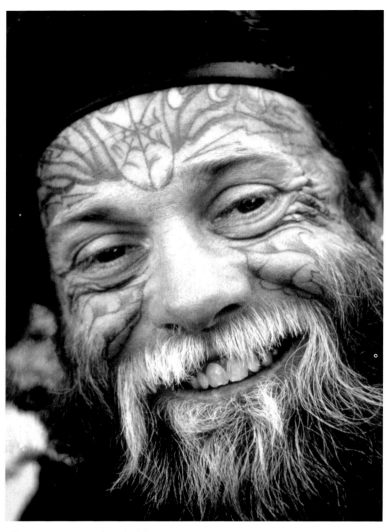

Biker, Daytona Beach - Florida 1994

Biker, New Orleans 19

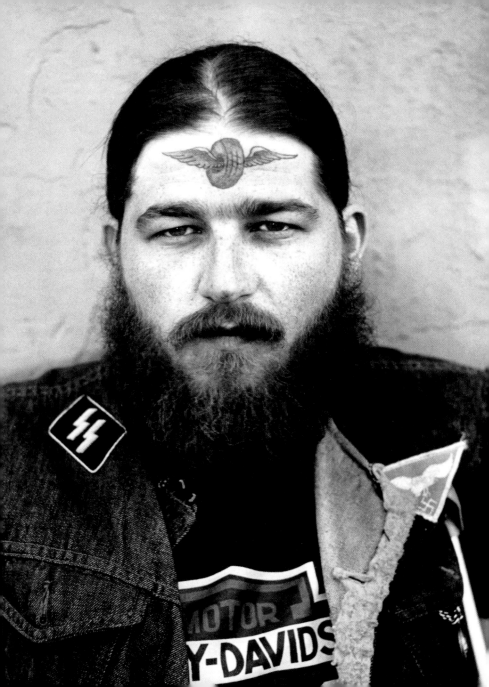

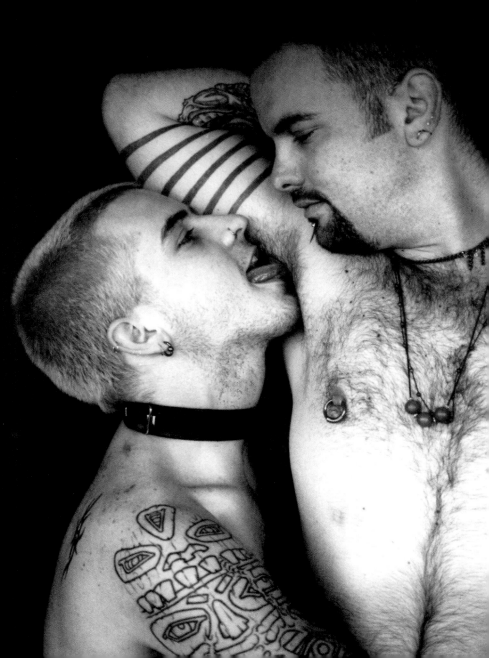

Sharee, San Francisco 1989

ın and Scott, San Francisco 1993

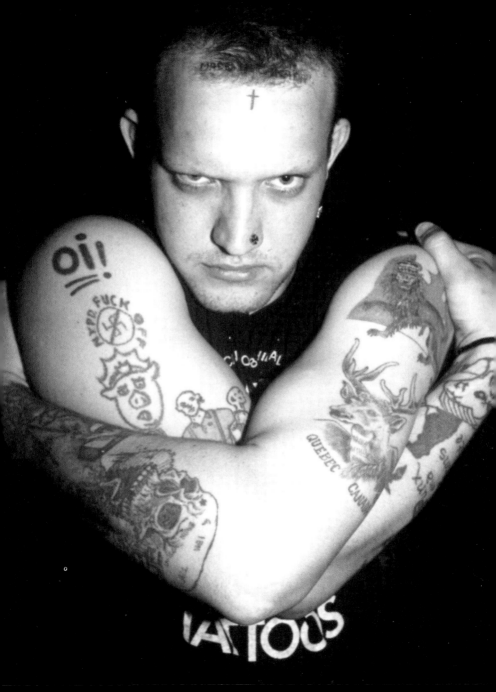

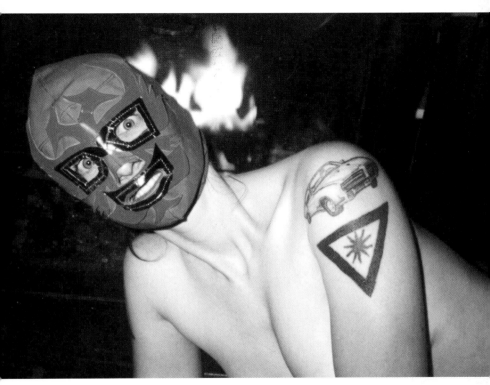

Julee, San Francisco 1998

w York 1994

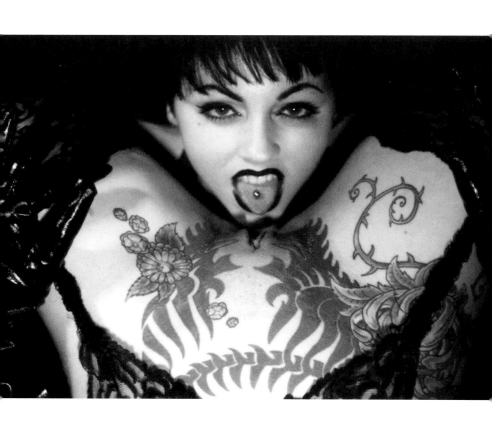

Maria and Jill, San Francisco 1995

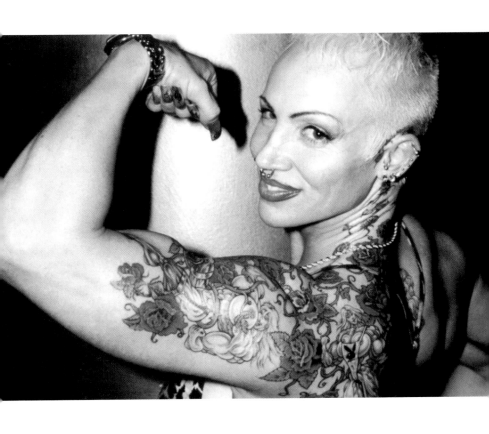

Dawn, New York 1999

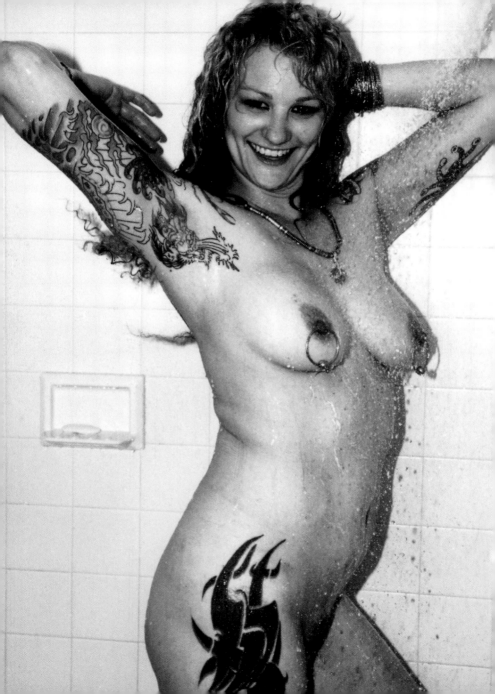

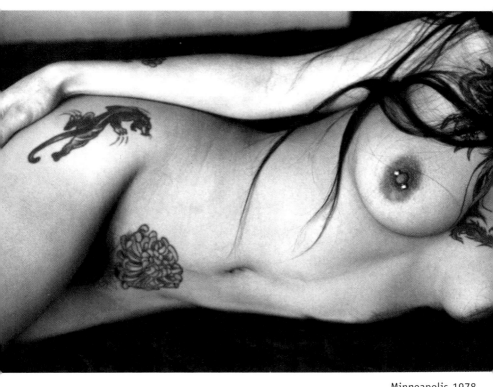

Minneapolis 1978

ette, New Jersey 1995

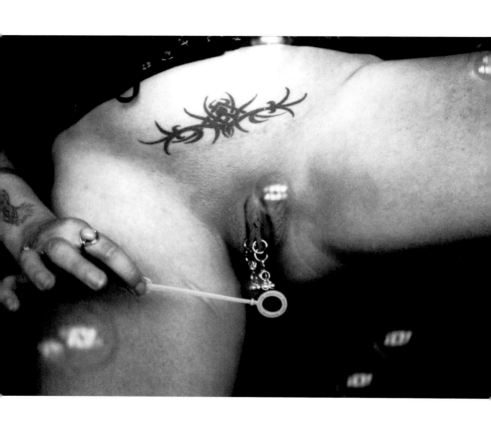

Amazing Grace, San Francisco 1995

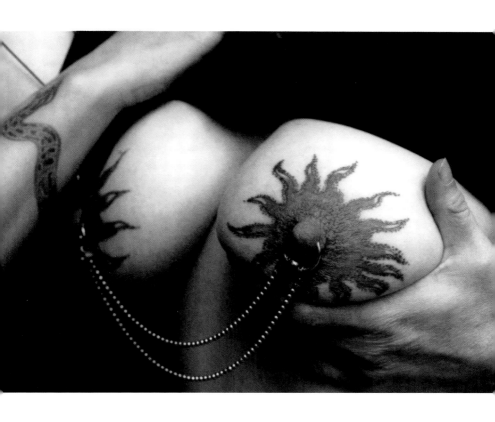

Flaming nipples, Amsterdam 1996

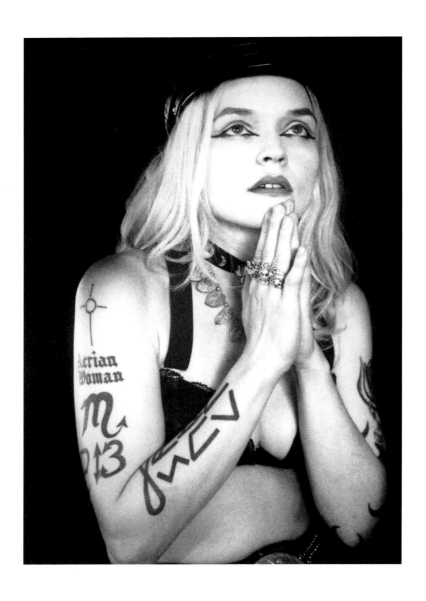

Angel, San Francisco 1991

Tattoo party, Hollywood 19

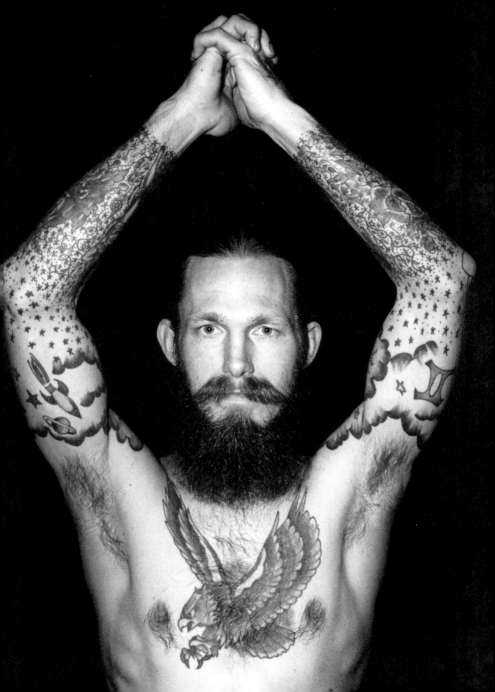

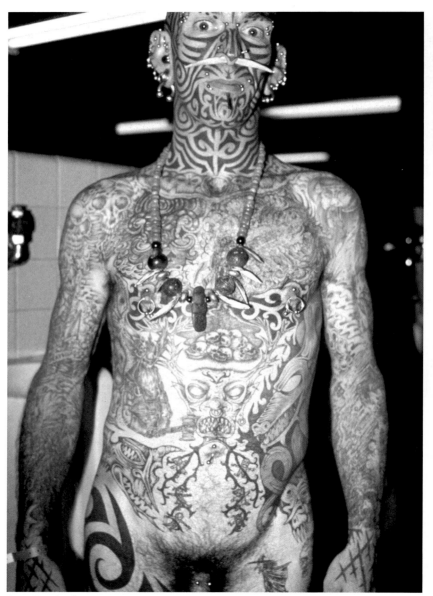

Tom, New York 1999

Mallory, New York 1

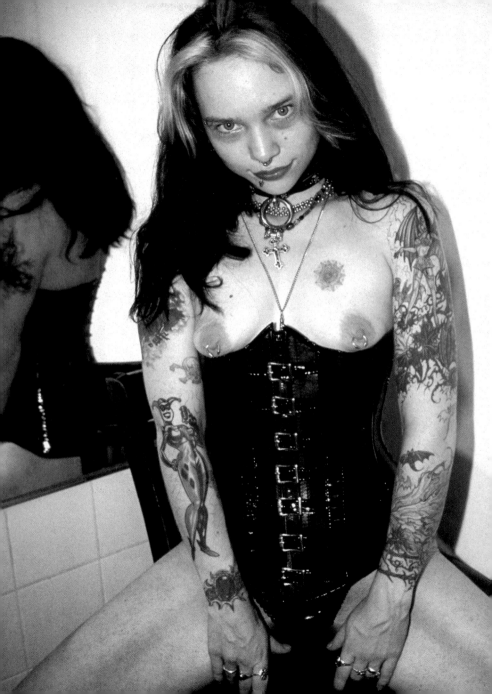

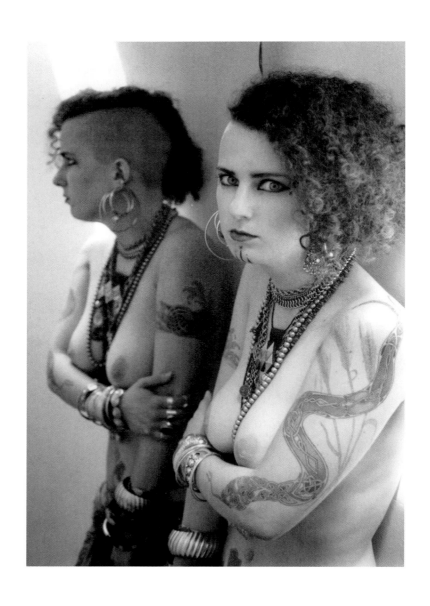

Theresa, San Francisco 1

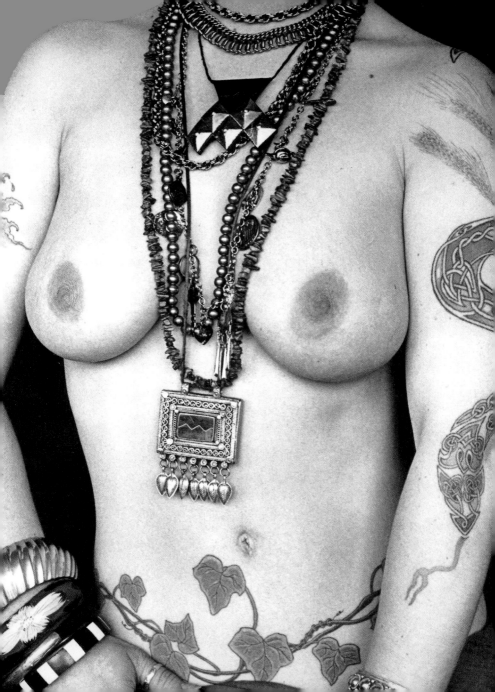

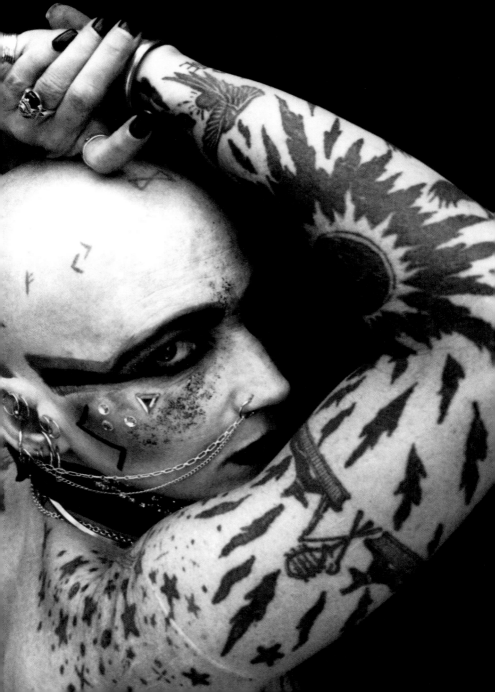

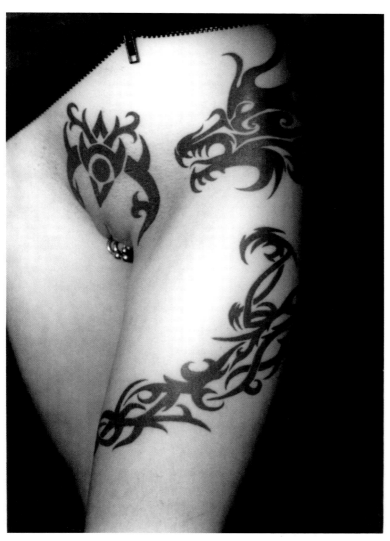

Michelle, Seattle 1993

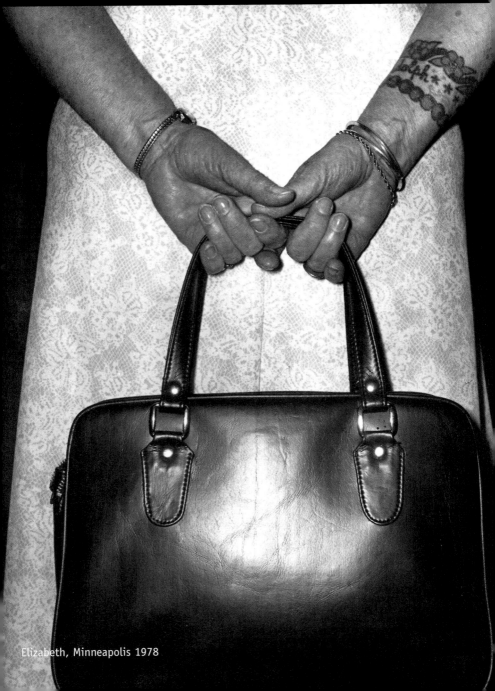

Elizabeth, Minneapolis 1978

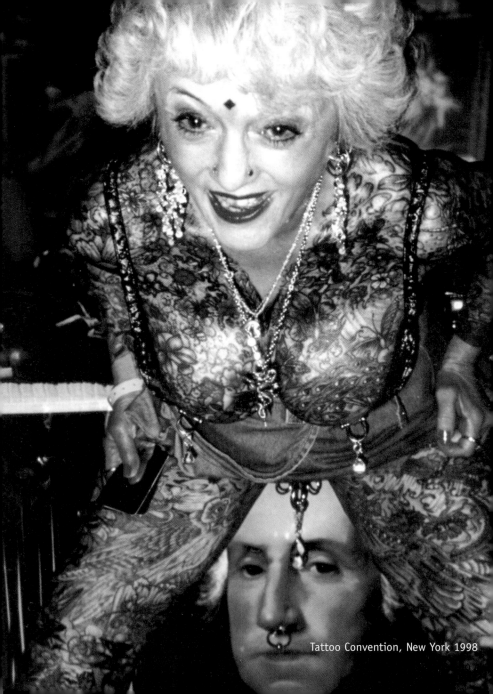

Tattoo Convention, New York 1998

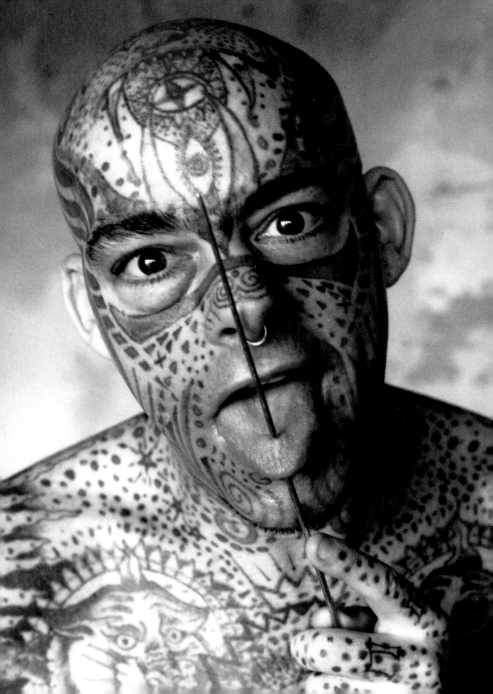

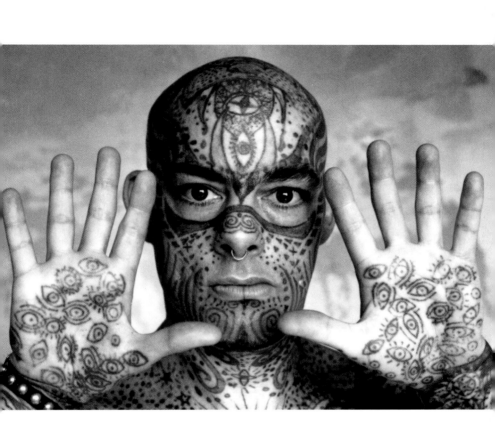

too Mike, New York 1994

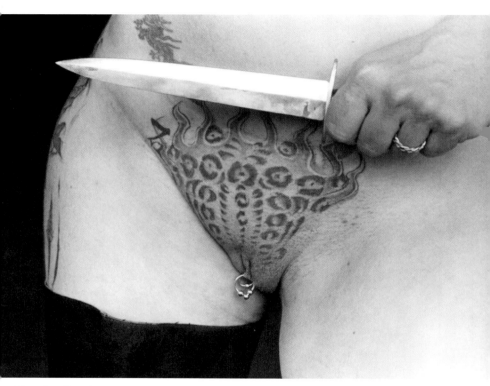

Rita, San Francisco 1991

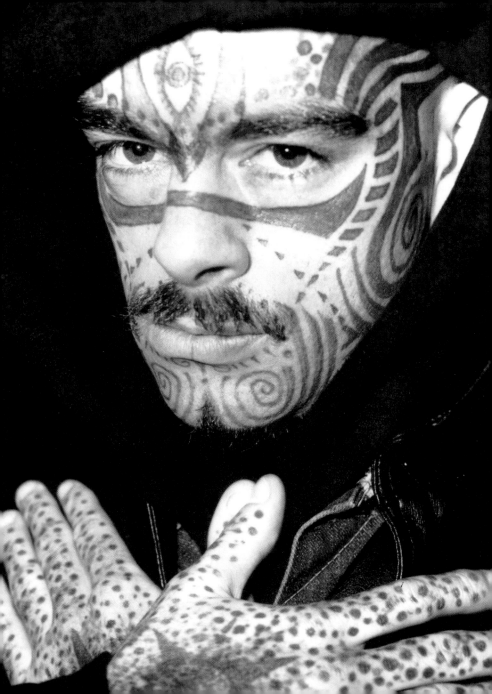

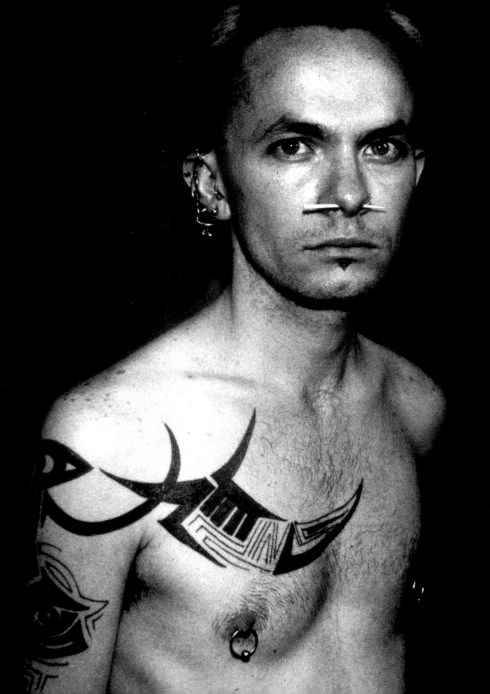

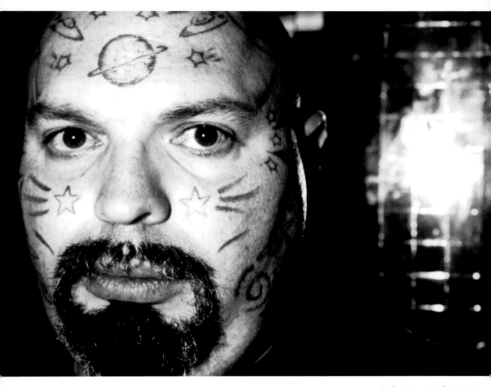

Eak, New York 1999

too party, New York 1989

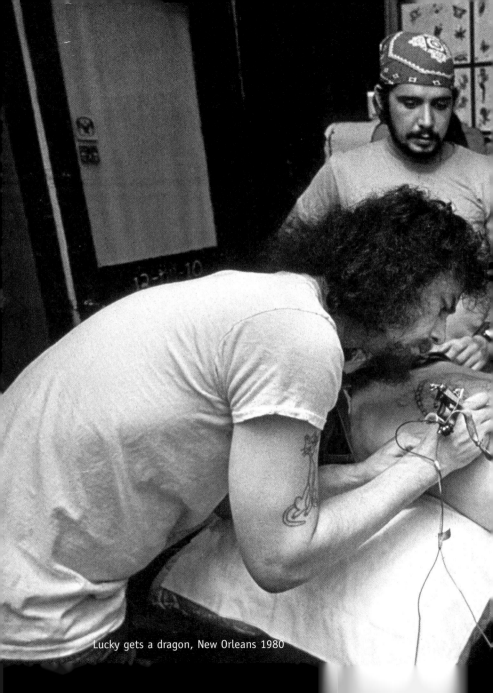

Lucky gets a dragon, New Orleans 1980

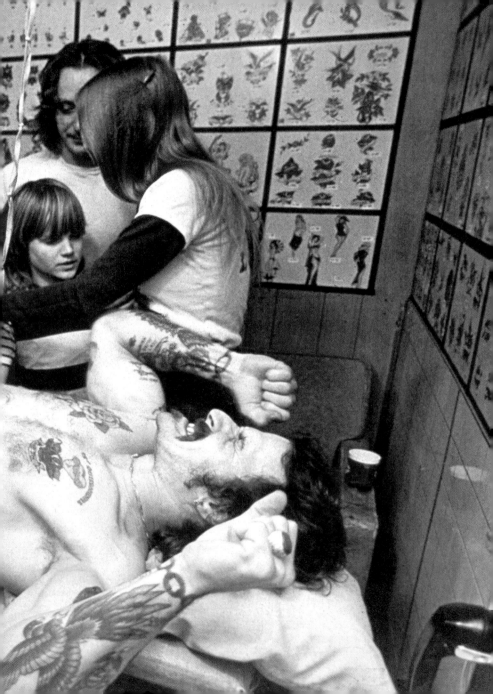

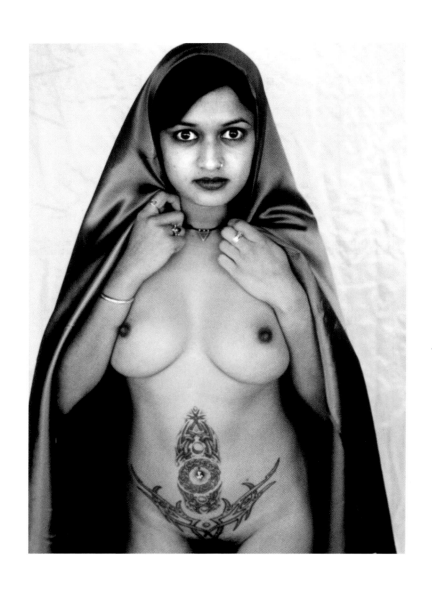

Ami, San Francisco 1994

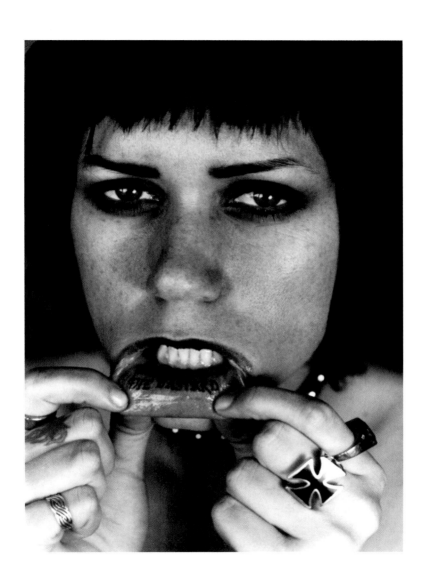

Tonie, San Francisco 1998

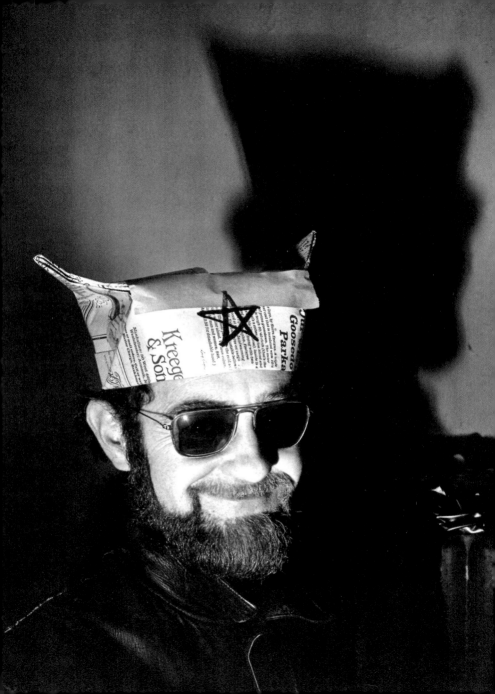

Charles Gatewood
interview

by Paul Benchley

- portrait, New York 1979

Q: Your work is so unusual - what compelled you to photograph all those strange situations?

CG: There´s a famous quote from Flaubert: "One does not choose one´s subject matter - one submits to it". I never had to think about what I wanted to photograph. It was the Sixties. There were anti-war protesters and Hell Angels and Black Panthers and crash pads and naked hippie chicks, and when I moved to New York City in 1966 I found myself right in the middle of it all. I began photographing alternative lifestyles, and that´s what I´m still doing.

Q: How is your fascination with strangeness different from thill-seeking sensationalism? Are you trying to shock people, or is there more to it?

CG: My first impulse was to document what I was seeing. Some of my motivations were sensational, but as I became involved with my subjects I found deeper meanings. My work has changed my thinking tremendously. This kind of work also makes me HIGH. I enter secret societies, magical worlds. It´s excited and creatively challenging. It´s fun!

Q: There seem to be certain subjects that give you this special feeling.

CG: Yes, certain subjects thrill me: tattoos, piercings, sexual weirdness, exhibitionism, fetish, anything forbidden. I also get high at scenes like Mardi Gras. I´m excited by the crazy energy of the costumed crowds. Imagine a million highly decorated drunks at one big street party - I love that kind of energy.

Q: How does it feel to be a voyeur, watching and recording other people´s lives?

CG: Well, I obviously like what I call "eyeball kicks". I love to watch. However I,m not only playing on that level - it´s just one level, one of many. The word voyeur means a "peeping Tom", one who gets sexually excited watching people do erotic things. It´s a shallow concept. I like to watch, sure, but on several levels at once. There´s an old English word - seer - meaning a person who sees deeply into things. I prefer that term, because it implies wisdom and understanding. Remember, my academic background is Anthropology, the study of human behavior. At the university, I was trained to go into the field, observe, record, and report back on what I´d seen. And that´s exactly what I do.

Q: What works have influenced you?

CG: In college I was very influenced by *The Family of Man* - a book of documentary photography - and by a weird Italian documentary film called "Mondo Cane". I love W. Eugene Smith´s classic photographic essays. Later I discovered the photography of August Sander, Brassai, Bill Brandt, Robert Frank and Diane Arbus, Then there were writers: Henry Miller, Norman Mailer, Hubert Selby Jr., Jack Kerouac, William S. Burroughs. Underground comics also influenced my early style - a lot of pictures in my first book, *Sidetripping*, remind me comic strip panels.

Q: How did you meet William Burroughs?

CG: I knew a writer named Robert Palmer who was a huge Burroughs fan. He persuaded *Rolling Stone* magazine to send him to London to interview Burroughs, and he invited me to come and take the pictures. I brought a dummy of *Sidetripping,* showed it to William, and ask if he would write text for the book. It blew my mind when he agreed.

Q: You don´t look so weird yourself. Why not?

CG: Burroughs wore three piece suits, yet he had one of the most radical minds on the planet. if you´re conservative in your appearance, you can access many worlds,

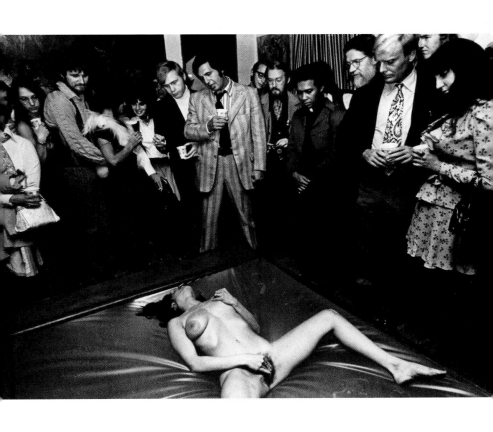

Gallery Opening, New York 1970

not just few. Often it´s best to fit in, be invisible. Looking weird can be very limiting for a reporter.

Q: What´s the story behind your famous shot of the woman masturbating for an audience at an art opening?

CG: The woman - wife of an artist friend - was doing an "erotic dance" on a water bed. Loud music was playing. The room was dark; she was in silhouette against bright colored lights inside the bed. I bounced a flash off the ceiling, wich captured everyone´s expressions. Only my camara saw it my way.

Q: Is that objective?

CG: No, it´s poetic. Your point of view depends on what you leave out, what you choose to take, and how you take it. In *Sidetripping*, for example, I used certain photographic tricks to make the images more savage, like the distortion of extreme wide angle lenses. I often also held the flash low, off camera, to give a kind of demon light. Very effective.

Q: Speaking of techniques, what films and cameras do you use?

CG: My early work was all done with Leica cameras and wide angle lenses. Today I use mostly Canon F-1´s and my normal lens is a 50mm macro. As for films, I formerly used fast films a lot (400 ISO, often pushed to 1000 or more), but today I prefer slow films (100 ISO), developed normally. Except for a hand-held Vivitar flash, I rarely use lights. I prefer natural light, especially north light, window light, and skylight.

Q: As an artist, do you find it difficult when people don´t understand the real threats of censorship?

CG: Of course. Censorship stinks. I´ve been censored many times. My latest book, *True Blood*, has been banned in five countries. I´ve fought for free expression and I admire others who have too, like Annie Sprinkle, Marco Vassi, Michael Perkins, Hugh Heffner, Lenny Bruce, Larry Flynt. Of course the battle continues, and I´m proud to be part of it. One of my main themes is transcendental liberation - and repression and liberation don´t mix.

Q: In your book *Forbidden Photographs*, you mention personal fantasies of transcendence, and having paid the full biologic price for all the "real experience" a body and soul could handle. How do you define "real experience"?

CG: Have you ever had experiences that were so deep and profound they shook your soul? I like to live intensely and passionately, so that when my time comes I can look back and say I´ve truly LIVED.

Q: How can piercing one´s penis, for example, be liberating?

CG: In the radical sex community, I hear people describing epiphanies all the time. They describe transcendental peaks, physical and psychological spaces they´ve explored. I call them astronauts of inner space. They use ancient techniques of trance and ritual and pain to attain altered states of awareness.

Society often tells us that our bodies are inherently sinful. That´s a false message. Piercing one´s genitals can be a way of affirming and reclaiming physical and sexual freedom. The act reminds us that our bodies belong to us - not the church, not the state, not our parents. As Fakir Musafar says, "It´s your body - play with it".

Q: How much of this have you experienced personally?

Burning Man, Black Rock Desert - Nev

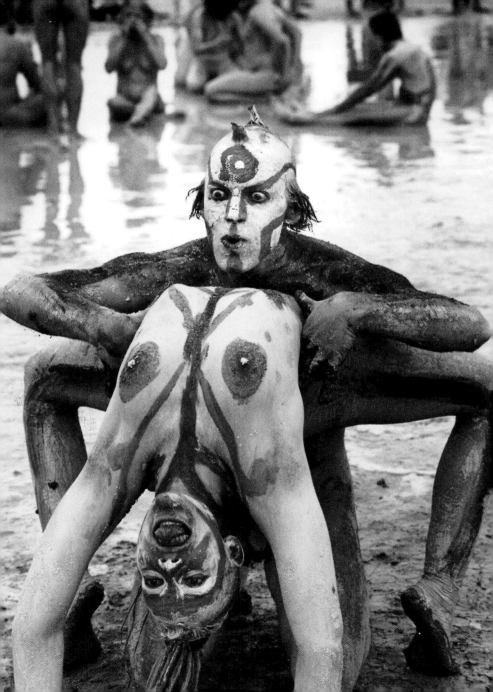

CG: I´m tattooed, and I´ve participated in a lot of elaborate S/M play and joined a lot of pagan rituals. One of my most interesting experiences was joining a "ball dance" during Fakir Musafar´s Ecstatic Shamanism Workshop. For two days we heard lectures about changing consciousness. We saw demonstrations of bondage, suspension, witch´s cradle, bed of nails, bed of blades, and so on. At the end of the workshop, Fakir pierced all of us. He pinched the skin above my nipples and pierced me with a large needle. It hurt, and I screamed. Then Fakir sewed large rubber balls with bells at the bottom, into my skin. Soon there were thirty of us, dancing to drums and chants. We all became extremely high from the endorphin and adrenalin rush, and from the incredible group energy. It was so exhilarating!

Q: So one can learn from pain?

CG: Yes indeed. There are many spiritual traditions that explore dark and dangerous paths. An important principle in paganism is to balance dark and light. Many people deny their dark sides, yet we all have darkness in us. It´s healthy to explore, to integrate light and dark, instead of trying to repress those dark instincts. Rituals provide a safe and supportive way to further those explorations. I was nervous about participating in the ball dance, and I found it paintful at first. But afterward I felt just great. I found the ritual to be empowering, cathartic, transformative.

Q: Tell us about the "new tribalism" mentioned in *Modern Primitives*.

CG: Modern society can make us feel weak and isolated, but as we connect with other conscious spirits we can regain our power. On the other hand, a tribe can mandate very rigid conformity. If you don´t fit in, you can be forced out into the cold. How can one be a rebel in a tribe? It´s an interesting paradox, and it´s a challenge to enjoy the support system and still remain a creative and free-thinking individual.

Q: What´s the weirdest place you´ve ever been?´

CG: San Francisco.

Q: Why San Francisco?

CG: The alternative communities are so huge here, so deep, so fascinating. There´s a whole new level of wonderfully strange behavior, including artistic and innovative tattoo work, elaborate and innovative piercings, cutting, branding, blood sports, and S/M and pagan activities. A lot of this is done in elaborate rituals - profound, deep, and spiritual - well thought-out and well executed. Many of these rituals facilitate true personal transformation and inner growth. I find that very important, even though to the straight world it looks weird as hell.

Q: Isn´t some of this activity just a passing fad, a trend?

CG: Yes and no. Much of it is deeper. During a recent ritual, a man I know had a large footprint of a bear cut into his back. The bear is his totem animal; he wanted a big scar to mark and commerate the ritual. For others, body modification can be part of a rite of passage. In primitive cultures. when you reach a certain age, you commonly receive some physical experience as an initiation. Suddenly you´re no longer a boy - you´re a Man.

It´s been called "ritual wounding". Your body receives marks that show that you´ve changed. A symbolic opening is created. You realize your vulnerabilities and your strenghs. You feel a strong bond with the others involved in ritual. And you´re experiencing this directly,

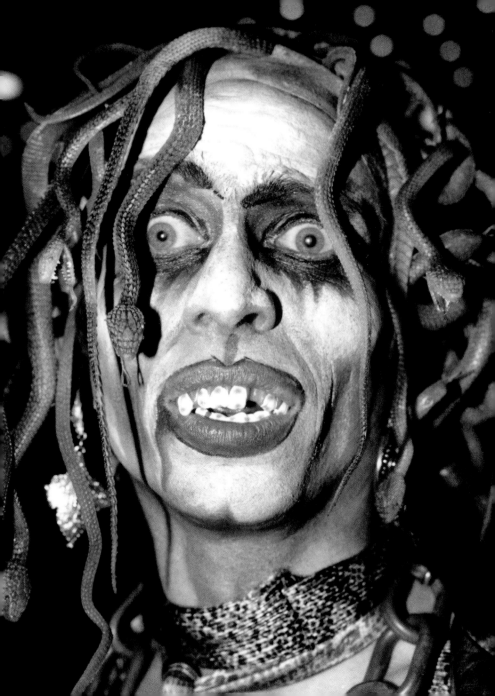

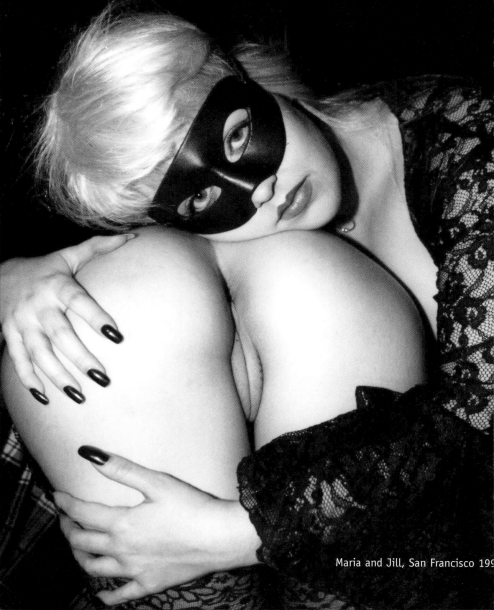

Maria and Jill, San Francisco 199

not watching it on television. That's important, because we get so much of our so-called experience second-hand, from the media. After you participate in a good ritual, television seems so silly!

Q: Do you try to show these deeper meanings in your photographs?

CG: Of course, and in my videos and writings as well. I want to show that there's a lot more going on than people think. Many people imagine my subjects are stupid, or crazy. Some of them are, but many are smart, conscious people searching for new means of expression. Hopefully my work will open some new possibilities to the viewer.

Q: How does sex fit into your work? Your photographs include a lot of sexual energy, yet you haven't published many photographs of people actually having sex.

CG: As you know, sex is about a lot more than putting the peg in the hole. I'm certainly drawn to erotica, yet I think of myself more as a photographer of the forbidden, where people are encouraged to drop their masks and show their true selves. There is, obviously, sexual energy in my work. It may be the excitement I feel when I see leather or piercings or spike-heeled boots. It may be outrageous sexual posturing, certain looks and stances that say, "Hi there; I'm alive and I'm erotic. I'm vibrating in a certain way, and that makes you excited, doesn't it?"

Q: Does all your work contain sexual dimensions?

CG: A lot of my early work was more political, but much of my later work does contain erotic dimensions. When I photograph Mardi Gras, for example, I'll capture certain types of pictures and find a certain kind of buzz. My work is not about theory - it's about practice, immediate experience. That experience may be explicitly sexual; it may involve going to a pagan party and rubbing up against some latex or smelling some sweat. Other times, though, I get just as excited by the creative challenges - trying to get the composition just right, putting all those tones in the right place.

Q: Fetish has hit the mainstream. Why?

CG: People are exploring their fantasies, experimenting with things that were formerly taboo: cross dressing, sadomasochism, dominance and submission, and so on. And others want to look the part, even if they're not heavy players. Fetish toys are fun and exciting, and fetish gear is sexy and demands attention. It looks good, it feels liberating - and it's so damn shiny!

Q: Fetish and body modification are also being exploited by mainstream commercial interests.

CG: Any time these underground activities hit the mainstream, a lot of energy is released and a lot of money is made. Often it's disgusting, because the original impulse is watered down and cheapened beyond recognition. On the other hand, the ideas still have power, and some newcomers will find the real thing if they stick with it. Part of my job is to serve up these radical ideas and behaviors. Viewers are invited to make of them what they will.

Q: Any final words?

CG: I want to be an anthropological reporter, a romantic visionary who brings back reports from uncharted territory. My reports may come as quite a shock. But just as my work has changed my own life, the right aesthetic shock might just change your thinking - an indeed, your entire being - forever.

Fetish girl

Mountain girl, San Francisco 19

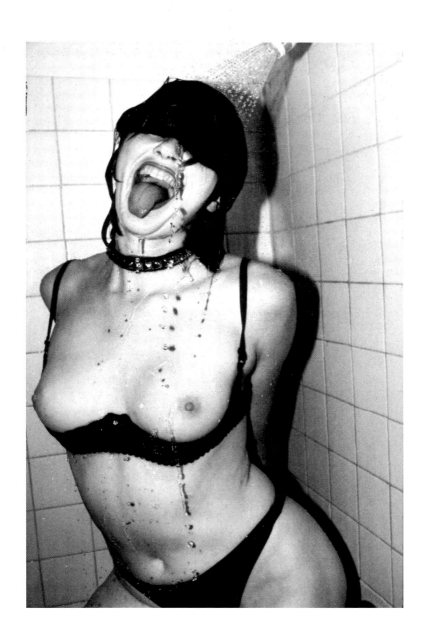

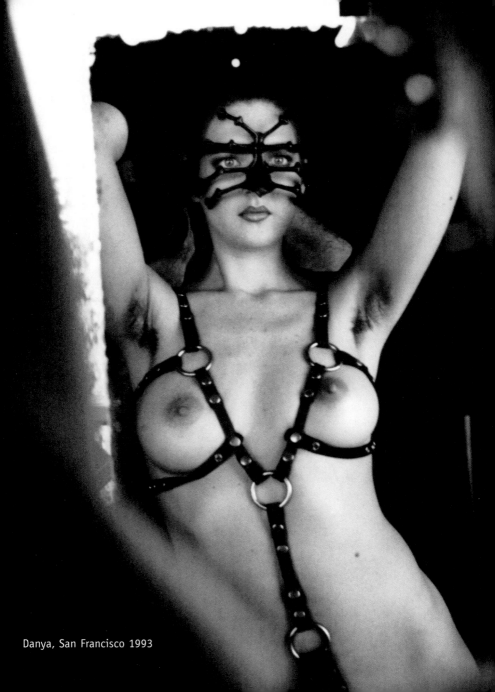

Danya, San Francisco 1993

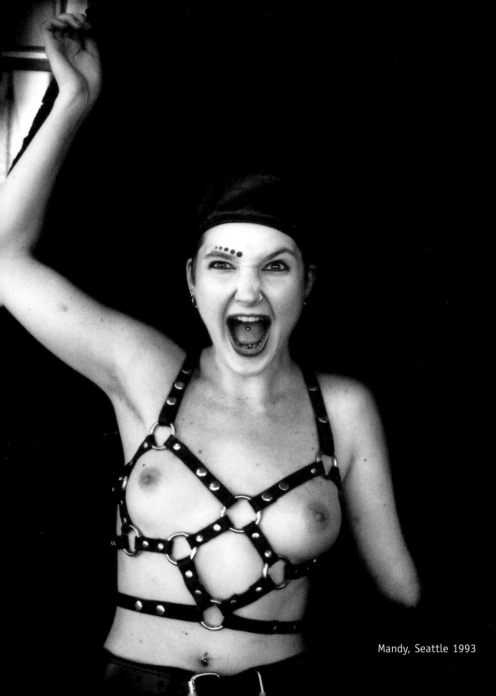

Mandy, Seattle 1993

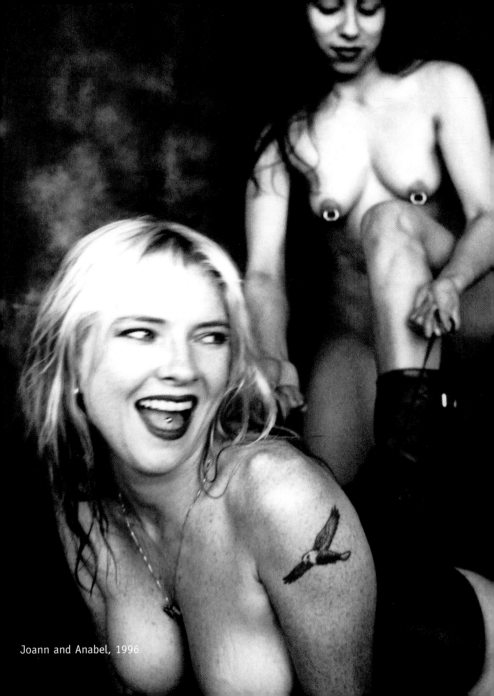

Joann and Anabel, 1996

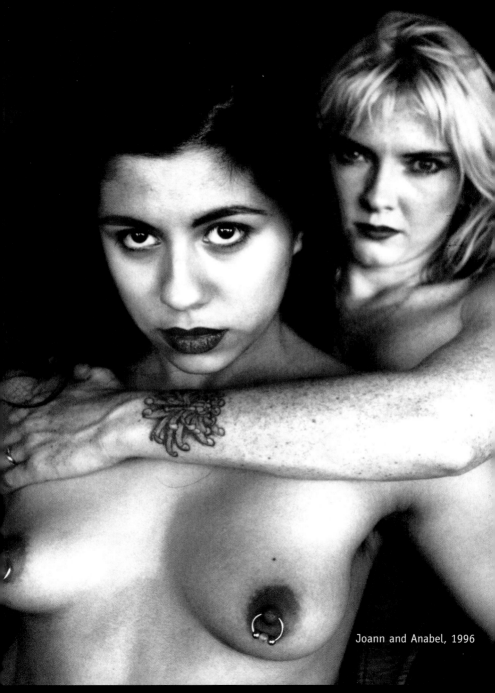

Joann and Anabel, 1996

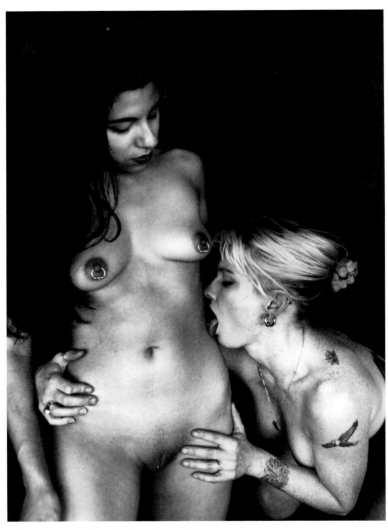

Johann and Anabel, San Francisco 1996

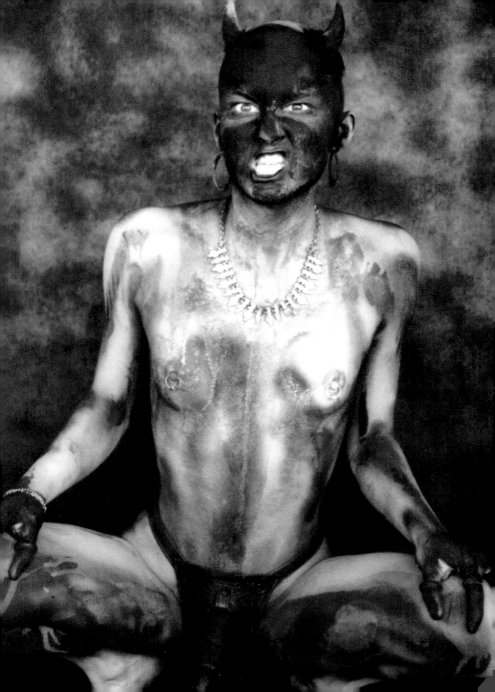

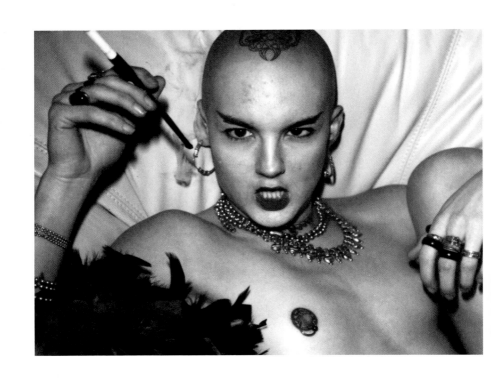

Star, San Francisco 1994

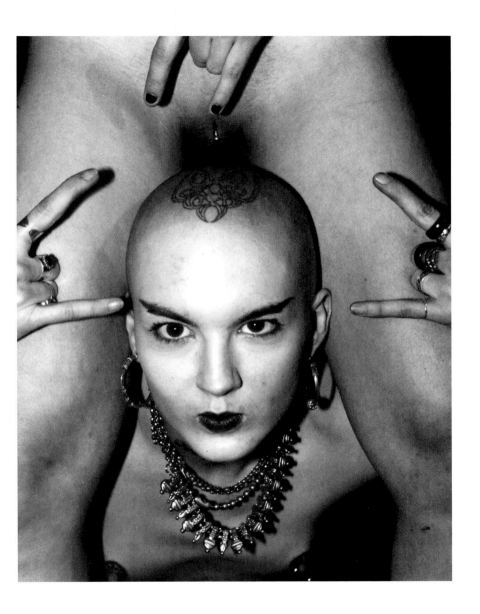

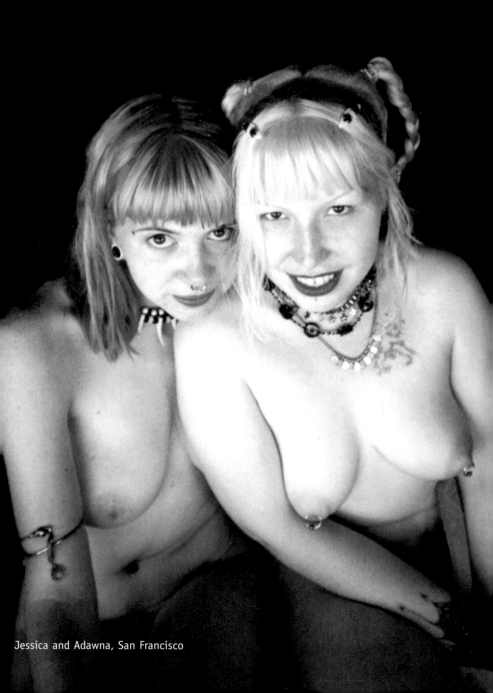

Jessica and Adawna, San Francisco

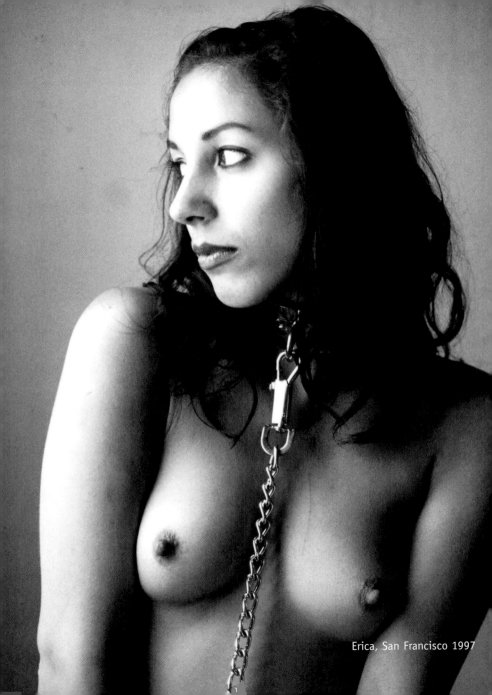

Erica, San Francisco 1997

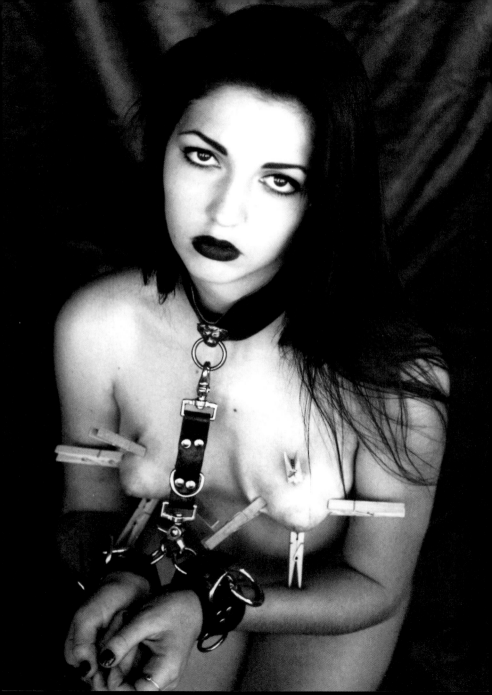

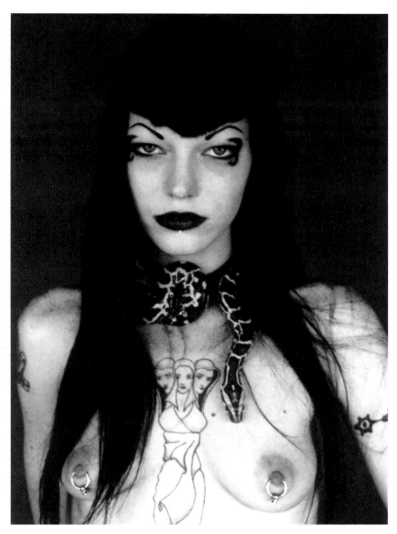

Stacee, San Francisco 1996

i, San Francisco 1997

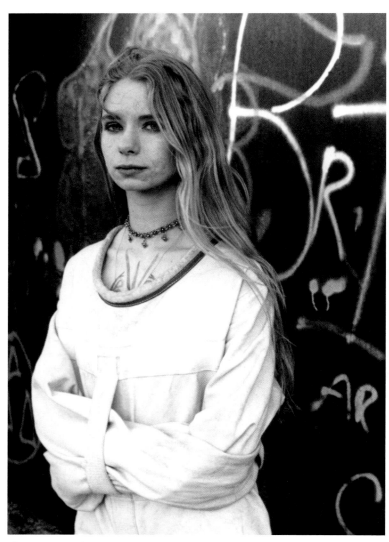

Bijoux, New York 1997

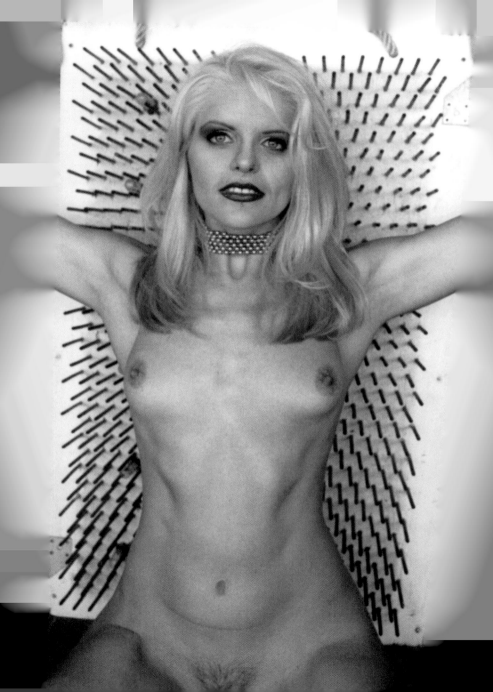

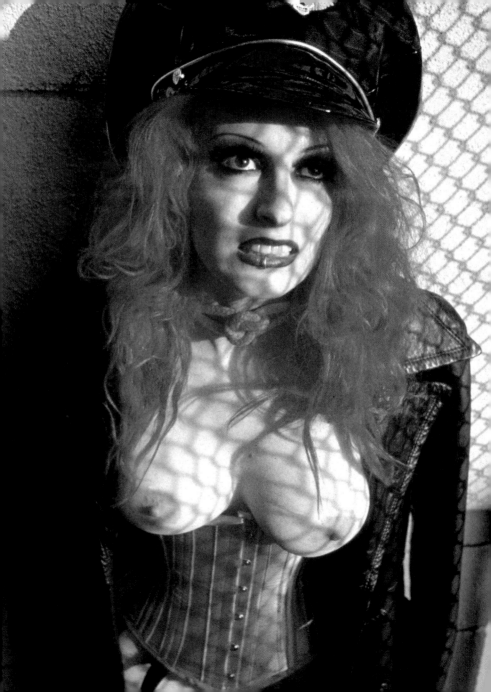

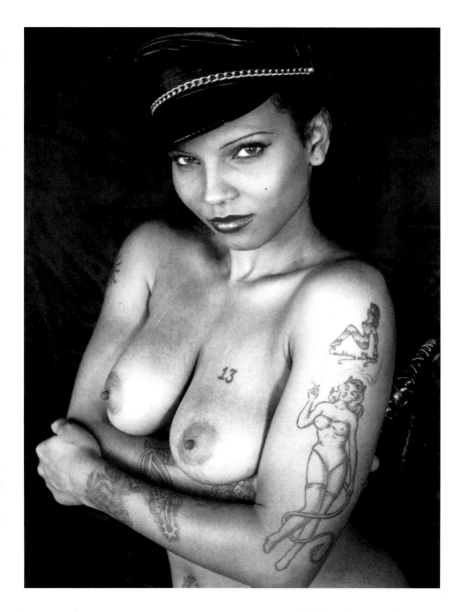

anda, Los Angeles 1999

Nicolette, San Francisco 1997

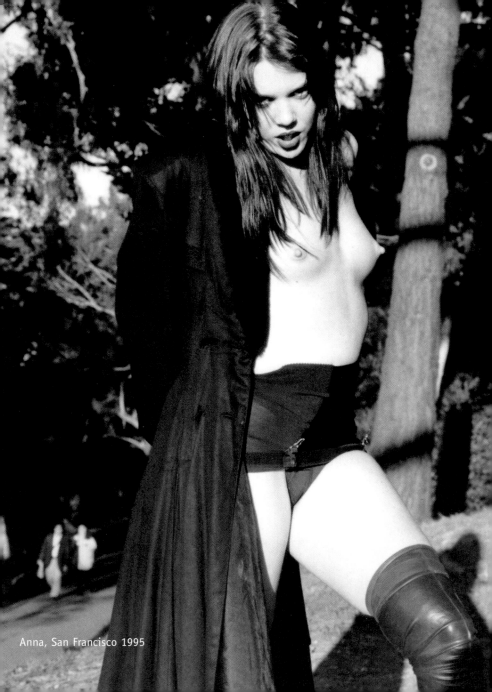

Anna, San Francisco 1995

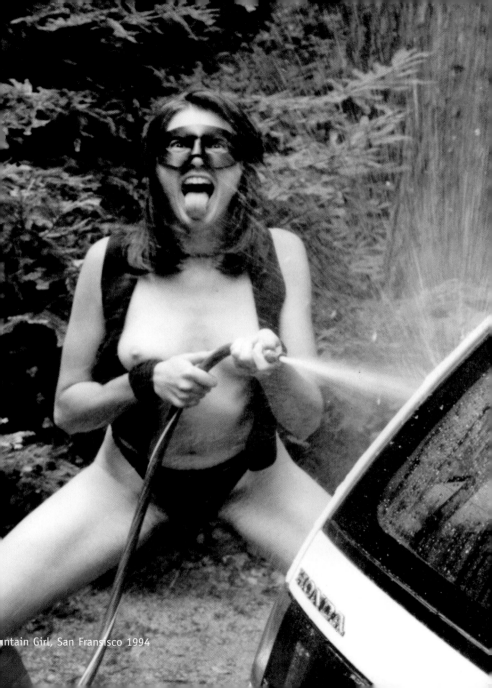

ntain Girl, San Fransisco 1994

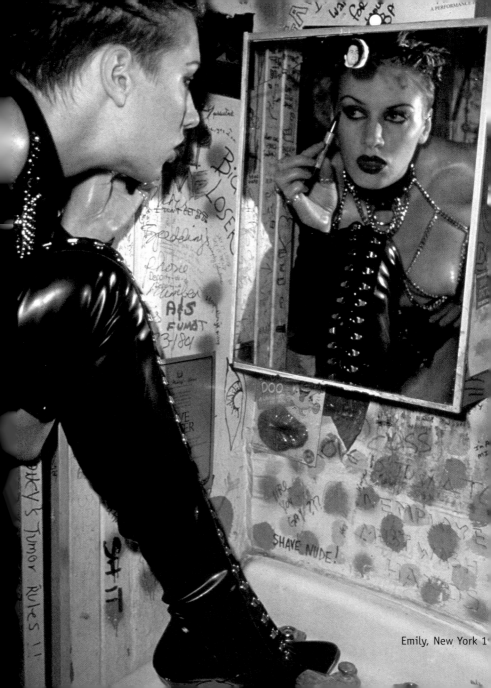

Emily, New York 1

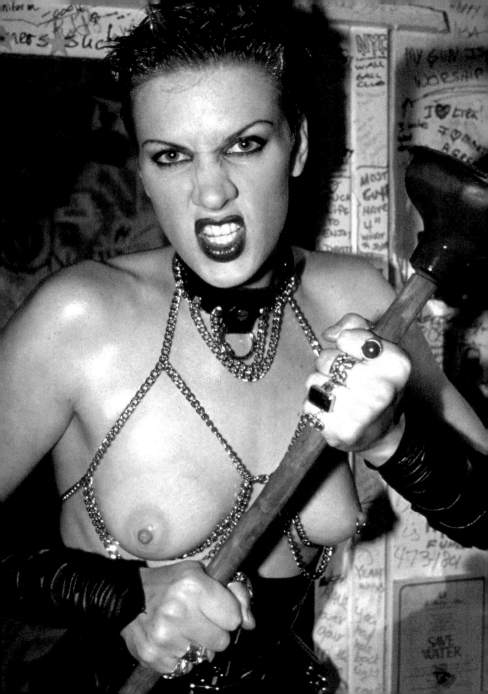

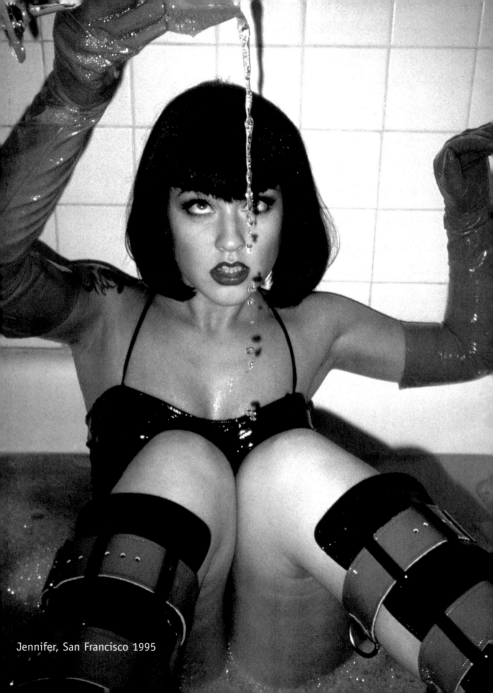

Jennifer, San Francisco 1995

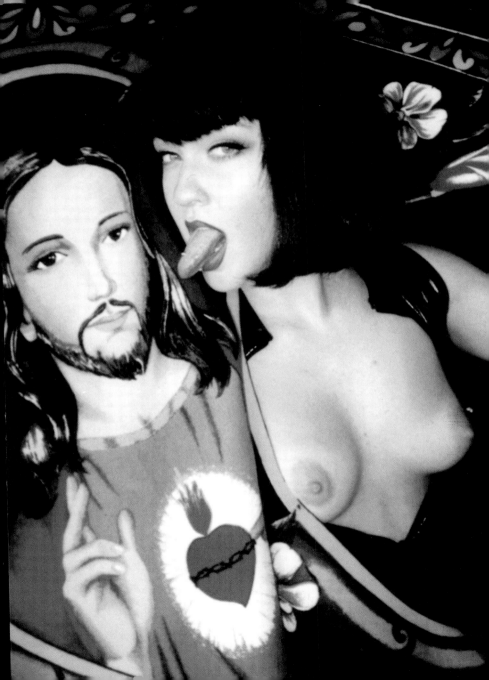

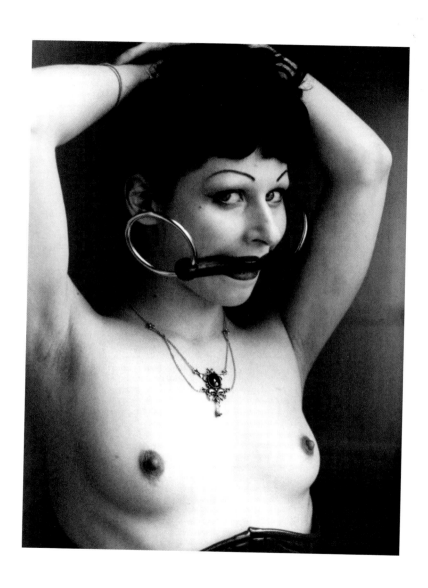

Pandora, San Francis[co]

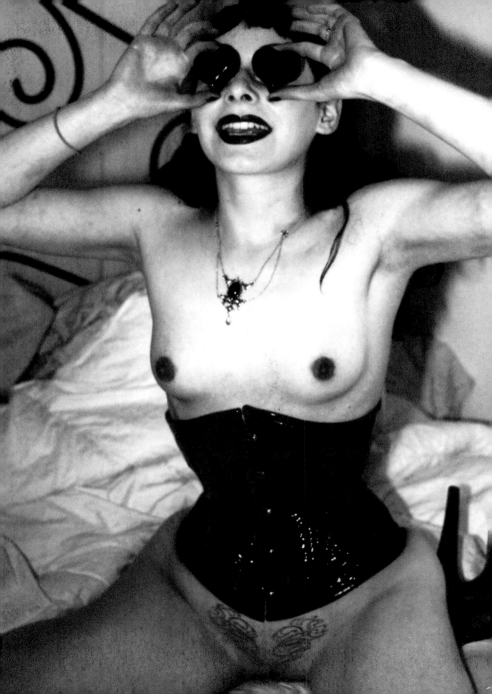

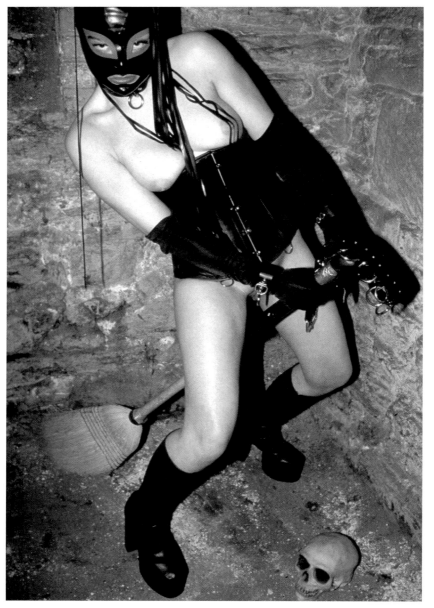

Phili, New York 1999

Nan, Copenhagen 199

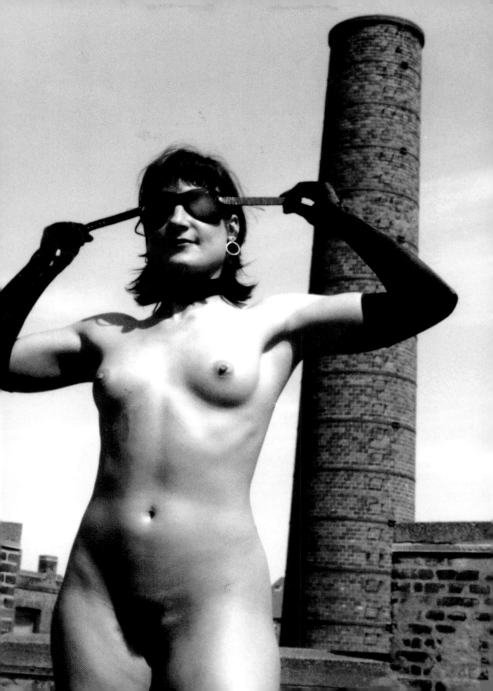

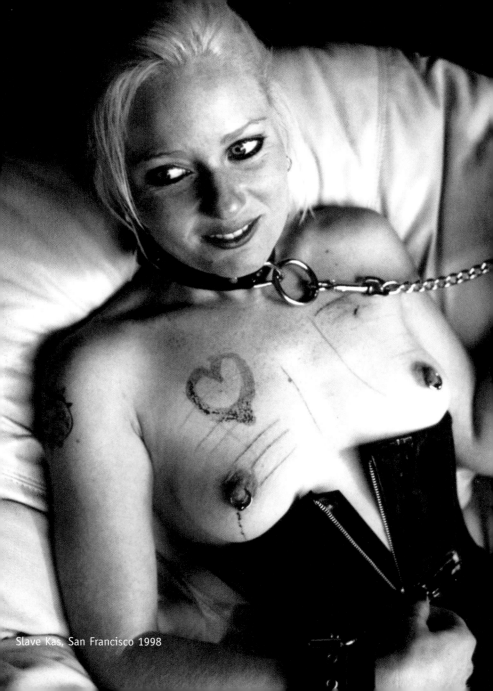

Slave Kas, San Francisco 1998

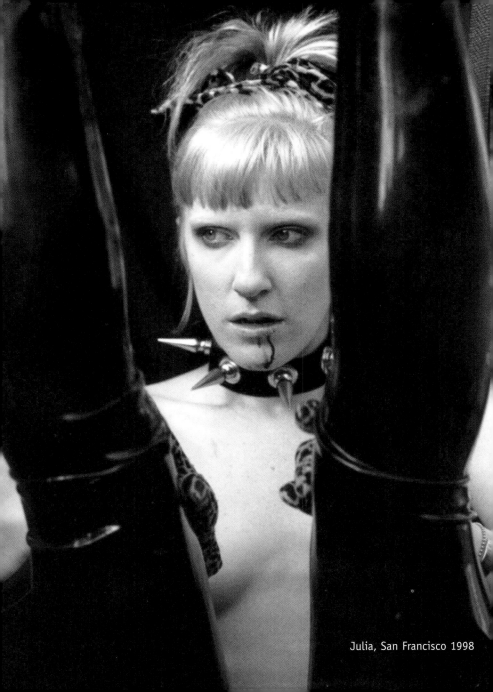

Julia, San Francisco 1998

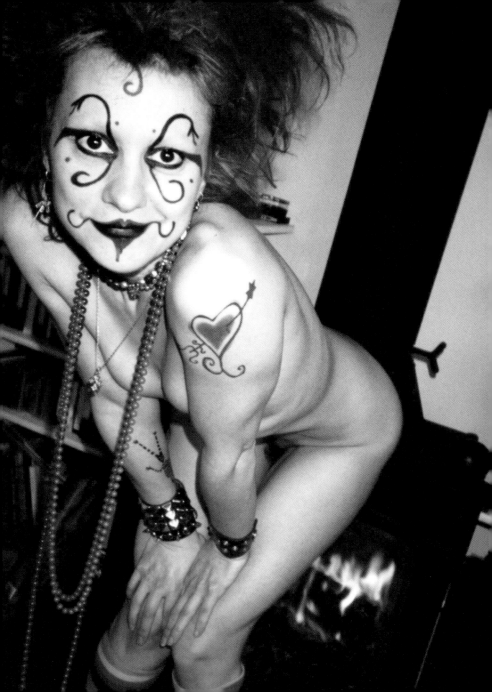

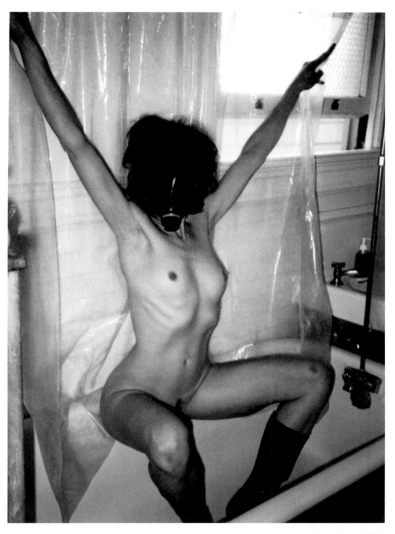

Linda, San Francisco 1997

a, San Francisco 1997

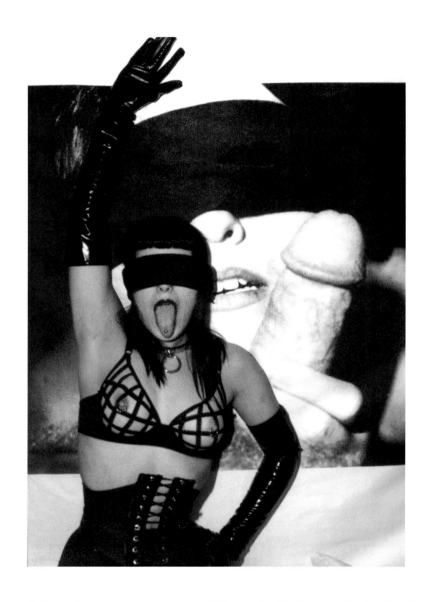

Rubbermaide Self-portrait with Rubbermaide, San Francisco 1

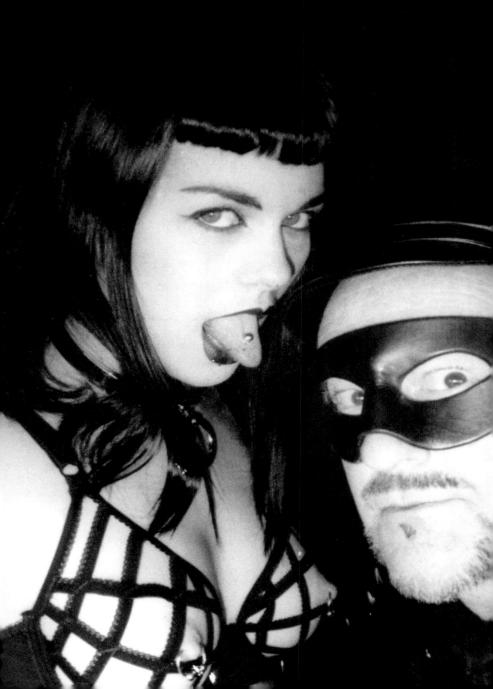

Wet dreams

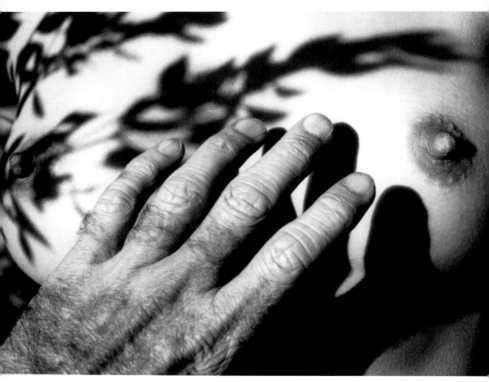

Self-portrait with Bamby, San Francisco 1995

Emily, San Francisco 1

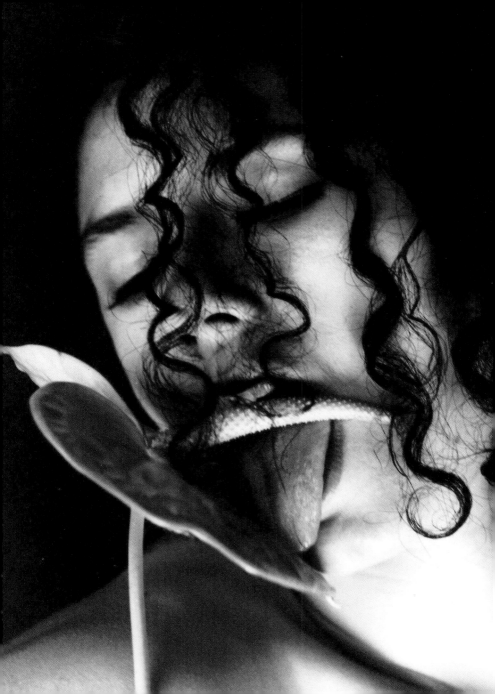

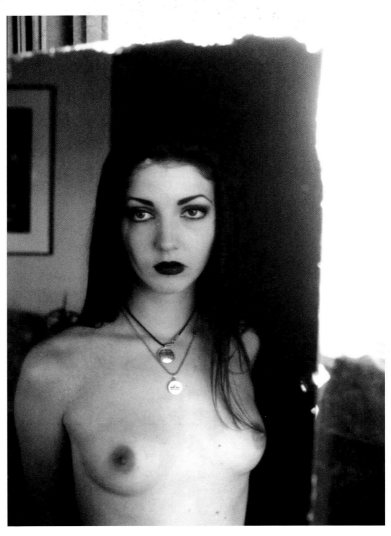

Tobi, San Francisco 1997

Laura, San Francisco 1

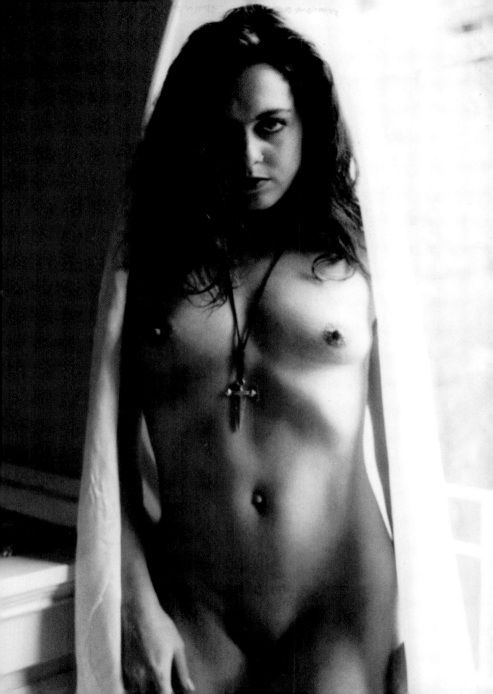

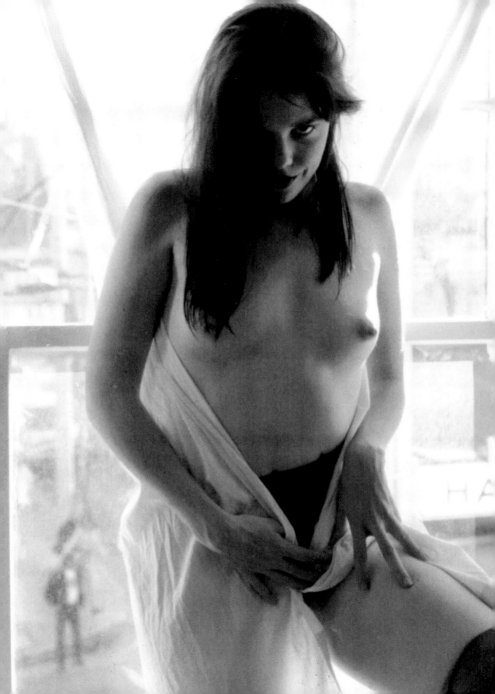

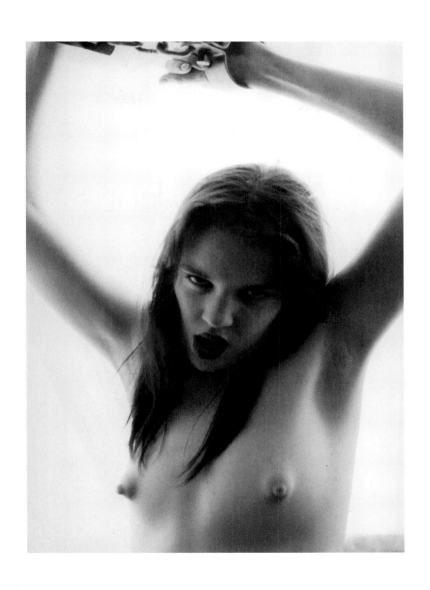

na, San Fransisco 1995

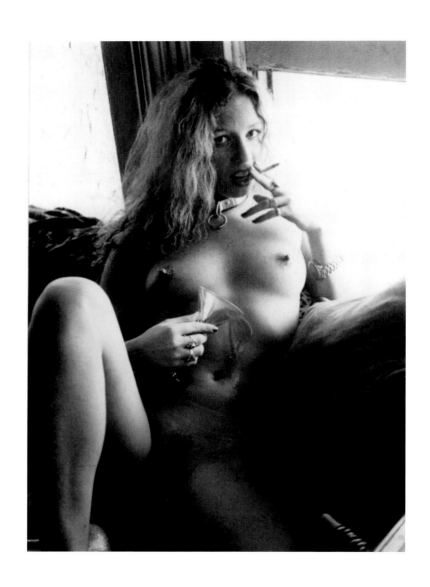

Sara, San Francisco 1997

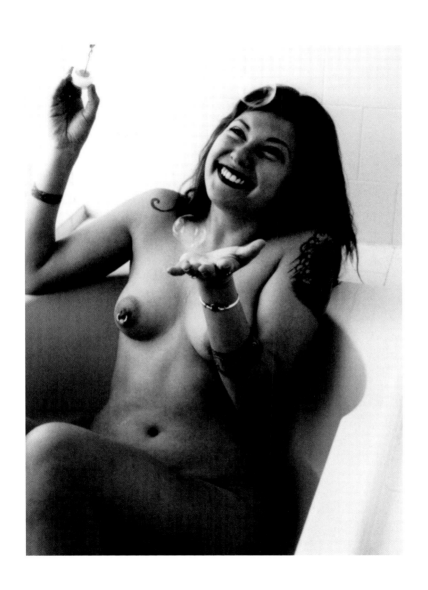

Amazing Grace, Rotterdam 1996

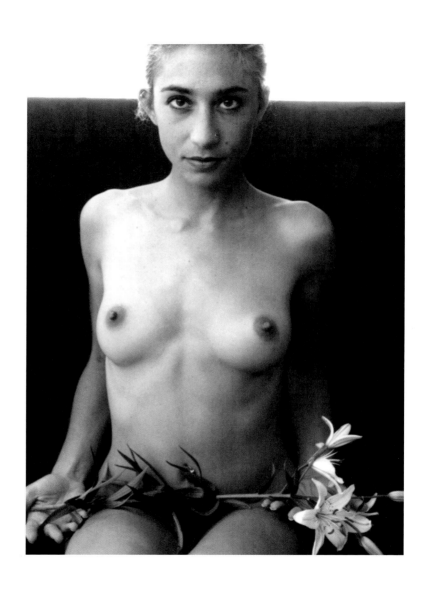

Bamby, San Francisco 1995

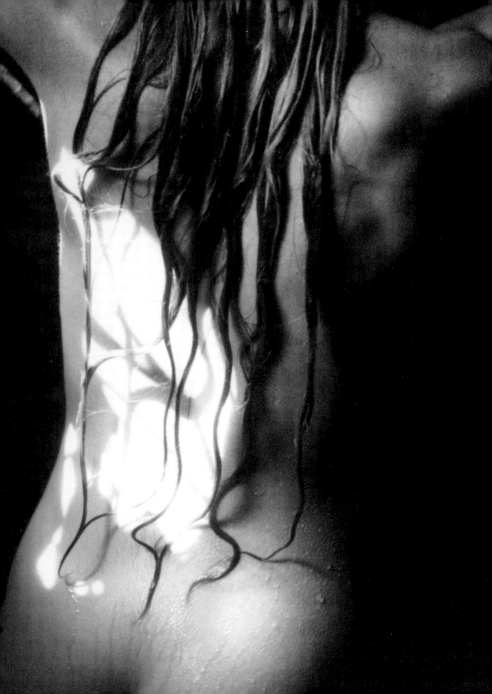

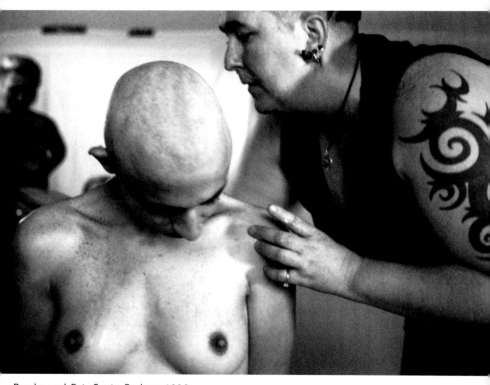

Bamby and Pat, Santa Barbara 1996

Bamby shaved, Santa Barbara 19

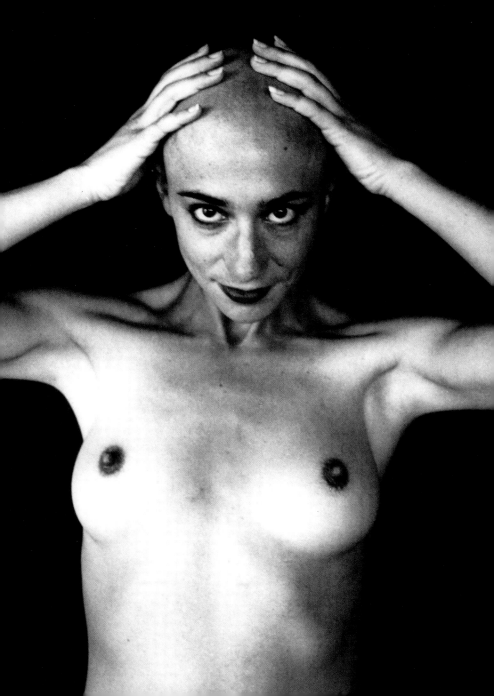

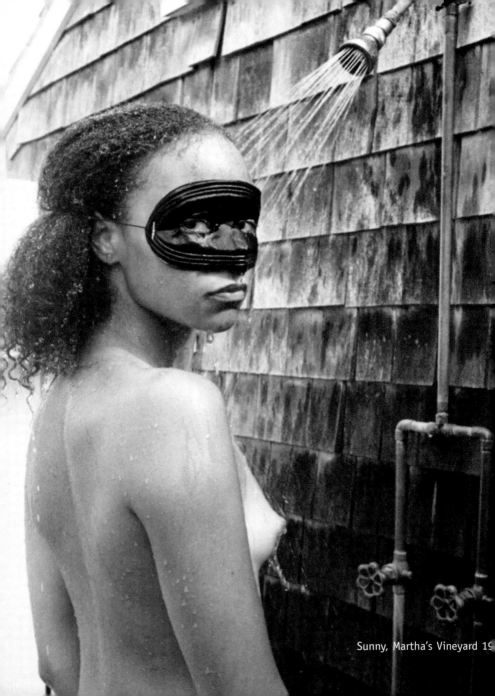

Sunny, Martha's Vineyard 19

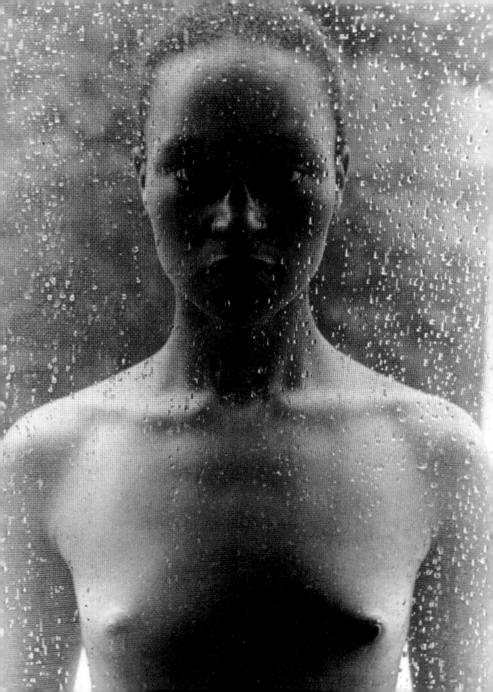

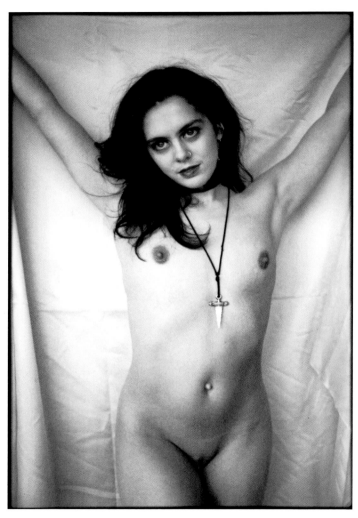

Laura, San Francisco 1993

Vicki, San Francisco 1

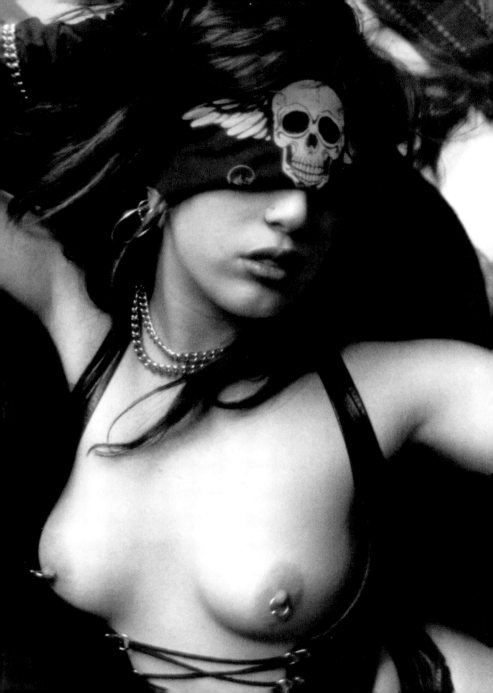

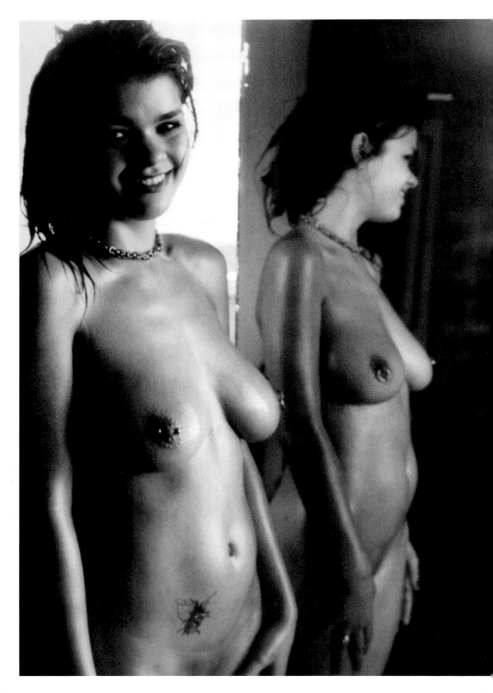

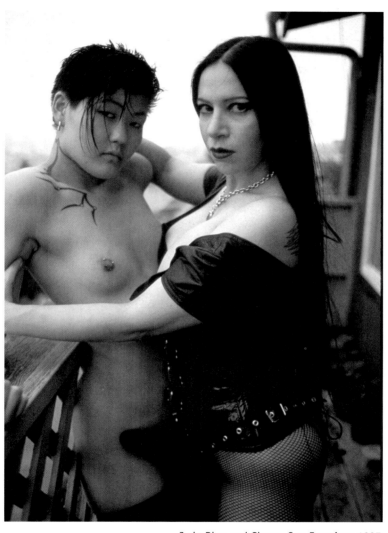

Jade Blue and Shane, San Francisco 1997

ntrelle, San Francisco 1995

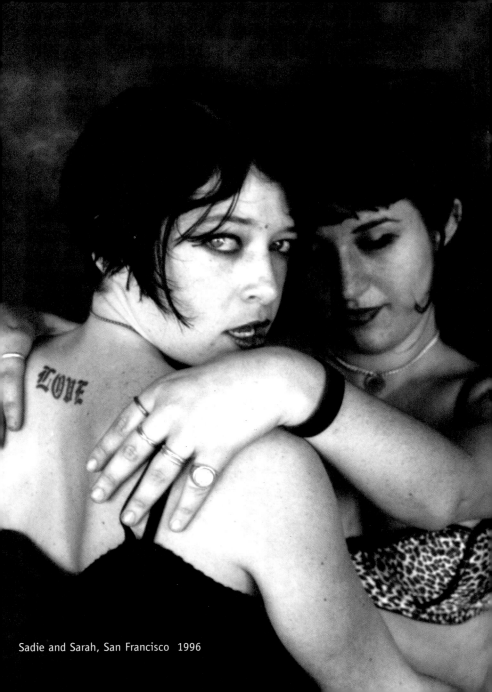

Sadie and Sarah, San Francisco 1996

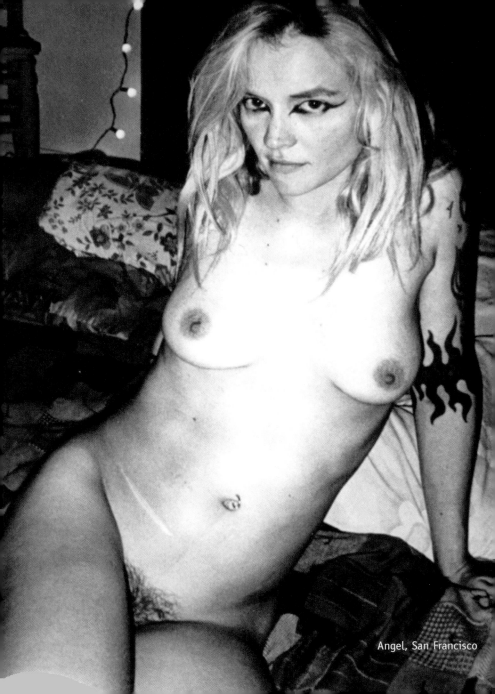

Angel, San Francisco

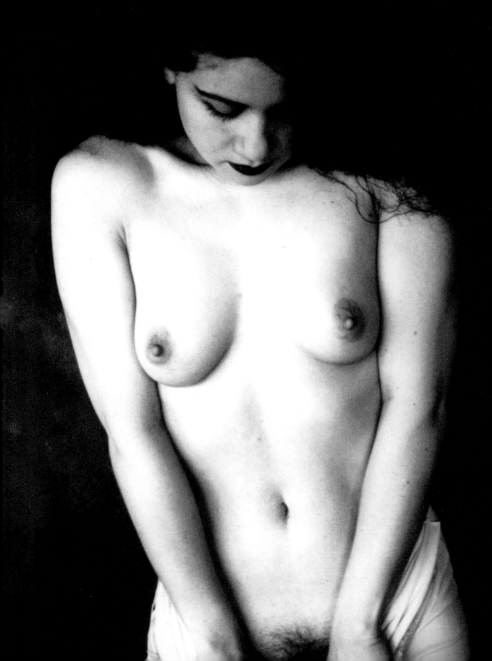

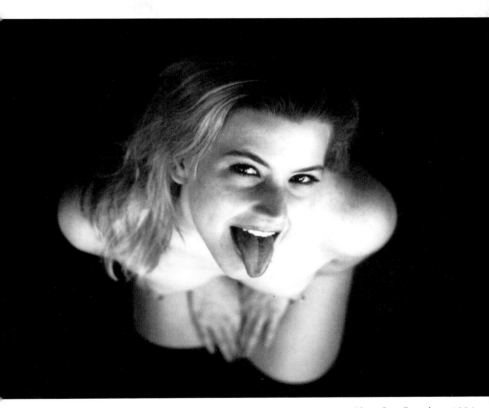

Alex, San Francisco 1994

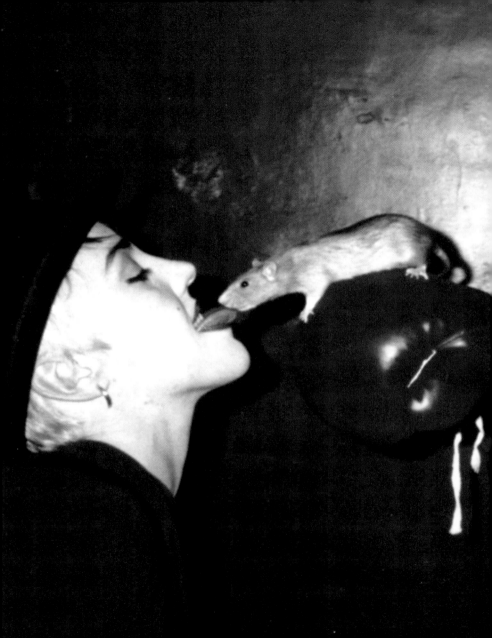
Heidi and Julia, San Francisco 1998

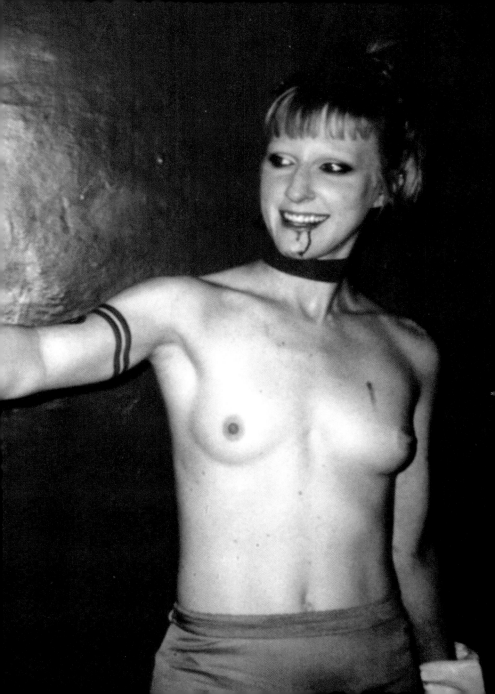

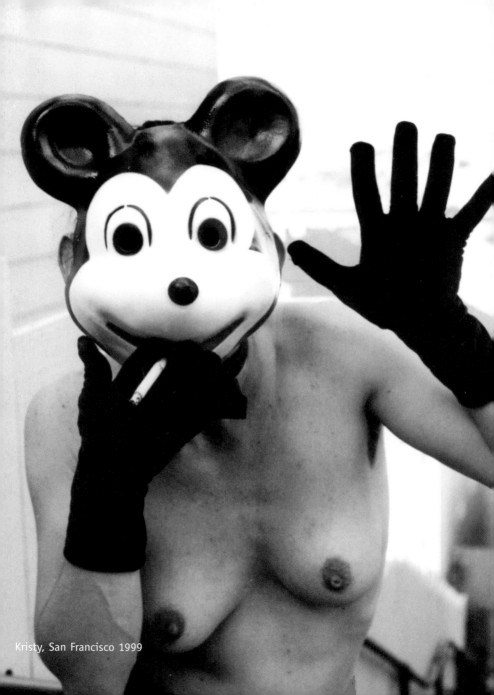

Kristy, San Francisco 1999

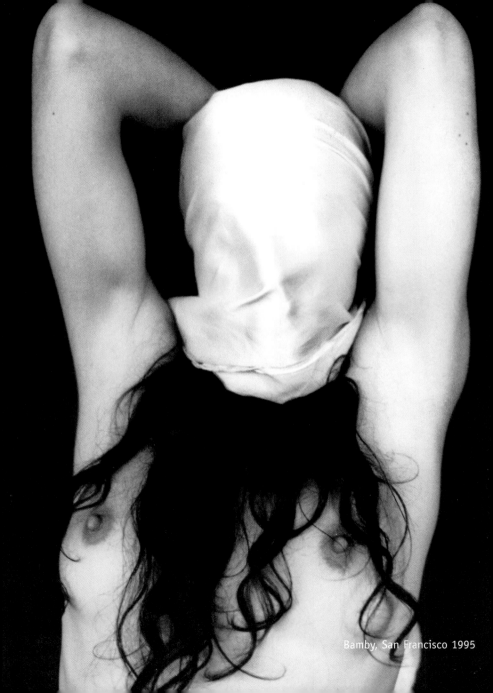

Bamby, San Francisco 1995

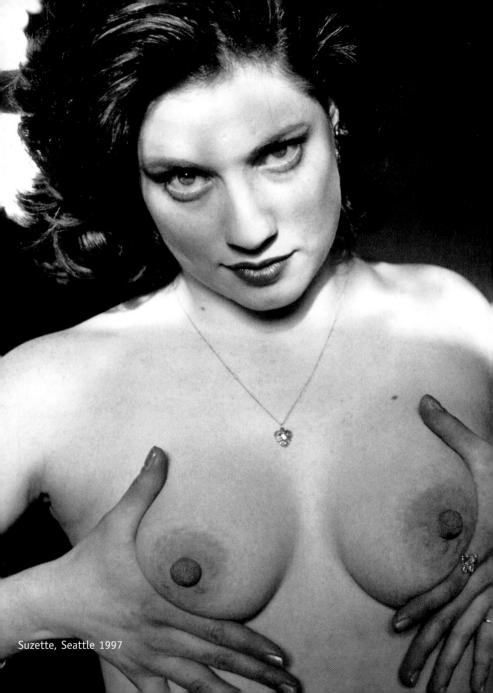

Suzette, Seattle 1997

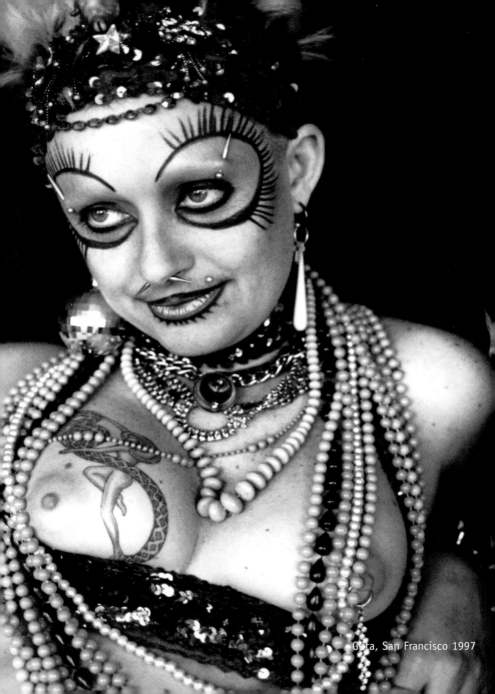

Guta, San Francisco 1997

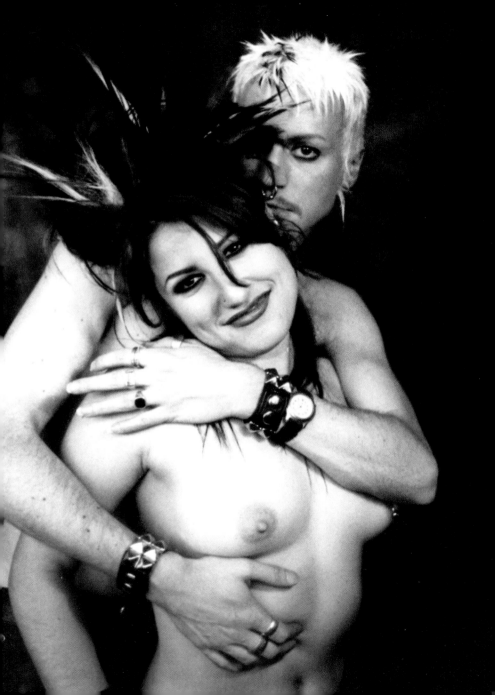

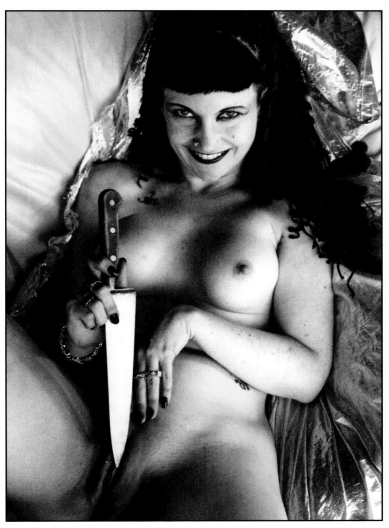

Absinthe, San Francisco 1999

rew and Erika, San Francisco 1999

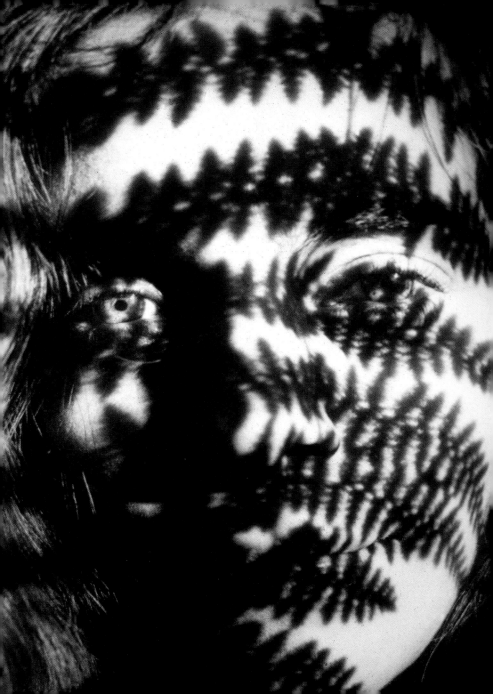

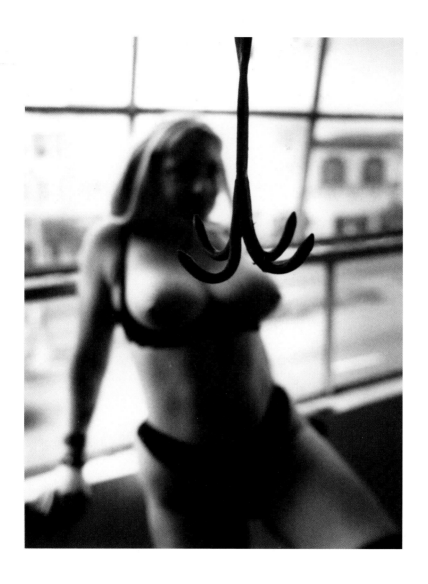

e, Woodstock - New York 1985 Dharma, San Francisco 1994

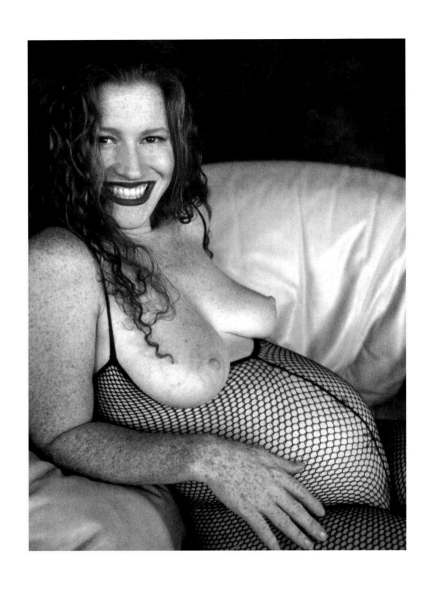

La Sara, San Francisco 1999 Tobi, San Francisco 1

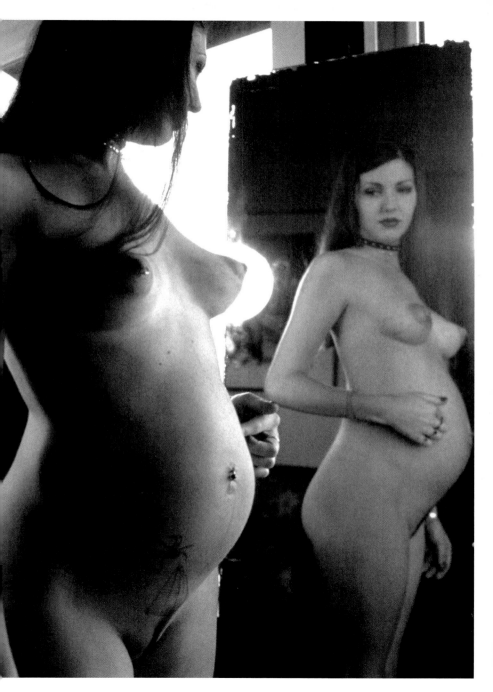

Zea and Dragon, New York 1997

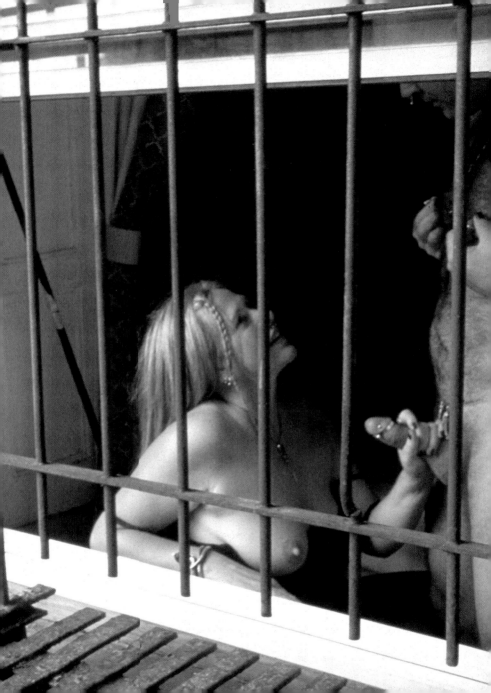

MESSY

MESSY

MESSY

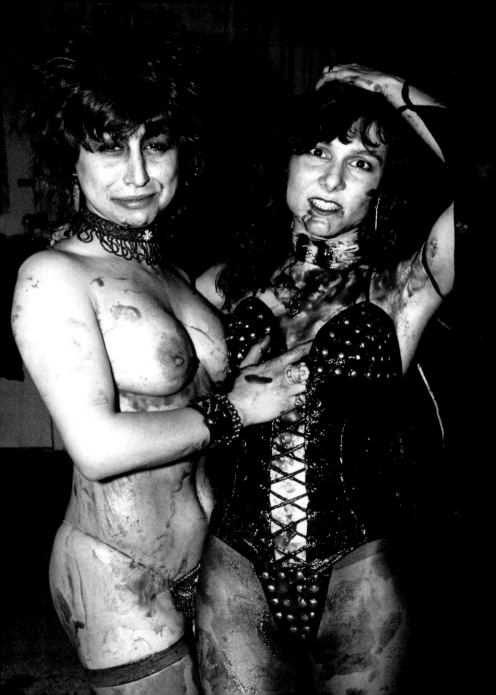

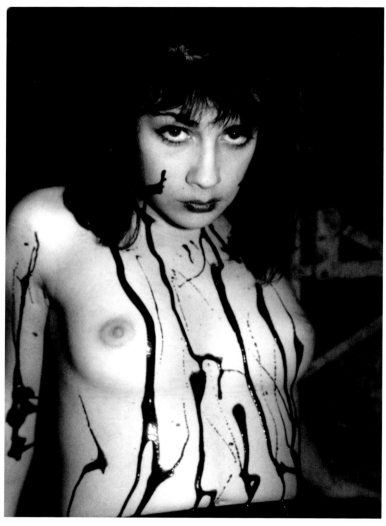

Tia, San Francisco 1994

Mayela and Erika, San Francisco 19

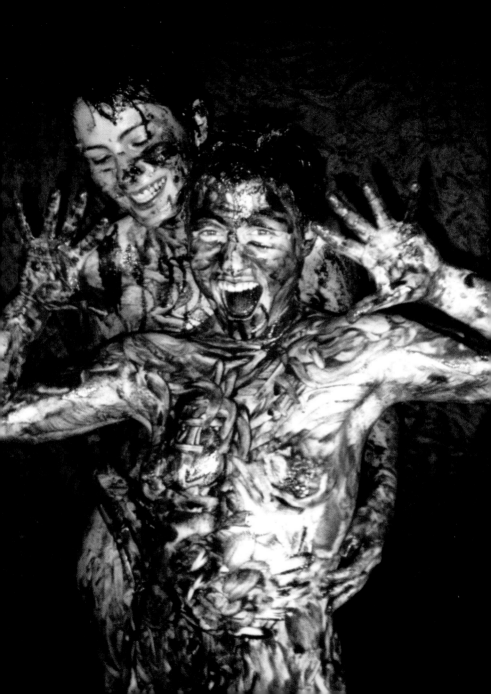

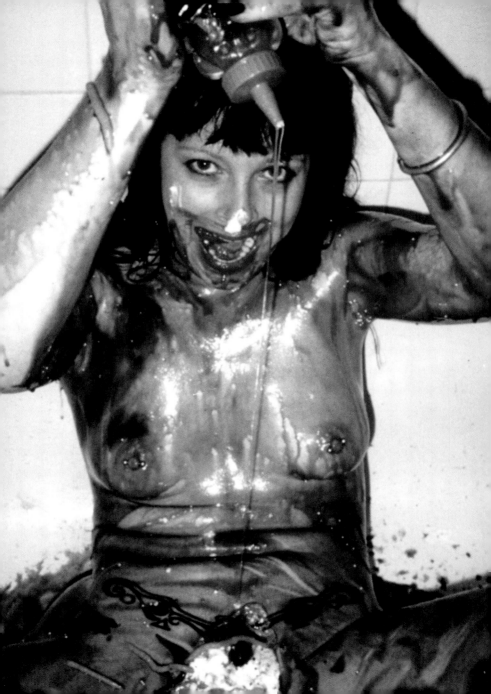

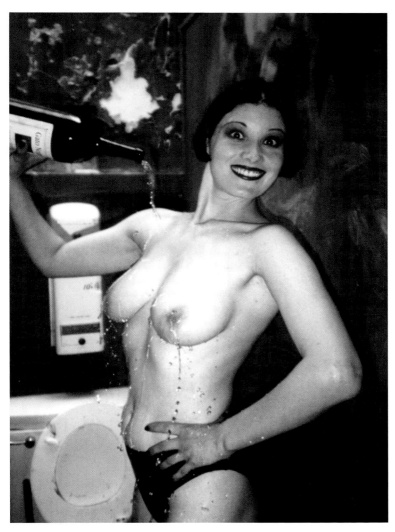

Vasiliki, San Francisco 1998

na, San Francisco 1997

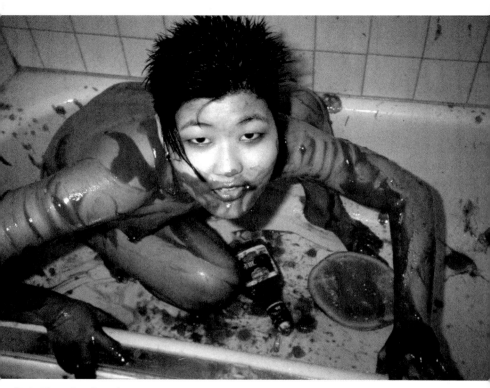

Jade Blue, San Francisco 1996

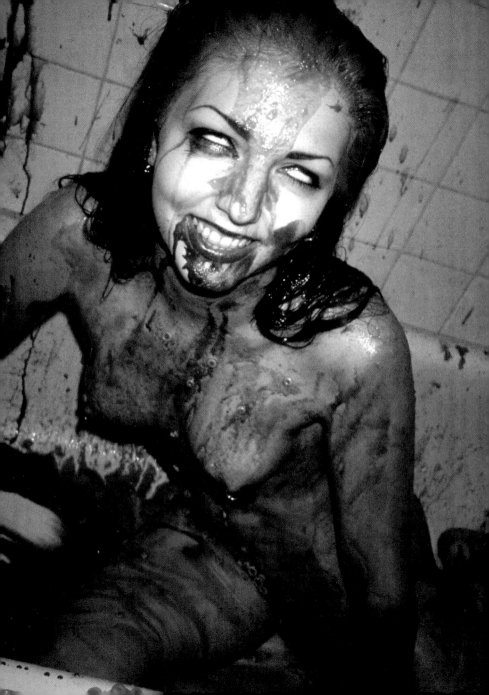

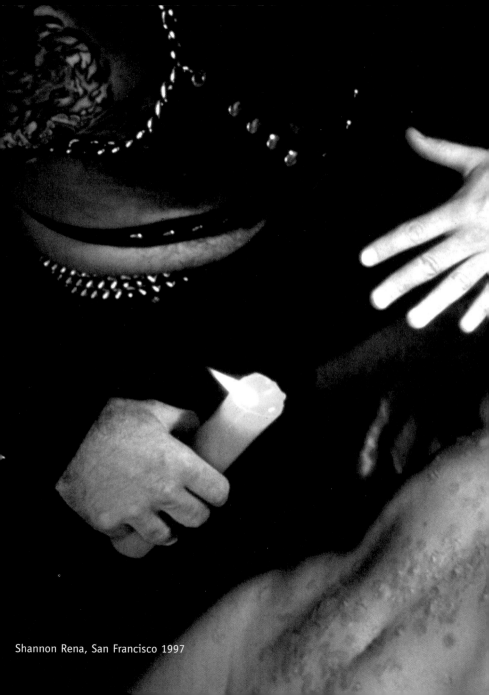

Shannon Rena, San Francisco 1997

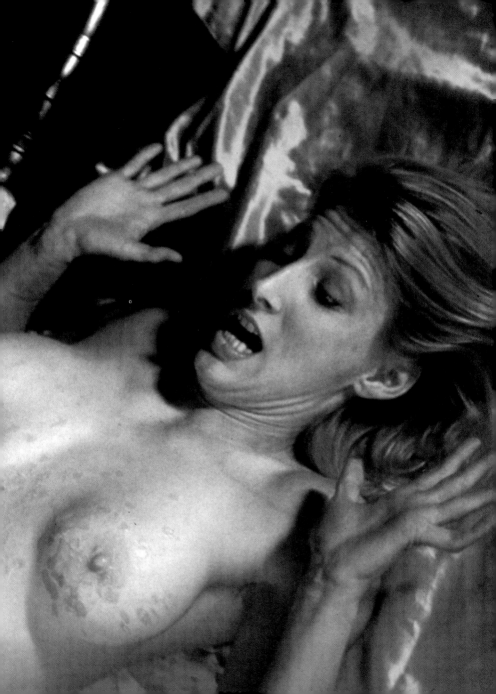

True blood

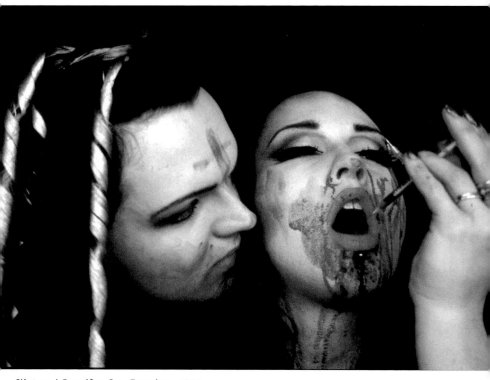

Clint and Jennifer, San Francisco 1996

Clint and Jennifer, San Francisco 19

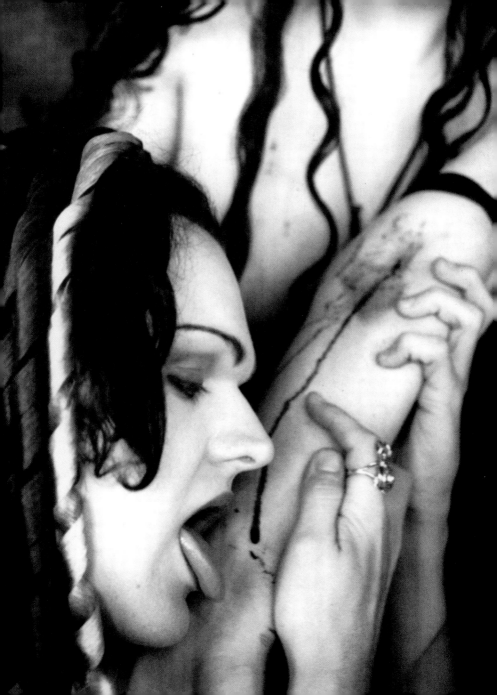

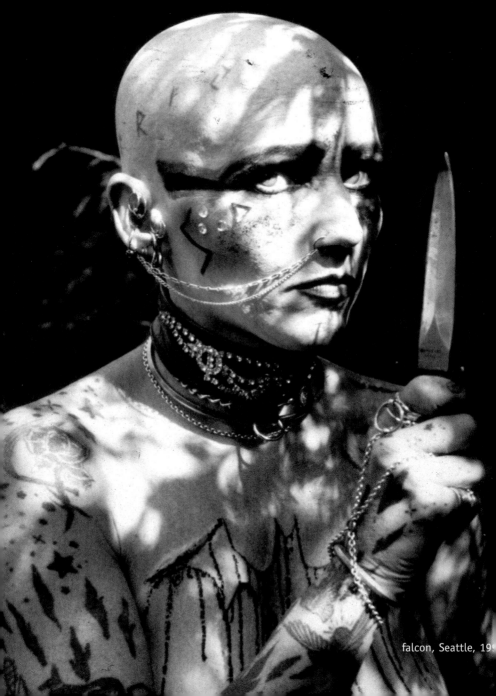

falcon, Seattle, 19

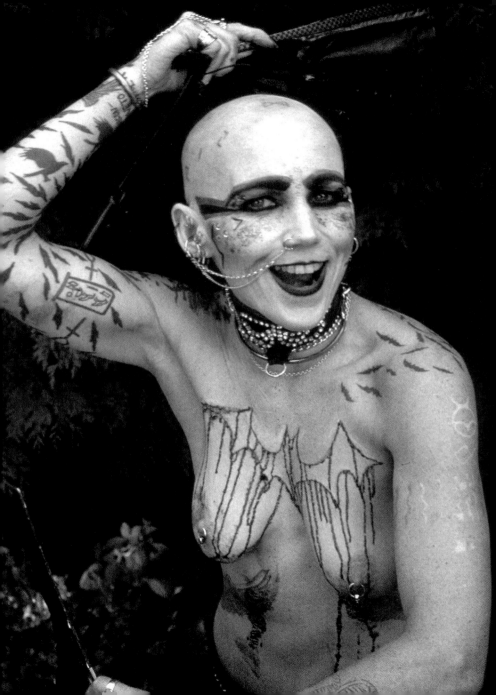

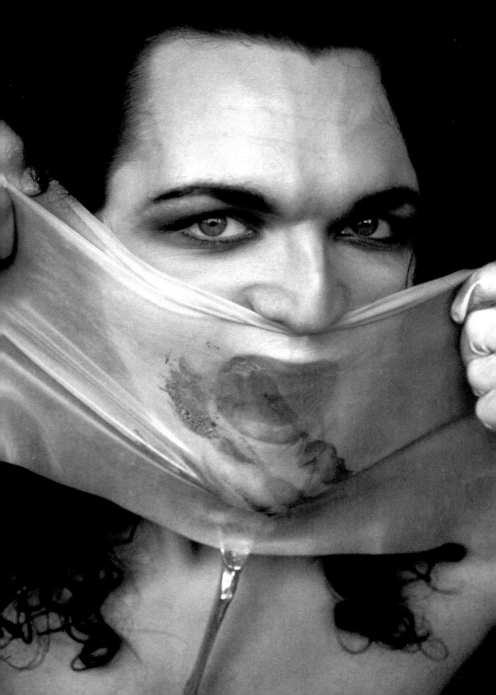

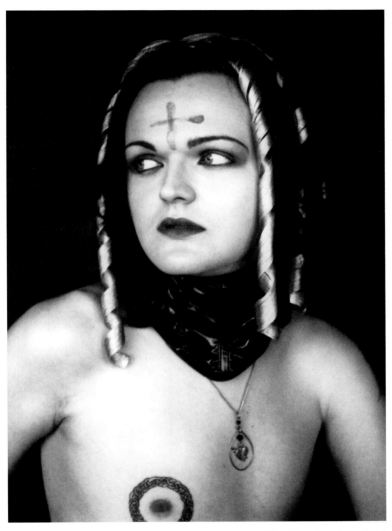

Clint, San Francisco 1996

nt, San Francisco 1995

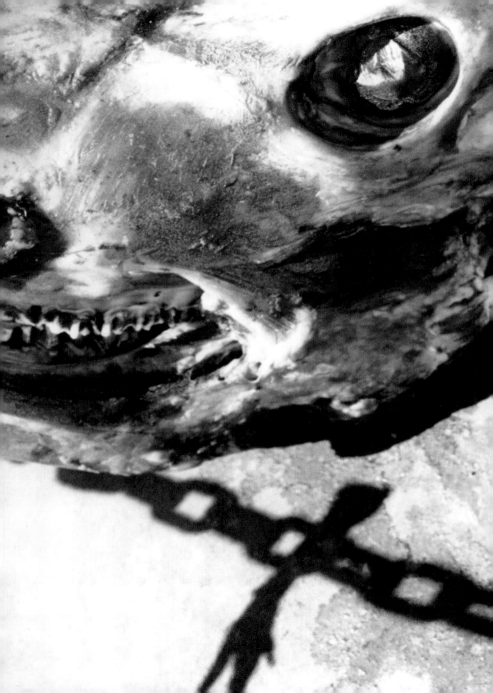

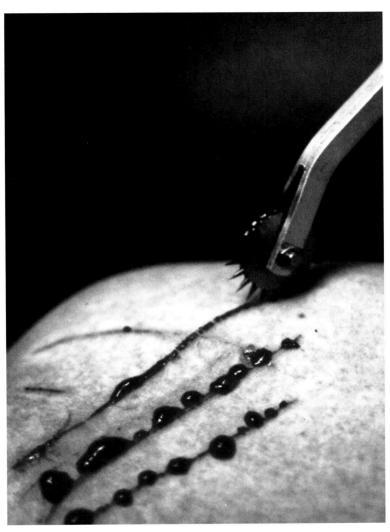

San Francisco, 1996

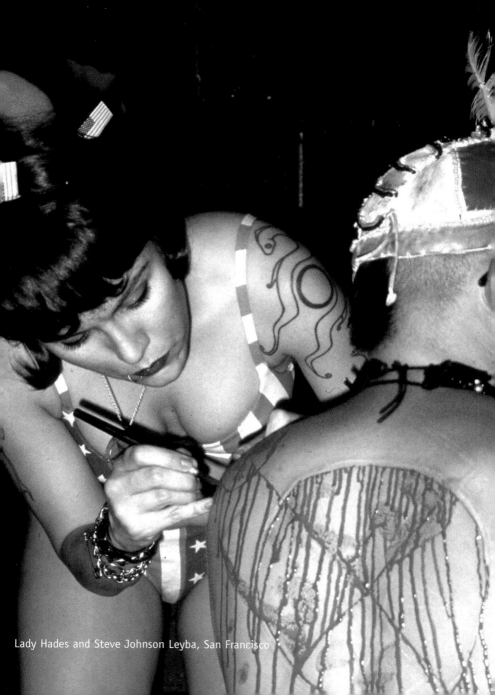

Lady Hades and Steve Johnson Leyba, San Francisco

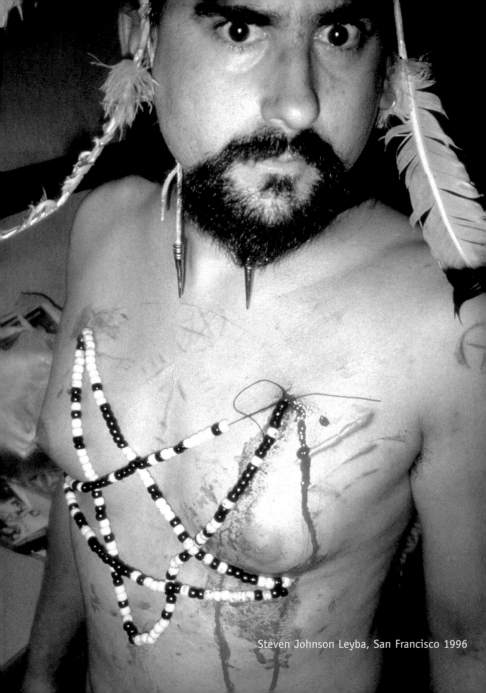

Steven Johnson Leyba, San Francisco 1996

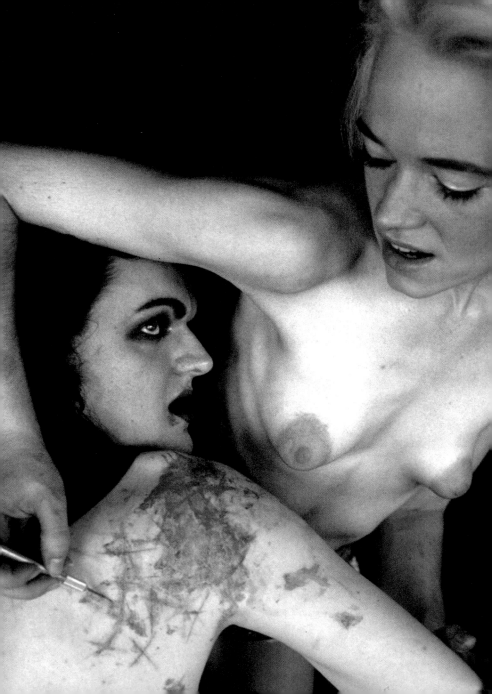

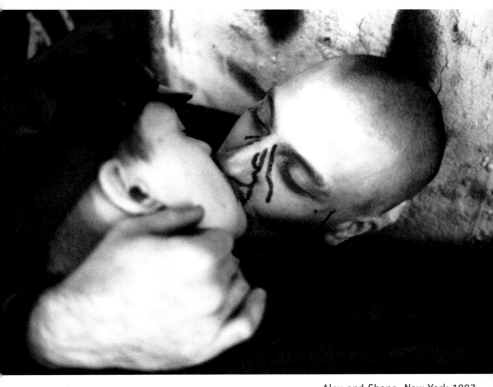

Alex and Shane, New York 1997

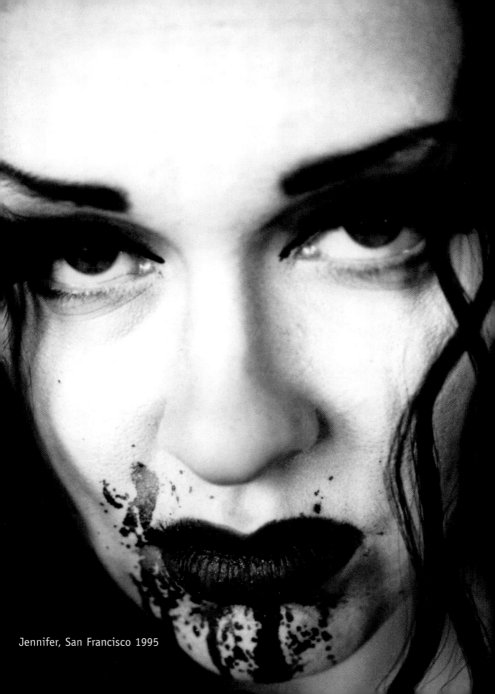

Jennifer, San Francisco 1995

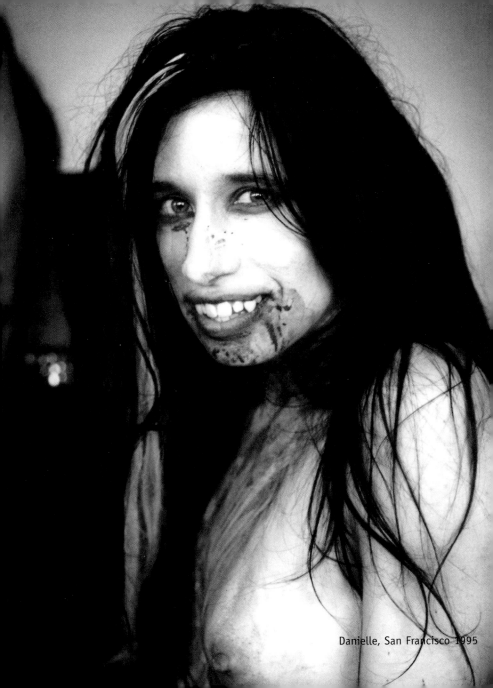

Danielle, San Francisco 1995

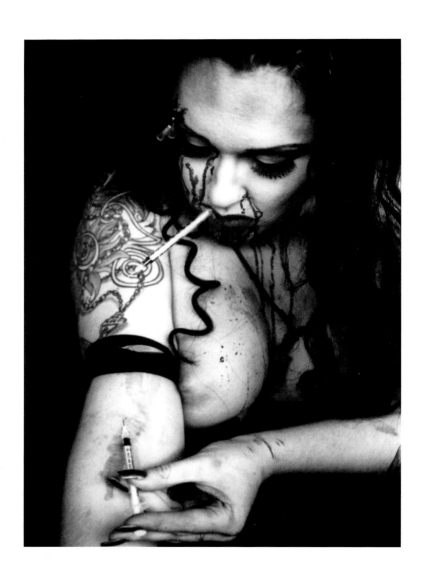

Jennifer, San Francisco 19

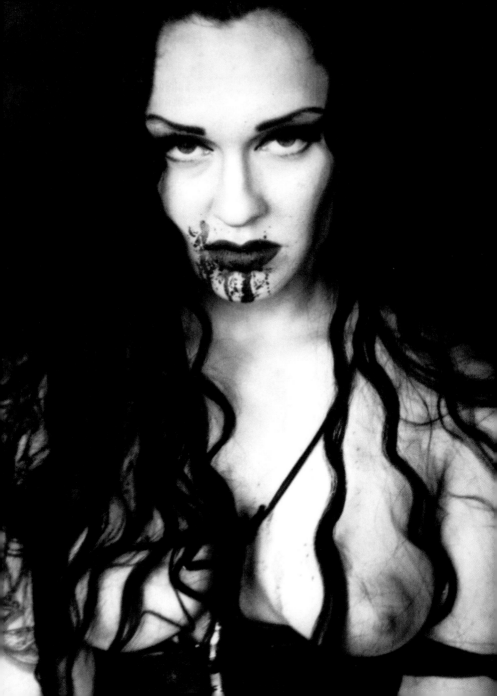

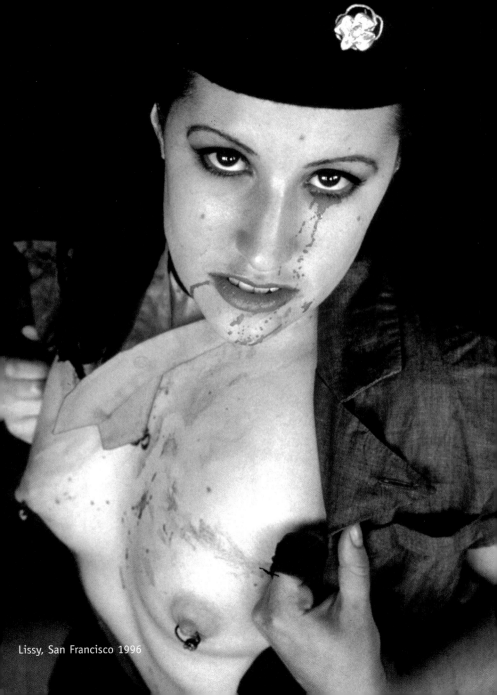

Lissy, San Francisco 1996

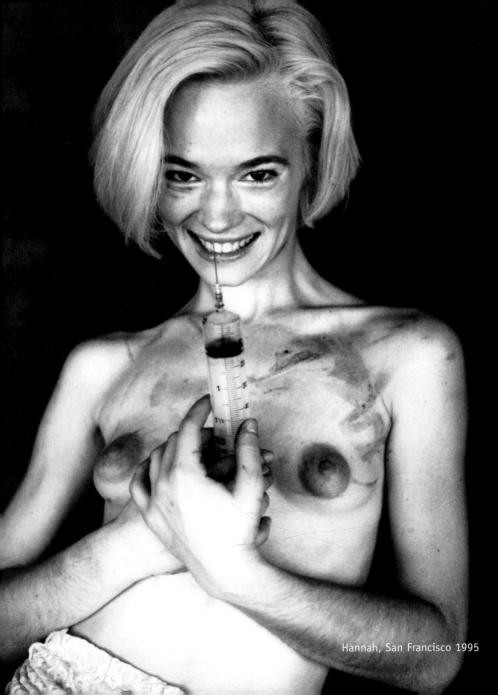

Hannah, San Francisco 1995

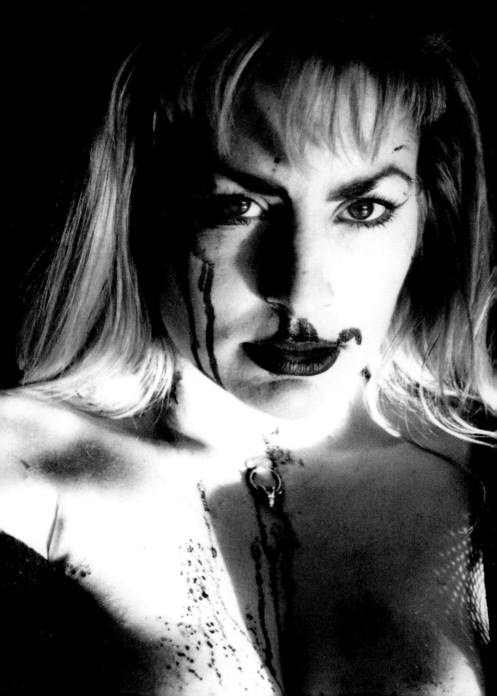

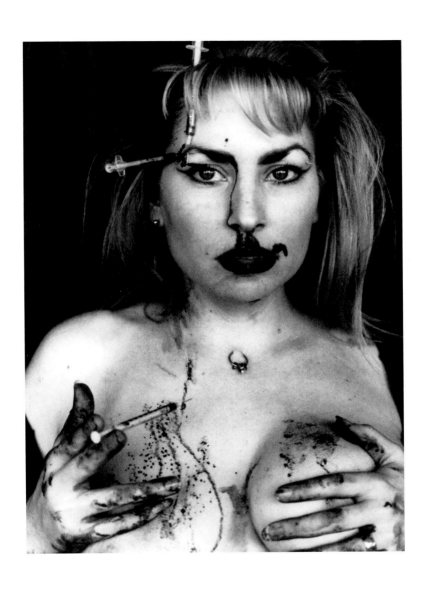

harma, San Francisco 1995

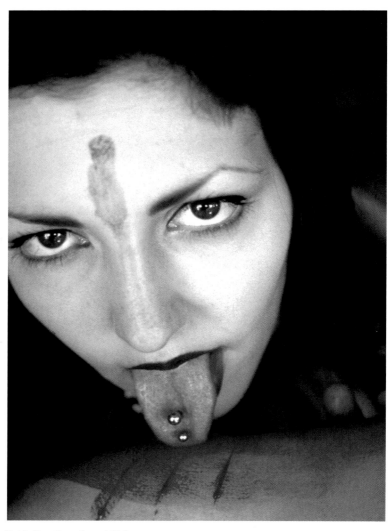

Tobi, San Francisco 1996

Sarah, San Francisco 199

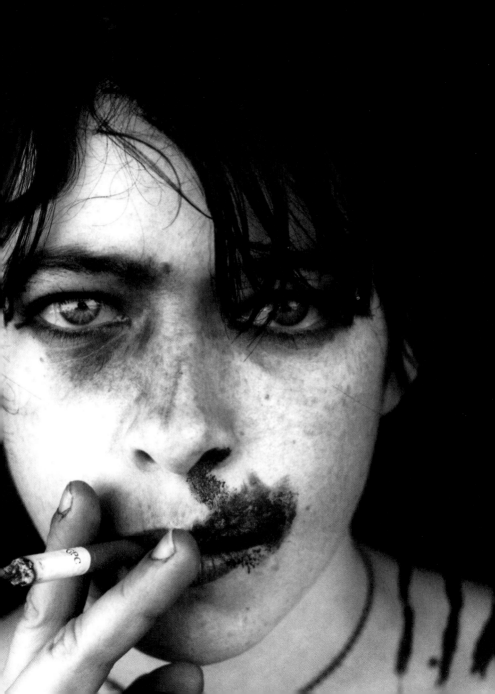

California

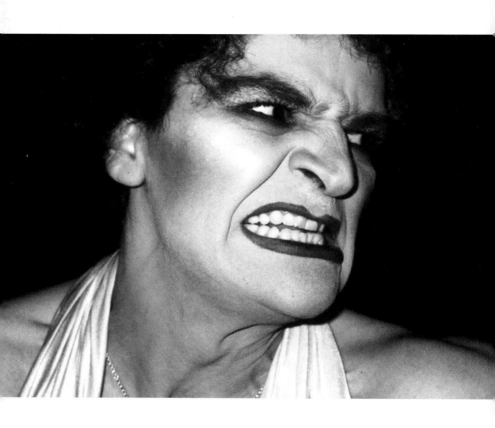

Transvestite, Portola Valley - California 1999

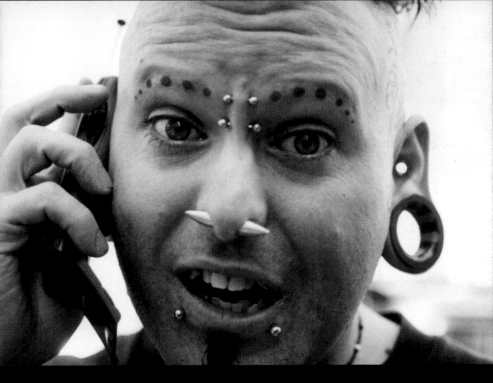

John, Los Angeles 1999

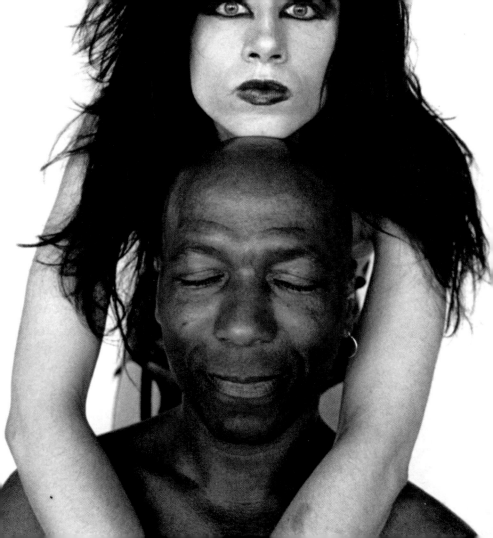

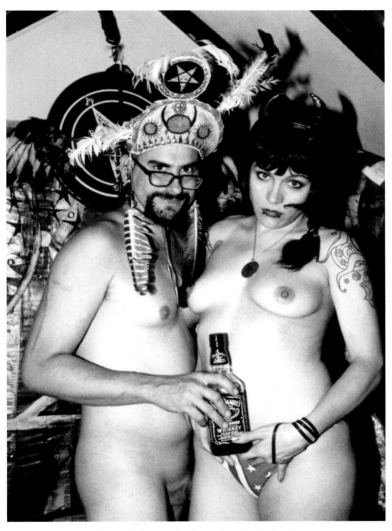

Steven Johnson Leyba and Lady Hades, San Francisco 1998

nielle and Ivory, San Francisco 1994

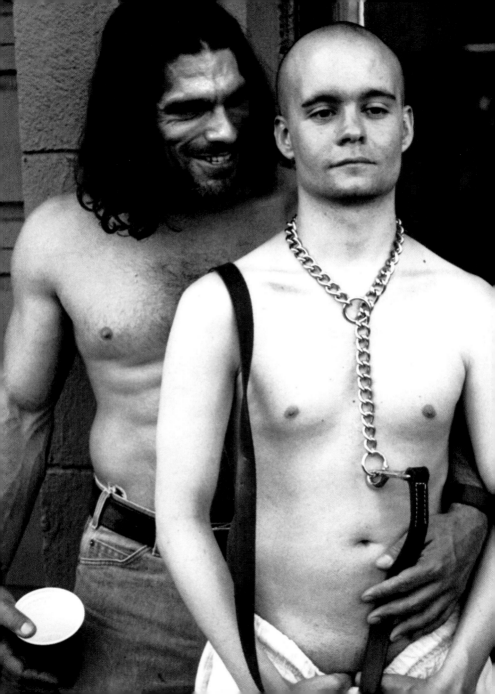

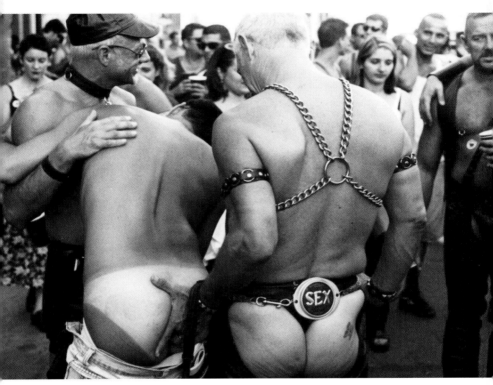

Folsom Street Fair, San Francisco 1997

lsom Street Fair, San Fransisco 1998

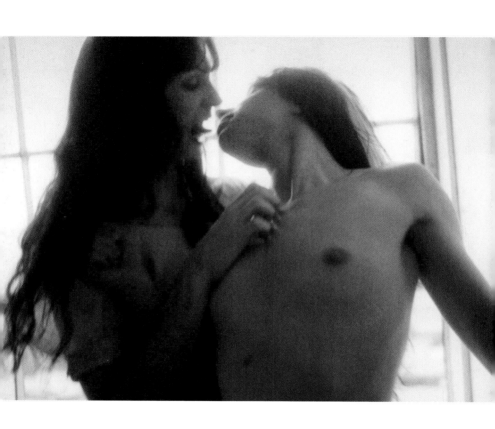

Violet and Danielle, San Francisco 1995

436

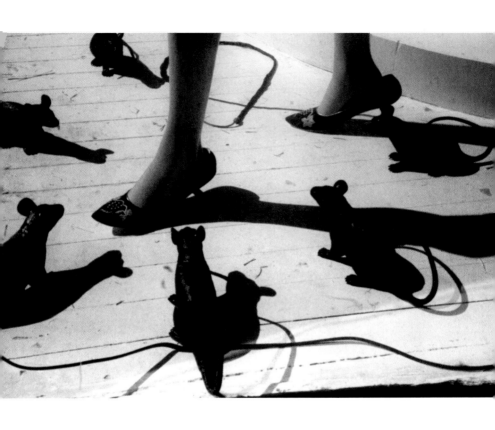

Store window, San Francisco 1997

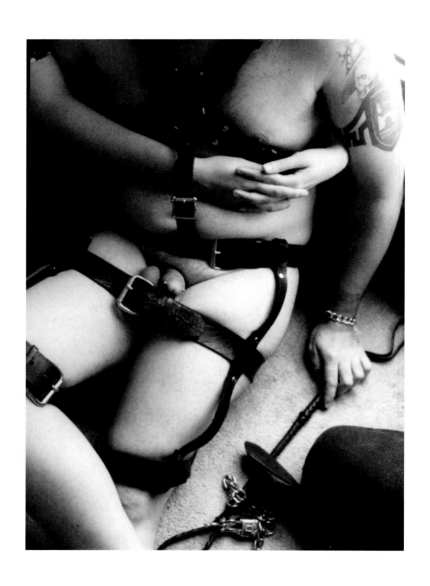

Play Party, San Diego 1994

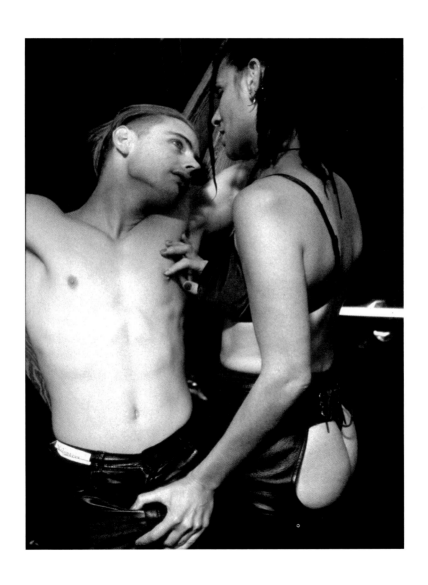

Mistress Izabella Sol and slave, San Francisco 1999

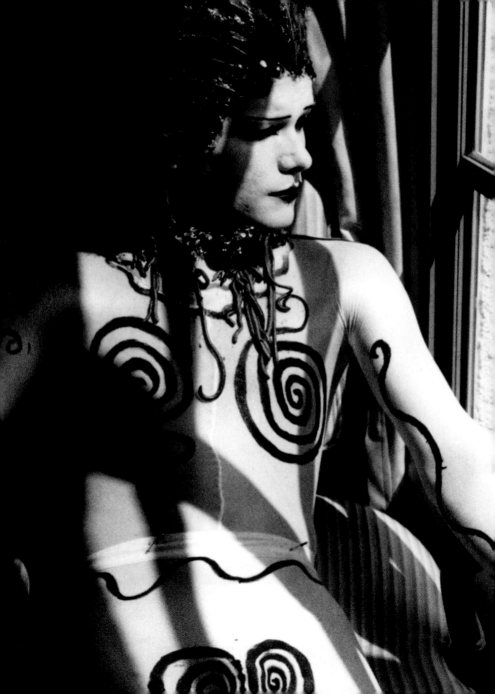

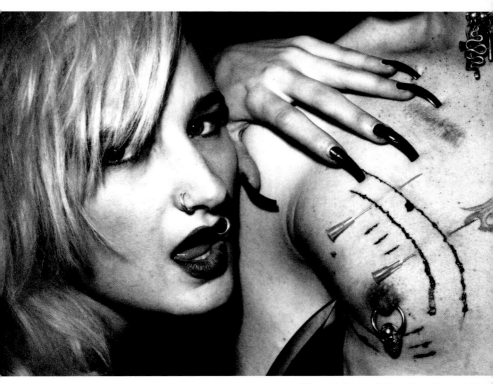

Lily and Michael, San Francisco 1991

te Fatale, Los Angeles 1998

Books by the Artist

Sidetripping (with William S. Burroughs), New York, Strawberry Hill Books, 1975
X-1000 (with Spider Webb and Marco Vassi), Woodstock, New York, R. Mutt Press, 1977
Pushing Ink: The Fine Art of Tattooing (with Spider Webb and Marco Vassi), New York, Simon and Schuster,1979
Forbidden Photographs, Woodstock, New York, R. Mutt Press, 1981, new edition 1995
Wall Street, Woodstock, New York, R. Mutt Press, 1984
Primitives, Woodstock, New York, R. Mutt Press, 1992
Charles Gatewood Photographs: The Body and Beyond, San Francisco, Flash Publications, 1993
True Blood, San Francisco, Last Gasp Press, 1997

Solo Exhibitions

1972 Light Gallery, New York City
1975 Neikrug Gallery, New York City, (*"Sidetripping"*)
1975 Brummels Gallery, Melbourne, Australia
1976 The Australian Center of Photography, Sydney, Australia
1977 Levitan Gallery, New York City, (*"X-1000"*)
1978 Steiglitz Gallery, New York City, (*"Wall Street"*)
1978 Light Works, Syracuse University, (*"Forbidden Photographs"*)
1978 Project Arts Center, Cambridge, Massachusetts, (*"Forbidden Photographs"*)
1978 Contemporary Arts Center, New Orleans
1978 Contrejour Gallery, Paris
1978 Colorado Center for Photographic Studies, University of Colorado at Boulder
1979 Gallery Vior, Toulouse, France
1981 Robert Samuel Gallery, New York City, (*"Forbidden Photographs"*)
1984 Rhode Island School of Design, Providence, Rhode Island
1986 Drew University, Madison, New Jersey
1988 Level Three Gallery, Philadelphia
1988 Bobo Gallery, San Francisco
1989 Neikrug Gallery, New York
1993 Morphos Gallery, San Francisco, (*"Primitives"*)
1993 Photographic Image Gallery, Portland, Oregon
1994, 1995, 1996 Clayton Gallery, New York
1994, 1996 Rita Dean Gallery, San Diego
1995 Dark´s Art Parlour, Santa Ana CA

Fakir Musafar, Sundance ritual, Wyoming 198

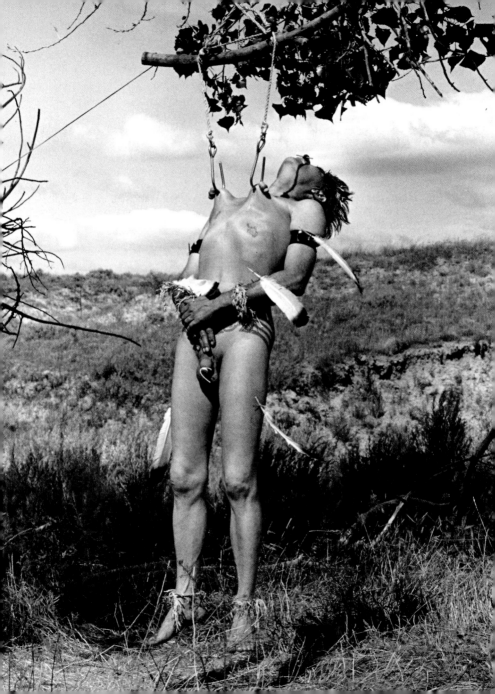

1995	Komm Ausstellungswerkstatt, Nürenberg
1995	University of Tübingen, Tübingen, Germany
1996	Catharine Clark Gallery, San Francisco
1997	Williamsburg Art and Historical Center, Brooklyn
1998	Merry Karnowsky Gallery, Beverley Hills CA

Awards

1974	CAPS Fellowship in Photography, New York State Council on the Arts
1975	American Institute of Graphic Arts Award
1976	Artist-in-Residence, Light Work, Syracuse University
1977	CAPS Fellowship in Photography, New York State Council on the Arts
1980	Photographers´ Fund Grant, Catskill Center of Photography, Woodstock, New York
1983	New York State Council on the Arts Fellowship for *Wall Street*
1985	Art Directors Club Merit Award
1985	Leica Medal of Excellence for Outstanding Humanistic Photojournalism
1986	Photographer´s Forum Magazine Award of Excellence

"Are there still areas of behavioral map marked UNKNOWN? If so, book my passage at once, for it is on these mysteriously familiar journeys that I fell most alive. In these dark worlds I sence no limits. In these forbitten acts I taste the infinite".

- Charles Gatewood

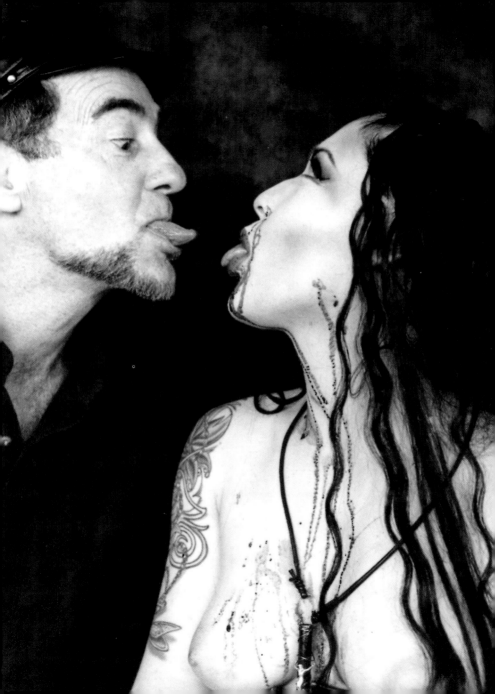

For information about

**Charles Gatewood,
books, prints and videos,**

a **free catalog** of other Goliath books,

distribution in your country
dealer information,

or if you are interested in publishing a book with us,
are a **photographer** or **collector**

please contact:

Goliath Verlagsgesellschaft mbH
Eschersheimer Landstr. 353
D 60320 Frankfurt/Main
Germany

Or send an e-mail to

goliath-verlag@gmx.de